LARA JADE
FASHION PHOTOGRAPHY 101

PIXIQ™

An Imprint of Sterling Publishing Co., Inc.
New York / Asheville

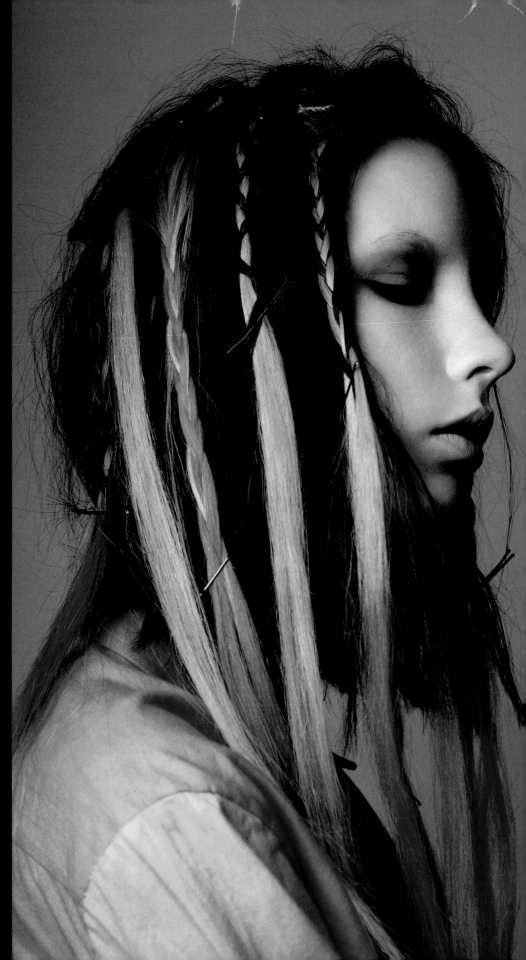

Fashion Photography 101
Library of Congress Cataloging-in-Publication Data

Jade, Lara.
 Fashion photography 101 / Lara Jade. -- 1st ed.
 p. cm.
 ISBN 978-1-4547-0418-8
 . Fashion photography. I. Title.
 TR679.J33 2012
 778.9'974692--dc23

 2012006473

10 9 8 7 6 5 4 3 2 1
First Edition
Published by Pixiq
An Imprint of Sterling Publishing Co., Inc.
387 Park Avenue South, New York, N.Y. 10016
© The Ilex Press Limited 2012
This book was conceived, designed, and produced by:
ILEX, 210 High Street, Lewes,
BN7 2NS, United Kingdom

Distributed in Canada by Sterling Publishing,
c/o Canadian Manda Group, 165 Dufferin Street
Toronto, Ontario, Canada M6K 3H6

If you have questions or comments about
this book, please contact:
Pixiq, 67 Broadway, Asheville, NC 28801
(828) 253-0467

Manufactured in China
All rights reserved
ISBN: 978-1-4547-0418-8

For information about custom editions, special sales, premium
and corporate purchases, please contact Sterling Special Sales
Department on 800-805-5489 or specialsales@sterlingpub.com.
For information about desk and examination copies available to
college and university professors, requests must be submitted
to academic@sterlingpublishing.com. Our complete policy can
be found at www.larkbooks.com (about/contact).

Photography credit:

Page 2:
Anna and Georgie for *Material Girl* magazine
(www.materialgirl-mag.com).
Models: **Anna and Georgie @ Profile Models London**
Makeup: **Leah Mabe**
Hair: **Craig Marsden @ Carol Hayes Management**
Styling: **Claudia Behnke**
Photography Assistance: **Oscar May**

Page 4:
Uliana for *FAINT Magazine* (www.faintmag.com).
Model: **Uliana @ Storm Models**
Makeup: **Leah Mabe and Keiko Nakamura**
Hair: **Tomoyuki**
Styling: **Krishan Parmar**
Retouching: **M. Seth Jones**

CONTENTS

Introduction THE FASHION PHOTOGRAPHER

FASHION PHOTOGRAPHY is one of the most sought after areas of work among upcoming photographers, and who could blame them? Along with the glamorous lifestyle and huge potential audience for your work, fashion—much like art—is constantly evolving. From the Hollywood glamour girls of the '30s and '50s, to the disco fever of the 1970s and the grunge of the 1990s, fashion photographers have been at the forefront of every movement, capturing the iconic moments of each. Some of the photographers have been even more celebrated than the stars they were shooting.

Breaking into the fashion photography industry may seem like an impossible dream, but with time, investment, passion, determination, and skill, achieving that goal is not as impossible as you might think. I created this book to give new photographers an insight into the fashion photography industry as I know it. This book is not just a photography handbook; it also aims to help you produce your own dynamic images with set assignments, hints, and tips to find your own style as a photographer—one of the most important aspects of launching your fashion photography career.

This guide gives you essential instruction on everything there is to know about fashion photography—covering shooting on-location and in studio environments, lighting diagrams and technical information, working with your model and creative team, and tips on model guidance. As digital imagery plays a large part in today's industry, I have covered some aspects of post-production that are vital for fashion photographers of any skill level. However, covering everything post-production can offer is outside the scope of this book, and those wanting to fully master the digital darkroom would benefit from a dedicated guide. That said, you will learn how to optimize your workflow, perfect your imagery, and also learn about one of the most important parts of the industry—the business side of photography; covering things such as marketing your work, catering to a specific audience, how to effectively organize your portfolio, and how to use social media to reach a wider audience. I hope this book will give you the confidence and inspiration you need to launch your career and get yourself noticed within the fashion photography industry.

OPPOSITE
Me on the set of one
of my workshops.
Photo: **Corina
Van Sluytman**

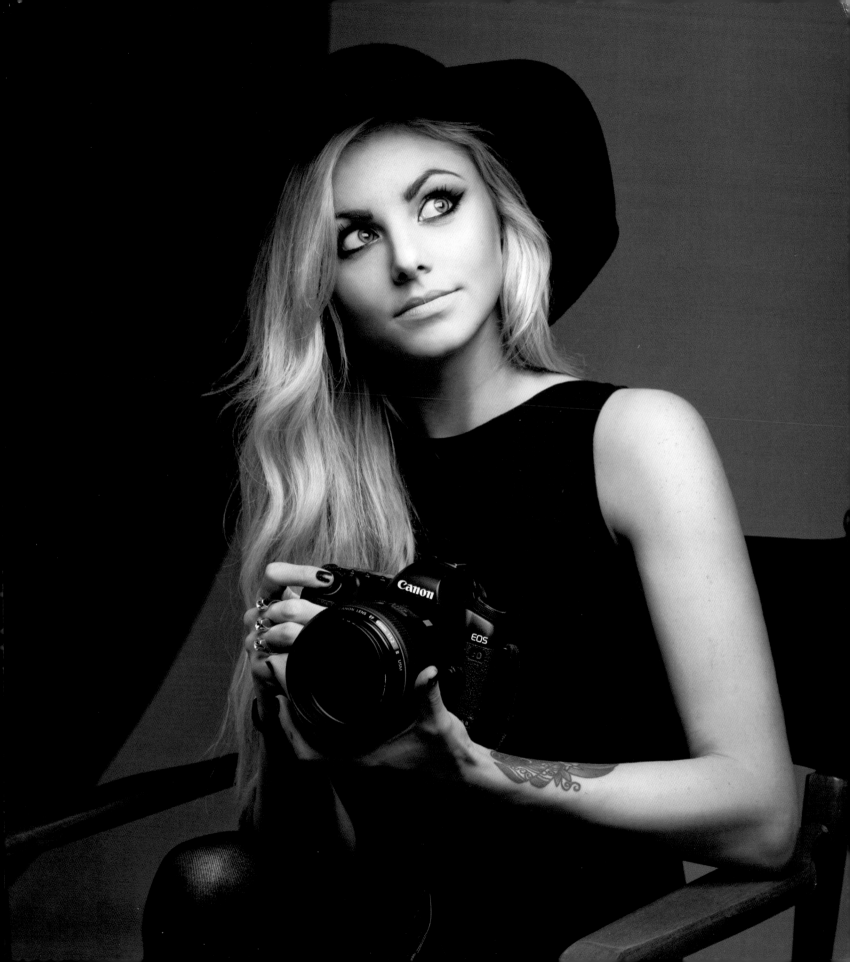

1

EQUIPMENT

Attendees at one of my
London workshops 2010.

Photo: **Oscar May**

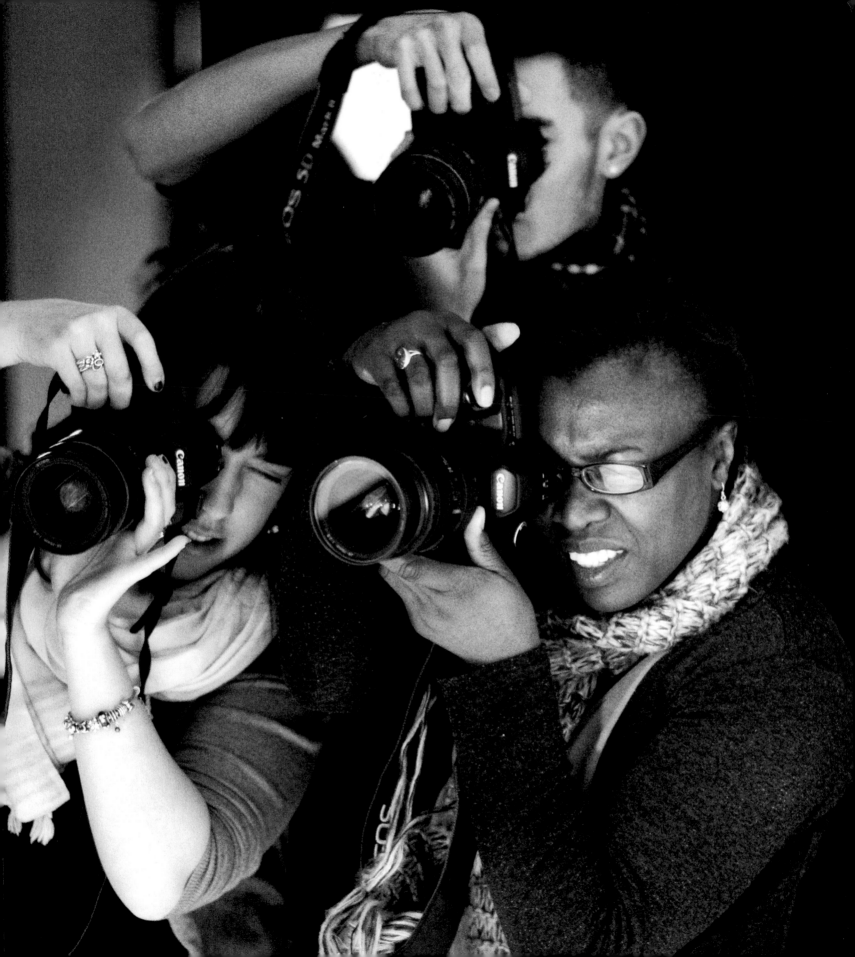

CAMERAS

THE FIRST STEP YOU MUST take on your journey is finding the right camera. So what camera should you buy? The answer isn't simple, but once you understand some important fundamentals you'll be better informed to make a good choice. One thing you should remember is that the camera is just a tool used in the process of making great photographs—an artist's vision creates the image, the camera simply captures it.

Many of you may already have some background knowledge of photography, whether from studying art at high school or college, or simply through practicing by yourself. My first experience of photography is still etched into my memory from the two years I spent at college—the red light of the darkroom, the smell of chemicals, and the many long hours I spent trying to perfect my compositions. One thing I knew for sure during those years was that I was desperate to learn and develop as a photographer, and so I tried to learn as much as possible from research and using new tools. It is those first years that really shaped who I wanted to become as an artist, and if you're anything like me, your initial experience will probably shape you as well.

In this opening section of the book I'll provide practical guidance that will help you make the right camera choice for you. However, it's important to remember that this information is a guide only—it's vital to try different models before you make your final purchase, so test as much as possible before buying. Your final camera choice will ultimately come down to how you prefer to work and your own photographic style.

BELOW
A great camera kit consists of a digital SLR and a set of fixed or prime lenses that suit the user's shooting preferences.

RIGHT
In an urban environment try using different levels of height (like this wall) to create interesting perspectives.
London workshop, 2011.
Photo: **Oscar May**

INTERCHANGEABLE LENSES
Unlike fixed lenses, which are built onto the camera, interchangeable lenses are removable. The benefit of this is that compatible lenses of varying focal lengths (from wide-angle to telephoto) can be used with the same camera body.

CAMERA BACK
In digital medium-format or large-format cameras, the camera back contains a large imaging sensor, and replaces the conventional film magazine. In this way the same camera system can be used either as a film or digital camera.

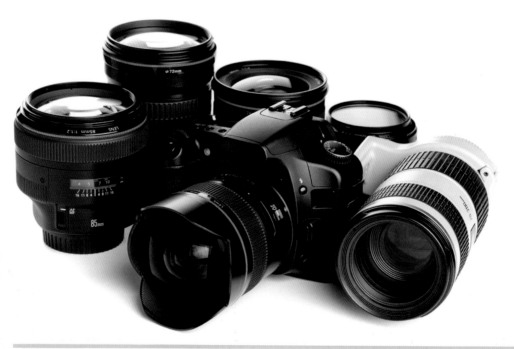

CAMERAS

Digital versus film
Although you may think that today's photographers work in an entirely digital world, there are still plenty of professionals shooting on film cameras. There are advantages and disadvantages to shooting either digital or film, and whichever you choose often comes down to the type of photography you want to produce.

Advantages of film: One advantage of shooting film is the initial outlay for equipment. You can buy good-quality film cameras for a fraction of the price of digital cameras. The price of film and developing costs will quickly add up and in the long run thus make shooting film more expensive. However, I would recommend that all photographers try shooting film at least once, particularly with black-and-white film.

When shooting film you have to get it right in-camera, as you don't have the option of reviewing shots and retaking them. I also found the experience of developing film and creating prints in the darkroom invaluable. It really makes you appreciate the process of photography and how the old masters worked. Shooting film will help you limit the number of images you take, really think about composition and exposure, and demonstrate how much time and patience you need in order to produce one great photograph.

Advantages of digital: The biggest advantage of shooting digitally is the fast workflow and low comparative cost of producing each image. In today's fast-paced fashion photography industry I need to be able to produce great images quickly and at low cost due to the competition in the fashion world and to satisfy the needs of my clients. Essentially, digital photography enables me to produce images quickly, relatively cheaply, and easily.

ANGLE OF VIEW
Essentially, what your camera is able to "see." Your angle of view will be determined by what kind of lens you have, from wide to telephoto.

FOCAL LENGTH
The distance between the optical center of a lens and its point of focus when the lens is focused on infinity. The focal length of a lens determines its angle of view.

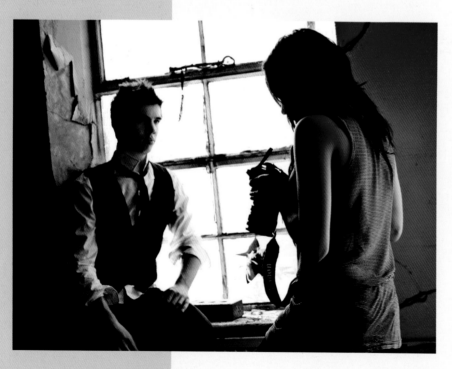

USING DIGITAL

Why digital is most popular with the majority of fashion photographers

Digital	Film
• Instant feedback	• Long developing process before images can be viewed
• Inexpensive	• Expensive processing (products/running costs)
• Large variable ISO range	• ISO range dependent on film you use
• More choice of lenses	• Limited lenses due to film not being popular in today's industry

LEFT
Me on-set with photographer Joey L. In low-light situations, like this shoot that took place in an abandoned building, window light can make for a beautifully lit portrait.

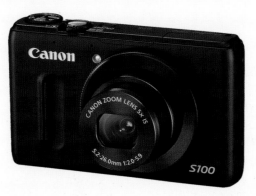
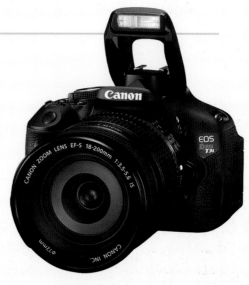

Digital camera types

Point and shoot/compact: Point-and-shoot cameras do exactly as their name suggests. They're intended to be used in fully automatic point-and-shoot mode to provide, for example, fun holiday pictures or photos of friends on a night out. They aren't designed to be used by a professional photographer on a shoot. They have little manual control, and as a professional you want to take full control over your images through shutter speed, aperture, ISO, interchangeable lenses and selective focus, to get the best out of your images. Furthermore, compact cameras have very small image sensors, and although in bright conditions they can produce acceptable results, in low light images are likely to be poor quality.

DSLR: DSLR stands for "digital single lens reflex"—these are the cameras you see most professionals working with. Although they are bulkier than compact cameras, they have much larger image sensors (which provide higher image quality) and support interchangeable lenses, so you can shoot wide-angle to long telephoto. All DSLRs let you have manual or semimanual control when shooting, and with practice these cameras will allow you to take

beautiful, professional-looking images. With affordable entry-level models now available, DSLRs offer the best trade-off between cost and quality and are the most appropriate option for anyone starting out in fashion photography.

Medium format/large format: Medium- and large-format cameras, such as those made by Mamiya and Hasselblad, can often shoot either film or digital, depending on the type of "back" attached to the camera. In either case they are capable of producing higher-quality images than DSLRs because of the large film/sensor format. These cameras are mainly used in big production shoots that require exceptional image quality. Medium-format camera bodies, digital backs, and lenses are extremely expensive and rarely used by amateur photographers today.

EVIL/MILC: EVIL or MILC cameras are the half-way house between SLR and compact cameras. EVIL stands for Electronic Viewfinder, Interchangeable Lens and MILC for Mirrorless Interchangeable Lens Camera. They are generally a lot smaller than SLR cameras, but accept various accessories and different lenses, which makes them more flexible and adaptable than bridge or compact cameras.

ABOVE LEFT
The Sony NEX-5 is an example of an EVIL camera—the body is the size and weight of a slightly chunky compact camera, and it gives the discerning photographer a full range of photography options—and far more flexibility than any compact camera.

CENTER
The Canon S100—a point-and-shoot or compact camera.

ABOVE RIGHT
The Canon EOS Rebel T3i—an entry-level DSLR.

CHOOSING YOUR DSLR

AUTOFOCUS

Autofocus (AF) systems use sensors and tiny motors to automatically focus a lens at specific focusing points. As opposed to manual focus mode, where you manually set the point of focus.

SENSOR

A camera's sensor is an array of photodiodes that converts light into electric signals, which are then recorded as digital data.

DEPTH OF FIELD

The distance in front of, and behind, the point of focus that appears sharp in an image. A wide aperture results in a shallow depth of field, while small apertures produce a deeper depth of field.

HOTSHOE

A hotshoe is a mounting point on the top of a camera to attach a flash unit or remote triggering system.

CROPPED SENSOR

Term used to describe any sensor smaller than the size of a frame of conventional 35mm film. A "full-frame" sensor is comparable in size to 35mm film.

Price

The cost of DSLRs varies enormously, but in terms of image quality, a camera costing thousands of dollars won't necessarily produce significantly better images than one costing hundreds. Much of the additional cost of more expensive cameras is down to added functions and shooting options and higher build quality, such as weather sealing—specifications that may not be important to you at this stage. It's probably fair to say there are no really bad DSLRs on the market at the moment, so in some respects you can't go wrong. Even the lowest specification DSLRs are capable of producing large, high-quality prints in the right hands. Read reviews and think about what you want from your camera. As we'll see later, image quality is more likely to be governed by the quality of the lenses you use rather than the camera body itself.

When budgeting for your camera equipment, remember you'll also need to cost in items such as:

- Memory cards
- Camera bag
- Extra battery
- Flash
- Filters
- Tripod
- Lenses

What are you going to use your camera for?

As you're reading this book, naturally you're going to want a camera that's suitable for fashion portraits, but are you interested in any other genres of photography? Are you a keen traveler and will you want to take your camera on adventurous journeys? Do you like to shoot fast-moving action, such as sports? Is street photography also an interest? Questions such as these will determine how rugged your camera has to be, how good the autofocus system is, or how large the body is. These are the sorts of things that do impact on the price of cameras, and you need to be sure you're spending your money on a camera that's appropriate for your particular needs.

Sensor size

One factor that is often cited as differentiating between a camera intended for professional use versus enthusiast use, particularly with fashion and portrait photography, is sensor size. Generally speaking, DSLRs can be broadly divided into two groups, "full-frame" sensor cameras and "cropped-sensor" cameras. Full-frame cameras are so called because the sensor is the same size as a 35mm film frame, the traditional format of film SLR cameras. Although cropped sensors vary slightly in size, they're generally around two thirds the size of a full-frame sensor. Without going into too much technical detail at this stage, full-frame sensors are often seen as providing better image quality (particularly when shooting in low light) and allow greater control over depth of field, which is important when you want to focus only on a very specific part of the image.

The other important consideration with cropped sensors is that because they have a smaller angle of view, the focal length of lenses is effectively increased by a factor of around 1.6. This is known as the "crop factor." So on a cropped-sensor camera a 50mm lens will have an effective focal length (efl) of 80mm. If you use a cropped-sensor camera you'll need to bear this in mind when you come to purchase additional lenses.

Which brand?

Try to avoid making your decision based on brand loyalty. Just because all your friends have Nikon cameras, doesn't necessarily mean you should too (although it can help when it comes to sharing lenses). Nikon, Canon, Sony, Pentax, and all the other manufacturers produce excellent camera equipment. Though do bear in mind that after a few years you're likely to have lenses that are only compatible with that camera manufacturer, so changing brands later down the line can mean having to change all your lenses as well.

DP REVIEW

www.dpreview.com is a great source for comparing and contrasting different camera brands. They produce excellent reviews on most DSLRs and compatible lenses.

BELOW

The Canon EOS 5D MKII I was using for this shoot has a full-frame CMOS sensor. This means it gives a true wide-angle view, without cropping or magnification effects.

SHEER Magazine shoot (www.sheermag.com).

Photo: Oscar May

LENSES

IN ORDER TO CREATE a sharp, high-quality image you need a good-quality lens. A photographer can own the best camera body in the world, but if he or she is using a poor-quality lens the image is going to appear just average compared with a photographer working with a great lens and an entry-level DLSR camera. So, when it comes to buying new lenses, buy the best you can afford.

The varying focal lengths of interchangeable lenses give you far more creative control over your images than anything else in your kit bag, so it's important that over time you develop a strong visual understanding of how focal length impacts on your images.

It's vital to stress that all successful photographers use a variation of focal length in creative ways no matter what genre of photography they work in. For example, using a wide-angle lens commonly used in landscape photos for a portrait shot can introduce a dynamic angle of view and distort an image in an interesting way. Similarly, many landscape photographers use telephoto lenses (often used for portraits) to isolate specific elements of a scene and for the foreshortening effect such lenses have.

Zoom lenses versus prime lenses

A zoom lens is a lens in which the photographer can vary the focal length. Broadly speaking, there are three categories of zoom lens: wide-angle zooms (taking into account the cropping effect) such as 16–35mm, medium zooms that range from 24–70mm, and telephoto zooms that offer 70–200mm. Although zoom lenses covering much wider ranges such as 55–300mm are available, these are generally of lower quality than zooms with narrower ranges.

The advantage of zoom lenses is that they offer a variety of framing and composition options thanks to the variation in the viewing angles they provide—all from the same spot.

Prime lenses are fixed at a certain focal length, so if you want to get closer or farther away from your subject you have to use your feet. Popular prime lens focal lengths for fashion are 35mm, 50mm, and 85mm. The advantages of these lenses is that they are generally sharper than all but the most expensive zoom lenses and have a wider maximum aperture. This last attribute means they allow for fast shutter speeds in low light, and narrow depth of field, both of which can be important on a shoot.

So which type should you go for?

The choice of one over the other really depends on what you require in your style of work. Good-quality zooms produce images that are nearly as good as prime lenses, but the maximum aperture is unlikely to be as large. Lenses with a greater range of aperture settings provide more artistic choice, but zoom lenses offer greater versatility. Many professionals have a mix of prime and zoom lenses, often buying prime lenses for their favorite focal lengths.

MACRO LENS
Macro means "macroscopic" (large) and refers to lenses that are specifically designed for close-up work.

ON LOCATION
Refers to a photoshoot produced at a location other than the studio, such as outside or in a location house.

CHOOSING YOUR LENS

The table below gives an indication of the type of photography for which typical focal lengths are used.

Lens focal length	Lens type	Typical photography type
Less than 21mm	Extreme wide angle	Architecture
21–35mm	Wide angle	Landscape
35mm–70mm	Normal	Fashion or documentary
70mm–135mm	Medium telephoto	Portraiture/beauty
135mm +	Telephoto	Wildlife/beauty

A fashion photographer's lens kit

As fashion photography is a unique combination of all types of photography, it is important to have several different lenses on-set at all times.

In order to choose the best lens for the situation, you have to understand what each lens does. I personally use Canon, but similar lenses from other brands are freely available. Check out www.dpreview.com for reliable and thorough reviews. Here are some recommendations from my Canon kit and what they are best used for.

24–70mm f/2.8: This lens is a safe option for studio and on-location work. The 24–70mm zoom gives a great range for a number of shots—including full-length shots and the option to shoot wide portraits. I favor using this lens because of the flexibility as you don't always have time to change your lens.

50mm f/1.2: On a full-frame camera body this lens is great for all types of work. I use this lens in location environments when working with natural light (due to its maximum aperture

setting of f/1.2). Other 50mm lenses with slightly smaller maximum apertures of f/1.8 are also available and considerably less expensive, and I would consider an essential purchase for any budding fashion photographer.

85mm f/1.2: This is one of my favorite lenses. It's great for portraits and produces stunning image quality. When shooting naturalistic portraiture you should always photograph your subject with a focal length of at least 70mm due to distortion. Anything over 70mm is true to the eye and will complement your subject.

70–200mm f/2.8: When shooting beauty work it is vital you have a lens that you can zoom into your subject's face without distorting important features. This is a great overall lens for very close-up portrait or beauty work.

Macro lenses: Macro lenses (such as the 100mm or 60mm macros lenses) aren't considered too important in fashion photography, but fun for beauty photographers wanting to experiment with extreme close-ups (such as eyes or lips).

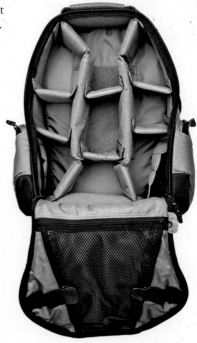

LENSES

HOLGA

HOLGA
A popular plastic film camera that creates uniquely color-shifted images due to light leakage. Check out www.lomography.com/holga for further information.

FISH-EYE
A super-wide lens that gives a near 360° viewing angle.

LIGHT LEAKAGE
Caused by a hole or gap in the camera body where light can leak in exposing the sensor/film to a section of light. It is popular in Holga or "toy camera" photography where this helps enhance the theme.

TIP
In order to get the best out of creative lenses such as a Lensbaby, you need to practice to gain confidence with them.

Lens brands

While you're likely to get better-quality images from proprietary lenses, such as those made by Canon, Nikon, Sony or Pentax, for example, as these have been designed specifically for the relevant camera bodies, these are expensive, becoming eye-wateringly so with those lenses with large apertures. There are options on the market for photographers who are working with a tight budget. Brands such as Sigma, Tokina and Tamron produce good-quality lenses for slightly less than the larger brands.

As with any photographic purchase, see if you can try before you buy so that you can compare and assess your various options.

Creative lenses

As well as standard lenses, there are a number of creative lenses currently available that are popular with many younger and experimental photographers. Creative lenses are fun to play around with and can produce uniquely memorable images. Be aware, though, that the glass of creative lenses can be of a lower grade and there are sometimes focal or quality issues.

Lensbaby: Lensbaby makes creative lenses for most DSLR body types. Known for their very shallow depth of field, results from the Lensbaby can also mimic the results from toy cameras such as the Holga. These produce the much-loved and very popular "light leakage" effect. Lensbaby lenses have to be focused manually by moving the end of the lens, or the "bellows," to create your own selective focus. You can find out more about Lensbaby at www.lensbaby.com.

Fish-eye: Fish-eye lenses give an extremely wide perspective on your subject, and create a round-shaped image with a wide angle of view. They are fun to use in environments such as busy streets or crowded concerts. The current Nikkor fish-eye is a perfect example of this—at 6mm it can even see behind itself!

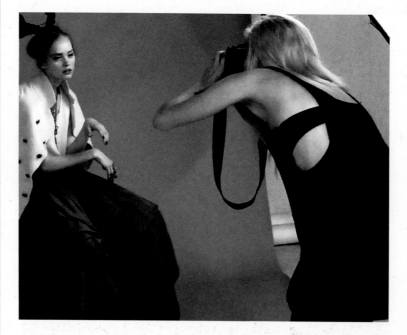

LEFT
Behind the scenes on my "Velveteen Rabbit" editorial shoot. When I'm working in the studio I'm always prepared with my Canon 24–70mm f/2.8 zoom lens. This is due to the variety needed in my editorial work; when I'm on-set, there isn't much time to think about changing lenses as the time between shooting and clothing changes is so short. This lens works perfectly all round—from beauty to full-length shots.

Photo: Nicole de Waal

BELOW
This photograph was taken on location with the Lensbaby 2.0. It is a perfect tool for enhancing a whimsical theme—like this set with Danielle.

Model: Danielle Foster

Makeup: Keiko Nakamura

**Canon EOS 5D
ISO 400
f/4 1/800**

RIGHT
The Lensbaby, if used correctly, creates an interesting point of view and is useful to keep the focus on a certain part of the subject that you want people to notice.

Model: Danielle Foster

Makeup: Keiko Nakamura

**Canon EOS 5D
ISO 400
f/4 1/400**

Equipment

SOFTWARE

THERE'S A VAST ARRAY of digital photography software available today. Most programs allow you to organize, manipulate, and output your images (either for print or screen) to a greater or lesser degree depending on how sophisticated the software is.

Choosing your software

It used to be the case that you could distinguish between two broad categories of digital photography software: there were the file-organizing programs and the image-editing programs. However, this distinction is no longer very clear cut. Programs that photographers used primarily for organizing and maintaining image libraries now offer good levels of image adjustment, and image-editing programs now allow you to organize your images into a logical hierarchy of folders. So here's a list of some of the more popular software used by professional and amateur photographers alike.

WHAT IS THE "DIGITAL DARKROOM?"

The "digital darkroom" is the name given to a computer and software setup that is used primarily for processing digital images downloaded from a digital camera. It is the digital equivalent of the traditional darkroom, where film and photographs are developed using various chemicals and light. Some see the traditional darkroom as a near obsolete, past irrelevance, while others see the digital darkroom as the realm of soulless manipulation of digital data. Using either type of darkroom successfully requires a knowledge of the equipment being used, a honing of skills, plenty of practice, and an artistic vision of what you're trying to create.

BELOW
My workflow is essential to the way I work so I use various programs to get different jobs done—Adobe Lightroom is my point of call for archiving, selecting and light editing, and Adobe Photoshop is my main retouching tool. It's never good to limit your knowledge of programs since they are all required on various jobs.

PLATFORM
In computer terms, a platform refers to the operating system that your computer works from.

METADATA
Literally "other data." In image editing, metadata is data recorded by the camera at the time of shooting, and which is embedded in the image data. Examples of metadata include exposure settings, time and date, copyright, and so on.

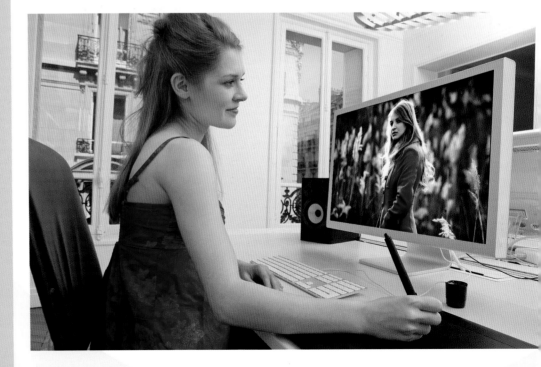

IMAGE EDITOR SELECTION

This is only a very small selection of image editors. Other popular programs include Ulead's PhotoImpact, Corel Paint Shop Photo Pro, and Serif PhotoPlus. The best advice I can give you is to try before you buy. Adobe and the other software producers usually give a free trial for 30 days for their programs. Perfect to try if you're just starting out and want to experiment!

ADOBE PHOTOSHOP
(www.abobe.com)
Mac and Windows compatible

The best-known image-editing program, Adobe Photoshop is immensely comprehensive with a mind-boggling array of tools, commands, and controls. A layer-based program capable of editing at the pixel level, Photoshop is the ultimate playground for retouching images from start to finish. The software comes with Bridge, an image organizer that allows you to maintain a basic image library, but which is not as accomplished as either Lightroom or Aperture at managing your digital assets. Photoshop also features ACR (Adobe Camera Raw) which uses the same processing engine as Lightroom for converting and manipulating Raw files. The drawbacks to Photoshop are the sharp learning curve required to get to grips with all its functionality and its high cost.

ADOBE LIGHTROOM
(www.adobe.co.uk)
Mac and Windows compatible

Lightroom was primarily designed as a photo management program and Raw file converter. It is perfect for processing many images at once, placing those images into organized folders, adding keywords and other metadata, and outputting final images for print or to publish online. With each new version, the program has become better equipped at making increasingly sophisticated and localized adjustments to Raw, TIFF, and JPEG files, with the result that along with Apple's Aperture, Lightroom has become a one-stop program for many professional photographers who don't need the specialist retouching ability of software such as Photoshop.

GOOGLE PICASA
(www.picasa.google.com)
Mac and Windows compatible

Picasa, like iPhoto, is another free image organizer, editor, and sharing program, but one that works on both Macs and Windows PCs. Also like iPhoto, Picasa only offers very basic image-editing functionality, but it may be all that you need if you aren't into image manipulation and simply want software that can store images, perform basic editing, and with which you can easily view and share your images.

APPLE iPHOTO
(www.apple.com)
Mac only

As part of the iLife package, iPhoto is free software that is preloaded onto all new Apple Macs. Many amateur photographers find everything they need in iPhoto (such as cropping, color and contrast enhancement, and red-eye reduction). It's a user-friendly and extremely simple program for basic organizing, manipulation, viewing, and sharing.

ADOBE PHOTOSHOP ELEMENTS
(www.abobe.com)
Mac and Windows compatible

For photographers Elements offers just about everything Photoshop has at a much more affordable price. The program is geared towards those new to image editing with tips and wizards showing you how to accomplish the most important editing tasks. Elements has a basic organizer built-in and also comes with ACR for converting Raw files. If you don't need to process large numbers of images quickly, Elements offers exceptionally good value for money.

APPLE APERTURE
(www.apple.com)
Mac only

Apple's Aperture program is similar in many respects to Lightroom. As well as having the ability to process images quickly, and store and maintain a large image library easily and efficiently, Aperture can also perform a wide range of image enhancements that is perfectly adequate for the vast majority of photographers who don't need to undertake any special-effect work on their images. Of those photographers working on the Mac OS platform some prefer Lightroom, others prefer Aperture.

GIMP
(www.gimp.org)
Mac and Windows compatible

GIMP is a free high-end graphics application. It shares many of the same tools and commands as Photoshop and other popular image-editors. Moreover, the interface, with its use of panels to show the application and status of its various commands, also resembles Photoshop and Photoshop Elements. For these reasons, GIMP is a wise choice for starting photographers on a budget who want to learn about the intricacies of layer-based image editing.

HARDWARE

MANY OF YOU WILL already own your own computer (whether desktop or laptop), but if you're thinking about upgrading your equipment or purchasing some new gear you need think about how powerful your chosen machine is and whether it will be appropriate for the tasks you want it to do. Is the computer powerful enough to run your chosen image-editing software? Does it have a sufficiently large hard drive on which to store your high-res images? Is its screen big enough to work on comfortably? Most importantly, have you thought about accompanying hardware to back up your images? In this section we'll address these common questions and clarify other hardware requirements.

Computer needs—Mac or PC?

Although historically Apple Macintosh computers were used, and still are used, by many in the creative and graphics industries, and are therefore popular with many photographers, there's very little to choose between a Mac or a Windows PC in terms of one platform being better suited than the other when it comes to digital photography.

In their favor, Macs have won fans around the world for their attractive, easy-to-use interface, sleek designs, and the fact that, as there are less of them than there are PCs, fewer viruses have been written to deliberately target the Mac operating system. Also in the Macs favor, the operating system has tended to be more stable than Windows, although this is less true now than it once was. The downside to Macs is their cost. Similarly specified Windows PCs tend to be cheaper than Apple Macs, and it's also much cheaper to upgrade memory on a PC than on a Mac.

So, if budget is your overriding consideration, then you're probably better off getting a Windows PC. You're more likely to be able to shop around for deals, find a computer suited to your specific requirements, and find bundle packages that include a good-quality monitor and an external hard drive thrown in. However, if money is less of an issue, Macintosh computers, certainly in the form of the latest iMacs—which all feature high-resolution backlit LED displays ideal for photo editing—offer a very neat space-saving option that will provide you with an efficient and user-friendly working environment that should last for many years.

Desktop or laptop?

The choice of laptop or desktop comes down to how you work and whether or not you have a dedicated work station you can use. Do you travel a lot, or are you going to be home-based? High-end laptops are more expensive compared with desktops, and the largest screens are probably too small if you intend to do a lot of image-editing work. (Although you can plug a large monitor into many laptops these days if your budget will extend to a separate monitor.) Of course, if you travel a great deal or don't have a dedicated work station where you can put a desktop computer, then a laptop may be your only option.

Many professionals have both a desktop and a laptop. The desktop (along with external hard drives) acts as a "base" for keeping archived images and for processing large numbers of images, while the laptop is used as temporary storage when on a travel shoot or while traveling, and is useful for making initial image selections, doing basic editing work, and good for staying in touch with people while on the go.

INTERFACE
Here strictly the GUI (graphical user interface). Collectively the interface comprises the menus, commands, and controls that allow you to manipulate the hardware and software.

COLOR MANAGEMENT
The controlled conversion of color representation in devices (usually scanners, printers, screens and digital tablets).

RAM

RAM stands for "Random-access memory" and is the memory that is available to run the computer's operating system, and programs such as Lightroom, Photoshop, or any other type of software. The data in RAM memory is lost when the computer is turned off, and this is one factor that distinguishes RAM from a computer's hard drive, where data such as photos, music, and documents are stored until deliberately deleted. Essentially, setting aside processing power, the more RAM a computer has, the faster it will run. Image-editing software, particularly layer-based programs, use up a lot of RAM, especially now that image files can be very large due to the high resolution of modern digital cameras. You can easily check a program's computer requirements on the specification page, and work out your RAM needs, but as a rule of thumb I would personally recommend a minimum of 4GB of RAM for a Mac or PC.

Computer storage space

Another important factor when purchasing a new computer is how much storage space the hard drive has. Today, most desktop computers have a minimum of 500GB, with many now offering 1TB. Although this sounds a vast amount of storage space, this can fill up relatively quickly, depending, of course, on whether you shoot a lot of images and if you also keep other data such as videos and music files on the same machine.

External hard drives

External hard drives are vital for backing up files, but also if you want to free up space on your computer. They are relatively inexpensive and can be purchased as desktop models or as portable versions—although the latter are more expensive.

BELOW
As a photographer it's essential you stay up to date on current hardware. Many photographers today combine the use of devices (such as the laptop, iPad and iPhone) to keep up to date with social media and to be able to work on the go.

TIP
It's relatively easy to upgrade the RAM on a Mac or Windows PC, so consider this if you find your computer is running slowly before splashing out on a new one.

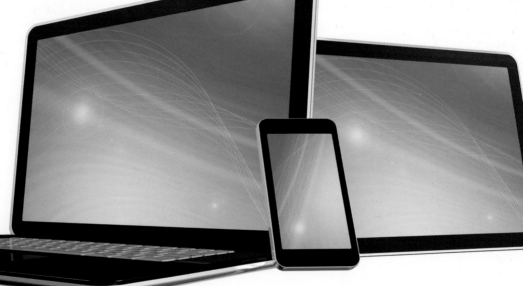

HARDWARE

Monitor

The 19-inch LCD monitor, whether backlit with fluorescent lighting or LED lighting, has become standard to desktop computers these days. However, most photographers who retouch their own work appreciate a larger screen. I would recommend a monitor of over 22 inches, with 27 inches being ideal. There are many well-known manufacturers, such as Eizo, Dell, or Asus to name just three, that produce high-quality monitors, so it pays to research and shop around for a good deal.

Monitor calibration
Calibrating and profiling your monitor is the only way of ensuring that the images you see on-screen are as accurate as they can be in terms of color fidelity. A calibrated monitor will help guarantee that your images will appear consistent and will match the prints you make either for yourself (with a calibrated printer) or that you get back from a professional printer. Newer iMacs are color-calibrated at the factory, but if accurate colors are essential to you, you may want to regularly check the calibration.

Calibrating and profiling your monitor is part of the broad and complex topic of color management. I'm only going to cover the basics of monitor calibration in this section, but it should be sufficient to help you achieve accurate and consistent colors.

Profiling hardware
To help ensure your monitor is accurately calibrated, there are a number of profiling devices that sit directly in front of the monitor. These work in tandem with software that gets the monitor to display pure colors. The profiling device takes readings and creates a specific profile for the monitor that, where necessary, adjusts the display so that the monitor is accurately calibrated. Popular profiling devices include those made by X-rite and Datacolor.

CALIBRATION

A way of correcting for the variation in color output of a device such as a printer or monitor when compared to the original image data as recorded in the photograph.

AMBIENT LIGHT

The light that already exists in the location you are shooting before you add flash or other light sources. Outdoors, the ambient light is likely to be daylight, while indoors it could be incandescent, fluorescent, daylight, or a mix of these. The strength and color temperature of the ambient light needs to be considered if you want to add anything to it, or mix it with photographic lighting.

CALIBRATION SUCCESS

1. If possible, ensure your computer is out of strong sunlight. Ambient light will impact on calibration,.

2. Make sure your computer has been turned on for at least 30 minutes before starting any calibration or image-editing work. This gives more time for an accurate color reading.

3. Set your wallpaper/screen background to a neutral gray.

4. Check that your computer is in high color or 24-bit mode. You may not be able to adjust this if you have a new iMac as colors are automatically set to millions. On an older Mac go to System Preferences, then click on Displays and then choose *Colors > Millions*. If you're using Windows, check this by right-clicking on your desktop and choosing Graphic Properties.

5. Check your screen is at its native resolution. This means the highest number of pixels your monitor can display, such as 1920 × 1200.

6. Adjust the contrast/brightness controls and set the target gamma and white point on your monitor. Your computer may have a built-in calibration assistant to help you find the correct neutral calibration.

7. Print a photo through a professional lab (not at home if your printer is not calibrated), view the print in normal daylight, and compare to the image on your monitor. You may want to consider changing the colors and contrast according to your image.

Other hardware

Retouching tablet While it isn't an essential tool for every photographer, particularly those who only perform a light edit on their photos, many professionals use retouching tablets for extensive retouching or for ease of navigation while working. Some specialist retouching requires fine brush strokes that can't be replicated by using a computer mouse or track pad. Although it takes some getting used to, a retouching pen and tablet make the job easier. Most pens respond to the amount of pressure you place on them—so they are useful for giving you full control over certain effects. Wacom is the leading brand in retouching tablets and they have several models available dependent on budget and requirements.

Scanner Not all photographers have or use scanners, but they are useful to have around, and they aren't prohibitively expensive nowadays. Some common creative uses for a scanner include:
- Scanning in film negatives or older photographic prints.
- Scanning in interesting textures to use.
- Scanning in tear sheets from editorial features to use in a digital portfolio.

Printers Some photographers may find printing their own material useful, though most professionals use printing companies if they need prints as they're guaranteed to be high-end prints. Home printers are useful for printing smaller personal images, contact sheets, proofs for clients, or business documents. The most common printers are of the inkjet type, and there are hundreds of models to choose from.

Tablets Tablets such as those made by Apple, Samsung, and Amazon can be great ways to store and show a digital portfolio, and some even have basic image-editing capabilities. If you are traveling or working from home they are useful to have for meetings, emails, or keeping up with social media channels.

You can now even preview your images once you've shot them by connecting your DSLR directly to the tablet—useful when you are working with clients who want to instantly see your images.

ABOVE LEFT
A retouching tablet (such as the Wacom tablet range) is a token item in a photographer's kit and improves photo retouching and general workflow greatly.

ABOVE RIGHT
A quality printer/scanner combination will not only be useful for home-printing, but will also increase your options for creativity by scanning in images and using them for mixed media or stock pieces.

2

PREPARATION

The creative team working together to put the final touches to Diana's look.

SHEER Magazine shoot, London 2011.

Model: **Diana R @ FM Models London**

Photo: **Oscar May**

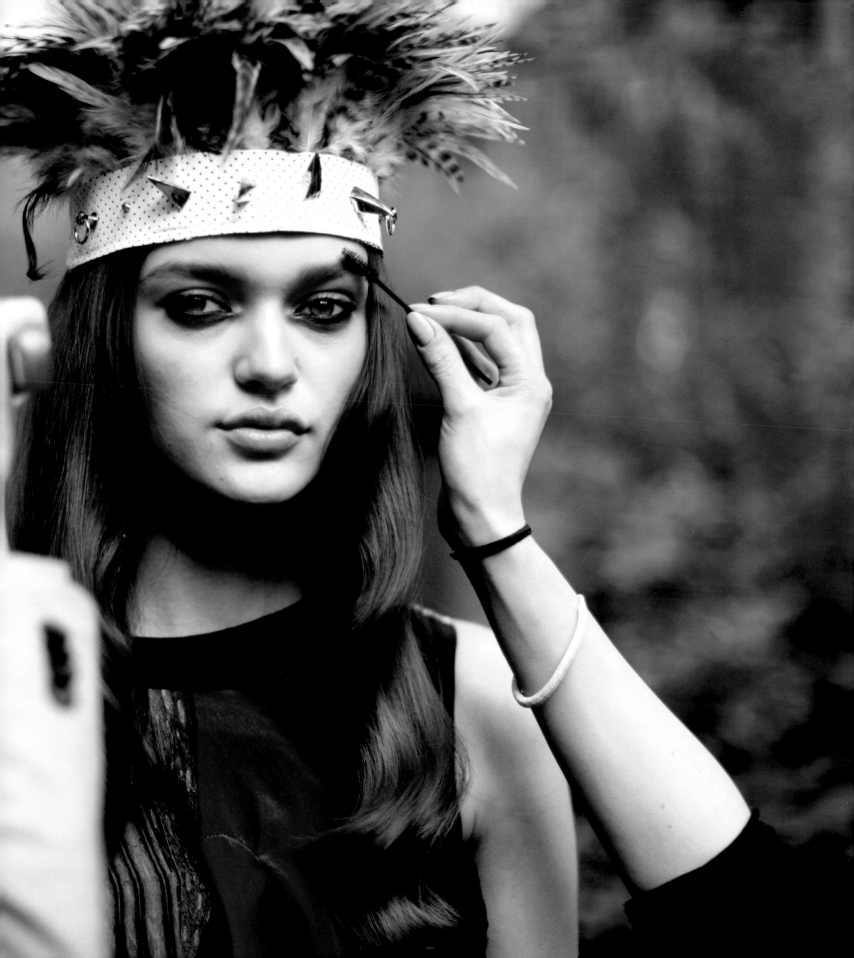

CAMERA BASICS

Camera basics explained

In order to get accurately exposed images and to be able to use your camera creatively, you'll need to learn a few photography fundamentals. The appearance of a photograph is affected by several different factors: exposure (which is governed by shutter speed, aperture, and ISO), focal length, white balance, and focus. Let's take each of these in turn and describe how they impact the appearance of an image.

Exposure

A photograph's exposure is the total amount of light that falls on the film or sensor. This is determined and controlled by three important camera settings:

Shutter speed All DSLRs have a shutter that opens and closes allowing light from a scene to pass through to the sensor where it is recorded. The length of time the shutter is open is known as the shutter speed and is usually measured in fractions of a second such as 1/25 second, 1/125 second, 1/640 second, and so on. In certain circumstances or for a particularly photographic effect, slower shutter speeds are used, ranging from around 1/2 second to 30 seconds or more.
Remember: The higher or faster the shutter speed, the less light is let through to the sensor. Fast shutter speeds are commonly used to freeze any movement and to prevent motion blur to ensure a sharp image.

The lower or slower the shutter speed, the more light is let through to the sensor. A slower shutter speed will often result in movement appearing blurred. This can be used to good creative effect.

Aperture All lenses used on DSLRs have apertures, adjustable openings that control how much light is let into the camera and through to the sensor. But as well as controlling the amount of light entering the camera, the aperture also controls depth of field—how much of the scene in front of and behind the focal plane is in focus. The size of the aperture is measured in "f/

numbers" or "f/stops." Typical f/number values are f/1.4, f/2, f/2.8, f/4, f/5.6, f/8, f/11, and f/16, with each f/number allowing in half as much light as the previous figure.
Remember: The wider or larger the aperture (the smaller the f/number), the more light strikes the sensor, but less of the scene will be in focus.

The narrower or smaller the aperture (the larger the f/number) indicates that less light is being let onto the sensor, but more of the scene will be in focus.

Being able to control depth of field is crucial to creative photography. Fashion photographers will often use a small f/number such as f/2 to deliberately throw the background (and foreground) out of focus. Known as selective focus, this ensures the viewer's attention is focused on the model and not a potentially distracting background.

ISO The ISO refers to the sensitivity of the film or digital sensor to light. The higher the ISO number, the more sensitive the film or sensor is to light. The sensors in all DSLRs have a base ISO setting of 100 or 200. At this setting there is no amplification of the signal. Increasing the ISO setting increases the signal amplification, so making the sensor more light sensitive. This is important in that it enables you to set a faster shutter speed (or narrower aperture) allowing for greater exposure versatility. Often in low-light conditions photographers will set an ISO of around 800 or 1600 to allow for a shutter speed that is fast enough to freeze action or prevent motion blur. However, increasing the ISO can introduce noise into the image due to the amplification.
Remember: The higher the ISO number, the more light sensitive the sensor becomes, but there is also a higher amount of noise in the resulting image. The lower the ISO number, the less light sensitive the sensor is and there is a smaller or even zero amount of noise. The combination of the shutter speed, aperture, and ISO setting together create the exposure.

FOCAL PLANE
The flat surface upon which the image is focused in a camera. This is the plane where the photosites of the CCD or CMOS image sensor sits.

Focal length

The focal length of a lens determines its angle of view. The longer the focal length, the narrower the angle of view and the greater the magnification. For example, wide-angle lenses have short focal lengths and a wide angle of view (much of the scene is visible), while telephoto lenses have long focal lengths and narrower angle of views (with only a small part of the scene visible). You should always consider your focal length when working with your subject composition. Perspective is a powerful tool in imagery if used correctly.

Remember: The longer the focal length, the narrower the angle of view (and the greater the magnification). The shorter the focal length, the wider the angle of view.

White balance

Different light sources emit light at different color temperatures. Your camera's white-balance setting is the way in which the camera compensates for the shift in color so that white always appears white. For example, if you're working with tungsten or incandescent lighting (the low-cast orange lighting found in many domestic environments), then selecting your camera's Tungsten setting (the lightbulb icon) will allow for the orange cast so that white objects will appear white. On the other hand, if you're working in the studio and you're using powerful flash heads (which create a blue color cast) then you will need to use the flash setting (flash icon) to correct the color temperature.

Although DSLRs have dedicated white-balance settings, you may find that leaving the setting on Auto will usually produce perfectly acceptable results. Also, if you're shooting Raw you can set the white balance to what you choose when converting the Raw file.

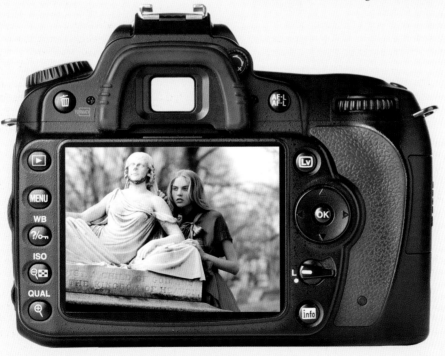

CAMERA SETTINGS

 AUTO
Camera sets white balance

 DAYLIGHT
Camera adds warm tones

 CLOUDY
Camera adds warm tones

 SHADE
Camera adds warm tones

 TUNGSTEN
Camera adds cool tones

 FLUORESCENT
Camera adds warm (red) tones

 FLASH
Camera adds warm tones

 CUSTOM
Photographer sets white balance

LEFT
The back of a standard digital SLR. Using your camera settings may seem intimidating at first, but they will soon become part of your workflow.

CAMERA BASICS

Manual or autofocus?

Although today's DSLRs have sophisticated autofocus systems that work well in many shooting scenarios, when shooting fashion portraits, focusing manually allows you to set focus wherever you want on your subject. This is particularly useful when you're using a wide aperture (for narrow depth of field) and you want to focus on fine detail—such as an eye or a strand of hair. To change from auto to manual focus use the AF/M switch on the lens barrel.

Which image format—Raw or JPEG?

What is Raw? The Raw format is often described as the equivalent of the negative in film photography. It's the image data as captured by the camera's sensor before undergoing any in-camera processing such as sharpening, color enhancement, or noise reduction. Think of it as unprocessed or Raw data, hence the term. In addition, Raw files contain the full 12- or 14-bit data recorded by the sensor, compared with the 8-bit data of a JPEG. The benefits for professional photographers of shooting Raw are numerous, but essentially all come down to improved image quality. Shooting Raw gives you much more data with which to adjust settings such as exposure. It's possible to increase the brightness of part or all of a Raw image by up to 2 stops without creating ugly artifacts. Also, Raw files by necessity have to be processed by a computer using powerful imaging software. This combination is much more effective than the processor on a camera, and allows for greater control over aspects such as sharpening, noise reduction, fixing chromatic aberration, and fine-tuning color. The drawback to shooting Raw is that files are larger and images have to be converted and processed before they can be viewed.

What is JPEG? A JPEG is a compressed image file created by the camera's processor. The processor will apply adjustments such as sharpening, color saturation, and noise reduction to a greater or lesser degree depending on user settings. The 12- or 14-bit data will be compressed down to 8-bit to create a much smaller file size. Aside from the space advantage, JPEGs are ready to view, print, and share straight from the camera. Although it's possible to adjust JPEGs using image-editing software, the 8-bit data responds less well to heavy adjustment. If you shoot JPEGs there is a greater need for accurate exposure and white-balance settings at the time of shooting.

What is TIFF? A TIFF is a lossless image file format that can support both 16-bit and 8-bit data. The format's known as lossless because, unlike JPEGs, no data is lost when the file is compressed. TIFFs are used for retouching once the image has been converted from its Raw state as the maximum amount of data is still available to work with. Many photographers archive their images as TIFFs as they allow for greater editing at a later stage than JPEGs.

ARTIFACTS
A range of unwanted image changes caused by the sensor and internal camera processor. These are noticeable in the final image and are commonly known as noise, blooming, chromatic aberations, JPEG compression, or sharpening halos.

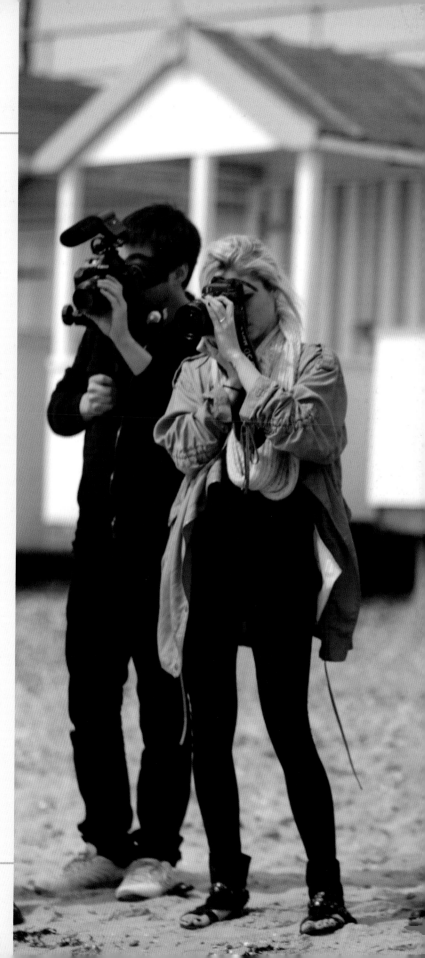

RAW VERSUS JPEG

Here are some common advantages and disadvantages between the Raw and JPEG formats.

Raw	JPEG
Capable of supporting 16-bit data	Compressed to 8-bit data
Greater exposure adjustments	Limited exposure adjustments
Full white-balance adjustment	Limited white-balance adjustment
Greater control over noise reduction	Limited noise-reduction control
Large file size	Small file size
Need Raw conversion software	Files read by most applications

Most cameras on the market today offer the option to shoot in Raw and JPEG. This option provides more instant image sharing and more versatile image editing if necessary.

Saving your images

When archiving your images save two versions:
1. A high-resolution file (either 8- or 16-bit TIFF or uncompressed JPEG) for printing and long-term archiving.
2. A web file in uncompressed JPEG format at a small size that you can easily upload to your online portfolio, attach to emails, and upload to social media channels. I always save my web files at a maximum of 600 pixels along the longest edge.

RIGHT
Myself and one of my creative team on-set at a shoot.

Photo: **Oscar May**

PREPARING YOUR SHOOT

EVERY PHOTOSHOOT is different. Even if you find yourself working for the same clients from time to time, the location, the models, and the clothes will be different, as may the creative team and the weather.

All sorts of factors come into play during the course of a photoshoot, many of which are out of your control. However, you can help the day run more smoothly by being properly prepared beforehand.

Here's a small guide to help you prepare:
1. Gather your ideas and have a clear concept of the photoshoot in mind. Give your creative team and model(s) any visual references that you might have found. If you're using model/creative release forms you will need to prepare the documentation before the shoot.
2. Put together a detailed call sheet of who you need when and ensure it's sent to your creative team so they arrive promptly on the day of the shoot. If you're working with an assistant and/or a digital assistant then it is a good idea for you both to arrive early and set up everything before your creative team and model arrive. You may also want to document your travel route and times to make sure you meet your call time. This is also useful to give to your creative team to help them plan the best way of getting to the location on the day.
3. Prepare your camera gear in advance! Be sure you have your camera batteries charged and your kit packed the night before. The worst thing to do before a photoshoot is rush around getting your gear together before you have to leave (from experience this is always an easy way to forget something).

Make a list the night before of everything you need to take to the shoot. Typically this should be:
- Camera bodies and lenses.
- Charged batteries.
- Sufficient memory cards.
- Computer/laptop for reviewing images and tethering cable for reviewing shots instantly (if needed).
- Sync cable for studio lights or on-camera flash or pocket wizards.
- USB cable or card reader if proofing images on a computer.
- Any documentation you may need: model releases, call sheet with phone numbers and contact information, visual ideas and references including moodboards or sketches.

LARA JADE
ASSIGNMENT/CALL SHEET

DATE:
date of shoot

TIME:
call time for everyone to arrive on-set

SHOOT/JOB:
client name and/or title of shoot

LOCATION:
your shoot location/set location

CREATIVE TEAM DETAILS
insert names of all your creatives below and their contact details

PHOTOGRAHER:

MAKEUP:

HAIR STYLIST:

WARDROBE STYLIST:

MODEL(S)

PRIMARY SHOOT CONTACT:
point of contact on the day (this is either you, or the client)

ANY SPECIAL INSTRUCTIONS/NOTES
insert any special instructions that your team needs to know

POCKET WIZARD
A brand name for a radio system device used to wirelessly sync the camera to the studio lighting system.

RIGHT
A call sheet is an important part of organizing a shoot and is essential when working with a larger team.

- Studio lights/tripod/accessories (reflectors scrims/umbrellas etc.) if not on location or at the studio.
- Notepad and pen (for writing down catering orders, model and creative team credits, and any other important information).
- Refreshments: water and high-energy foods such as nuts, fruit, granola bars etc. These are very useful on shoots for you and your creative team. If you're organizing catering, make sure you have the details of the service or restaurant you are ordering from.

4. On the day of the shoot (and if you haven't already done so) familiarize yourself with your location or studio as soon as you arrive—this will give you a better idea of how to work once everybody else arrives. It is also important to brief your creative team so that they know where vital facilities such as rest rooms, dressing rooms, and refreshment areas are. If you're working with a client you may want to arrive early to be briefed on your assignment and the areas which they want you to shoot in.

BELOW
In preparation for your shoot, the chosen studio space should be cleaned and checked for health and safety issues by you or your assistant. You should also note that there's enough working space for you and your team to perform your tasks comfortably.

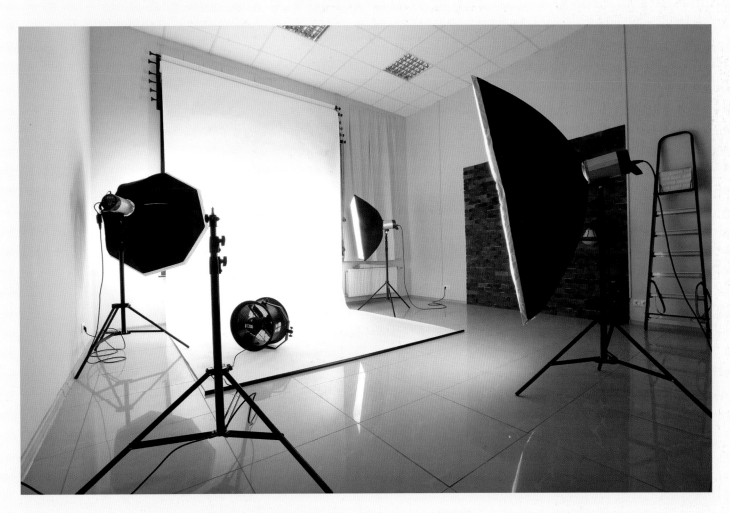

FINDING INSPIRATION

ART DIRECTOR
Large clothing and store brands as well as fashion magazines will have an art director who will attend photoshoots. It is the art director's responsibility to plan and create the overall theme of the shoot and control the creative direction on the day of the shoot itself.

THEME
A theme is a topic or motif you might decide to give a body of your work. For example, you could shoot a series with an environmental theme, using natural backdrops, and a muted color palette.

INSPIRATION IS ONE of the most important elements behind successful fashion shoots—without inspired ideas, your photography will lack creativity. A successful shoot is one in which everything is planned out weeks ahead of the shoot date and has been properly researched—and in order to plan great shoot ideas and themes you first need to be inspired.

Inspiration comes in many different forms and each is personal to the individual. What inspires you as an artist? Is it the everyday in your environment? Or is it the point at which you close your eyes, dream, and escape from reality?

On most photoshoots you do early in your career, you will play the role of art director, so it's important to draw inspiration for every part of your shoot (finding styling inspiration, lighting inspiration, location ideas, and how they will all work together) It may be that you cast your model first, or that your idea comes first and you cast your model and team to fit it. Or you could find the clothing first and think of a theme around it. When researching your shoot, you should consider what steps you will take to arrange it.

First and foremost—be original! By all means seek inspiration from published photoshoots and the work of other photographers you admire, but it's vital that you use these purely as a basis on which you can start to build your own unique individual interpretation. By the same token, however, it's very likely that ideas that you have and which you think are unique are unlikely to be so—everything you see, both in art and in fashion, has already been repeated. Everything you shoot is a direct inspiration from something else, whether it is intentional or not.

An artist should always be looking to find inspiration in unlikely settings and places. Go to a gallery full of artwork that you consider different to your personal style. Walk around a city and people-watch—notice how people act, how they dress, the emotions they show. Look in shop windows for fashionable styles and themes. Flick through foreign fashion magazines and look at the photography or the illustration, or even pick up a local newspaper and look at the recent news. Movies are also a great source of inspiration. They don't have to be the latest releases—watch old classics and take note of how the themes of romanticism and beauty are portrayed.

You should always be looking, noticing, writing, noting, or sketching. There are thousands of ways to be inspired, but many people don't want to look past what they know because they have got too comfortable. As artists we should be thinking outside of our comfort zones, trying to be one step ahead, and embracing the unknown.

LEFT
The inspiration behind this shoot was to recreate a fine-art scene using old photo techniques (such as the daguerreotype technique). The shoot was purely experimental and one of my first successful fashion photoshoots. You can see some more finished images from this shoot on pages 103 and 109.

Model: **Danielle Amber**

Makeup: **Leah Mabe**

Canon EOS 5D
ISO 500
f/4.5 1/3200

ABOVE
Makeup artist and stylist Leah Mabe would instruct and help Danielle at the side of the set when shooting. As it was cold she was on hand to provide a warm jacket when needed!

Model: **Danielle Amber**

Makeup: **Leah Mabe**

SKETCHING

AS ALL PROFESSIONAL ARTISTS know (and as many of us are taught when studying art) it's vitally important to keep a visual record of what you find inspirational so that you can start to build and develop entire concepts and projects. The visual record can consist of sheets torn from magazines and stuck into a notebook, or a digital collection of screengrabs that you've found while surfing the net and saved onto a computer. On my computer I have folders of visual inspiration arranged by themes, and by shoot ideas, so that when I need to find some inspiration I have a healthy archive to draw from.

SCREENGRABS
Screen captures of a desktop or webpage taken by your computer or digital imaging device.

Moodboards and storyboards

Gathering your own inspiration for personal projects is good working practice and will help enormously when it comes to working with clients and art directors on future shoots. Some clients will expect to see a moodboard/storyboard way ahead of the shoot so that they know you understand the concept they are trying to achieve and that everyone involved in the shoot has a clear visual goal to aim for.

Moodboard A moodboard can consist of cut-outs and images placed over one-another in a rough digital layout, and can either be a collection of makeup and/or clothing ideas that you can show a stylist. A moodboard could even provide ideas for the entire shoot which will help everyone involved visualize what you are aiming to achieve. Your creative team and model will appreciate the extra reference on the day!

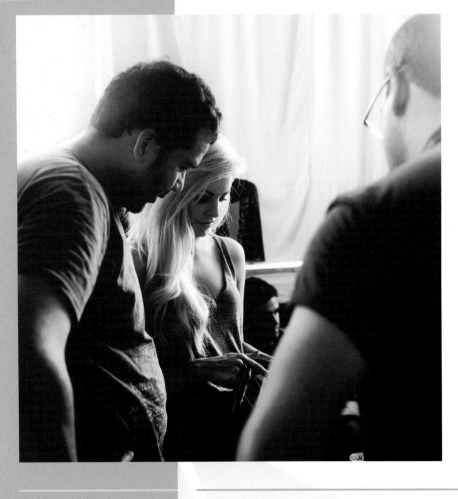

LEFT
Me talking to students on a workshop, sharing our ideas and reference images for the scheduled shoot. Even on the day of the shoot, you should re-brief your team at the start of the scheduled day so that they understand your vision and in case there are any further changes needed. I often share my ideas on my iPad, but feel free to use sketches, paintings, or whatever method works best for you.

NY workshop, 2011.

Storyboard Storyboards are used on movie sets to show the creative team how the director is visualizing the way a sequence is going to be shot. They consist of square sketches on a page showing which characters are involved, how the shots are to be framed—whether close-up or scenic—and whether any specific element needs to be captured. The same technique is often successfully used in fashion shoots. You and your client can sit down and plan what shots you want to achieve for any given day of a shoot and sketch up a comprehensive storyboard.

When on the shoot set, your storyboard is your main visual reference and can also guide you on how you should structure your time. For example, if your storyboard consists of eight sketches and you have a studio booked for eight–ten hours you should divide each image capture to between 40 minutes and one hour. Planning your studio time ahead of the shoot date will save you a lot of time on the day.

Sketches

All photographers should be able to sketch their ideas onto paper—no matter how accomplished they are at drawing. A visual reference will help support your ideas. You might want to combine sketching and moodboards as a page full of mixed-media inspiration—your creative team and clients will appreciate the effort and it will also help them understand your vision.

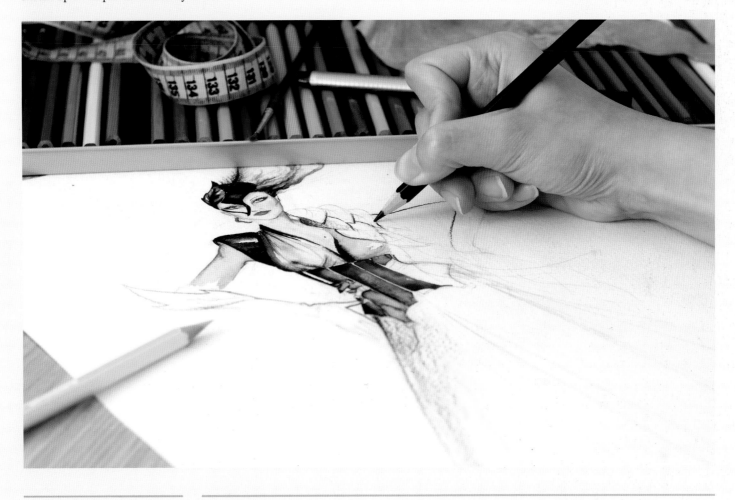

GETTING INTO FASHION PHOTOGRAPHY

Z-CARD/COMP-CARD

A fashion photographer's Z-card, or "comp-card" will usually be a postcard-sized double-sided printed card showing the photographer's contact details and some of their images that best reflect their style, market, and ability. A Z-card is usually sent to potential clients as part of your marketing program, and followed up with a phone call.

LIKE MANY CREATIVE JOBS, the defining moment of a photographer's career relies on those first crucial steps—getting into the industry and understanding which doors to knock on, so that clients will listen to what you have to offer.

In many cities all over the world, it's becoming more and more competitive to get your foot in the door because there is in general less work out there and fewer positions to be filled. If you're at the start of your career, taking a photographers' assistant or internship position at your favorite fashion magazine or photography agency is a wise move—you will understand the industry and how it works a lot more by gaining firsthand experience. In the beginning, you will have to pay your dues in order to gain respect for your craft from your peers. It takes years to hone your skills and understand how to break into the industry. Networking is crucial so that you can make those all-important face-to-face connections. Many photographers turn to cold calling because they think it's an easy way to connect with somebody, although it's not always, simply because many clients like a referral from somebody they've worked with, for example an agent, representative, or editor of a magazine. However, it's a good idea to try every angle possible. You may want to consider making an interesting comp-card or Z-card that can be sent to art directors or potential clients—something simple, but something that makes them remember you, or excites their interest enough for them to want to check out your website.

LEFT
Le Book Connections is a good example of how photographers and agents can connect with important industry contacts through prestigious events.

BELOW
My current online portfolio is the forefront of my business to many clients who consider me for jobs, so it's important that the content stays fresh and exciting for new visitors.

WEBSITE RESOURCES

Some websites that provide good resources include:

WORKBOOK
www.workbook.com
This is a database of creative buyers, artists, representatives, and suppliers across the USA and Canada.

LE BOOK:
www.lebook.com
A resource that offers exposure to companies and members of the creative arts community. Their Connections event is a tradeshow for the creative community that features thousands of artists, portfolios, and professionals throughout the industry and gives a great opportunity for photographer representatives and industry talent to get feedback on their work and connect with others.

MY FASHION DATABASE:
www.myfdb.com
Market themselves as the fashion industry's go-to resource by showcasing all the new fashion editorials and advertisements.

F.TAPE
www.ftape.com
A free online resource that connects the fashion industry via its vast fashion directory. Find out who are the upcoming big faces of the modeling industry, the up-and-coming photographers, and browse the most recent editorials and campaigns for inspiration.

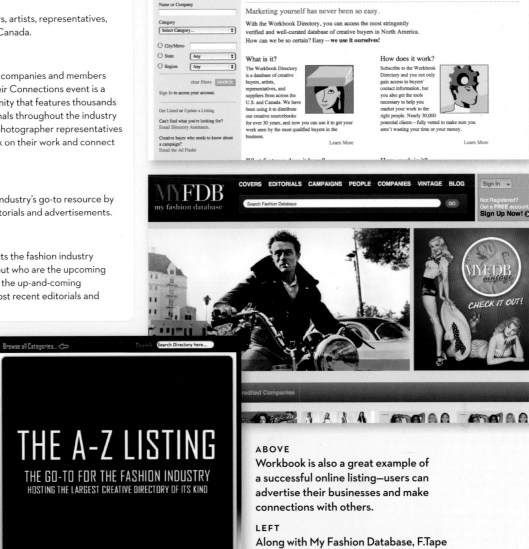

ABOVE
Workbook is also a great example of a successful online listing—users can advertise their businesses and make connections with others.

LEFT
Along with My Fashion Database, F.Tape is a great online resource to keep up with what's happening in the industry. I keep this bookmarked for easy reference!

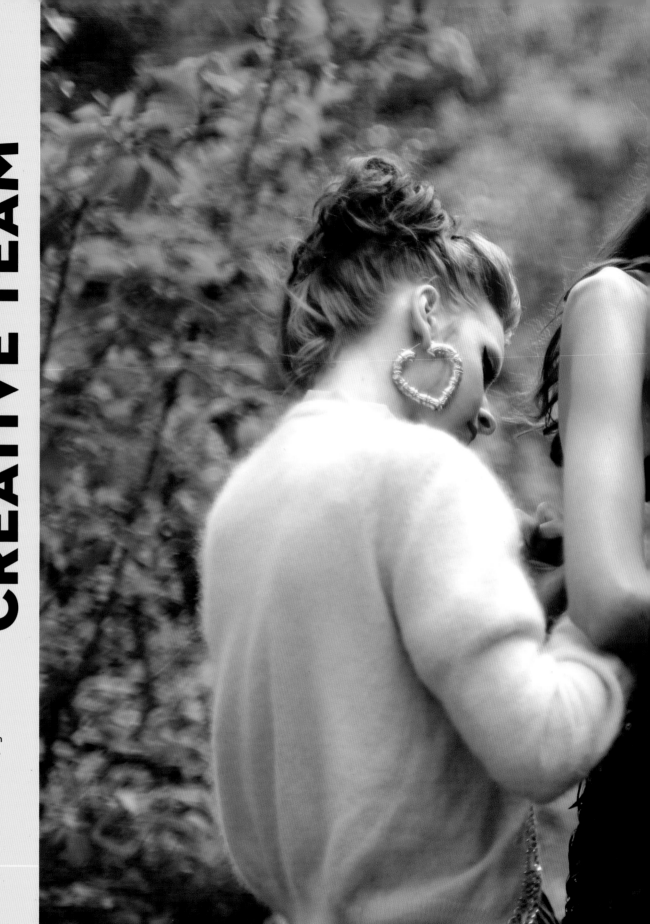

3

CREATIVE TEAM

Our full creative team at work on the day. When you're working with tight time frames (especially when you're working with daylight) a team will have to work together to get the styling done quickly.

SHEER Magazine shoot, London 2011.

Photo: **Oscar May**

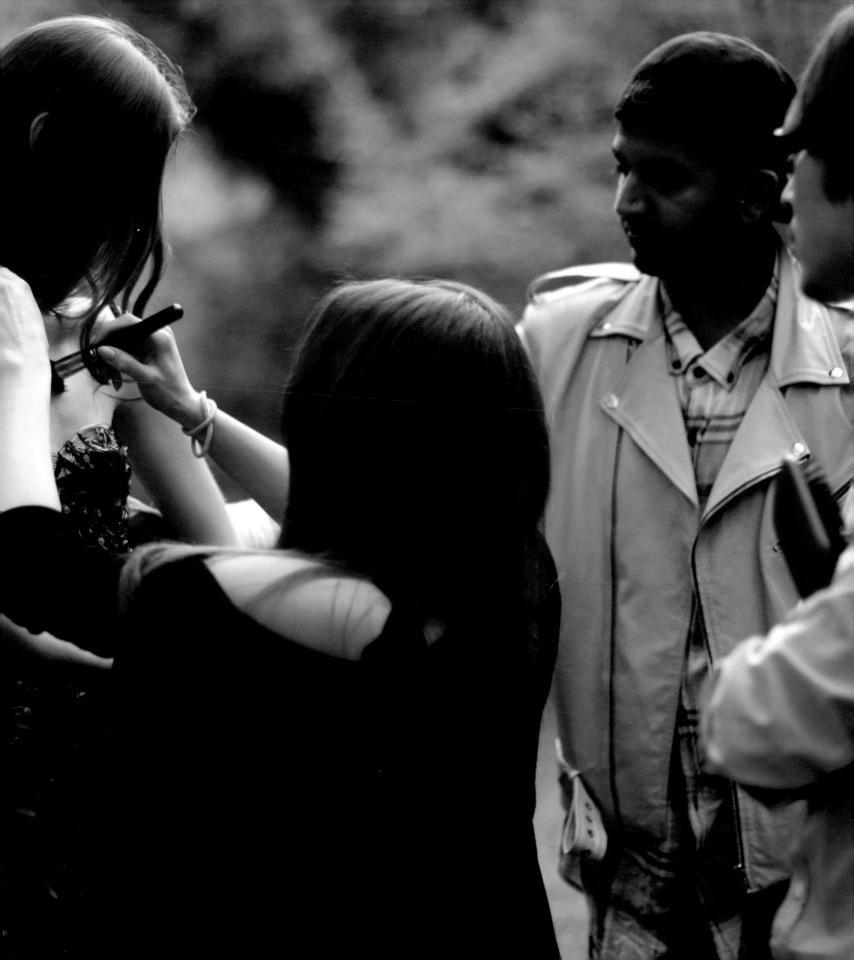

OVERVIEW

ON ANY FASHION PHOTOSHOOT a talented creative team is just as important as the photographer. With a stylist, makeup artist, and hair stylist working alongside you, you'll find that you can create the impossible.

A typical creative team consists of:

Stylist: A stylist's job is to assess the creative brief, whether from the photographer, a magazine editor, or art director, and pull (select) clothes accordingly. The clothes are sourced from a variety of places, either from a designer's collection or from brand stores. The stylist must then ensure that the clothes arrive ready to be photographed on or before the morning of the shoot. On the day of the shoot itself, the stylist is responsible for dressing the models and making sure that the clothes look good. He or she will also source appropriate accessories to accompany the clothes.

Makeup artist: A makeup artist is responsible for applying makeup to the models so that they are ready to appear in front of the camera. The style of makeup should complement the brief, and may vary from very simple to *avant garde*. A good makeup artist will instantly know what works for a particular model or client.

Hair stylist: The hair stylist works alongside the makeup artist and has similar responsibilities—ensuring that the model/client is looking his or her best for the camera, and if necessary styling hair so that it follows a specific creative brief.

Manicurist: Depending on the photoshoot, sometimes a manicurist is required to enhance the appearance of the nails on the hands and feet of your model(s).

Art director: Large clothing and store brands, as well as fashion magazines, will have an art director who will attend photoshoots. It is the art director's responsibility to plan and create the overall theme of the shoot and control the creative direction on the day of the shoot itself. In some cases the art director is also the stylist or even the editor of a magazine—in this case, you as the photographer work under their direction toward the planned theme. It's important that you take direction from art directors as it's their theme you're working toward and they're the point of contact and representative of the client.

Personal assistant: A personal assistant (PA) is vital on any photoshoot—to handle all the jobs a photographer cannot do on the day and to keep things running smoothly behind the scenes. Photoshoots are complex and have numerous elements that cannot always be the responsibility of the photographer alone. Common PA tasks include general assistance on the day, administration, tidying, cleaning, working alongside the photographer on-set, collecting/taking parcels, and organizing catering and transportation.

Digital assistant: A digital assistant is vital on larger photoshoots, particularly when you're working with the camera tethered to a computer. Working this way, so that shots can be reviewed immediately on-screen by the photographer, art director, and client, often requires quite a complex setup. Other digital assistant jobs include preparing the images after the shoot and most other computer-related tasks. In many ways digital assistants are like personal assistants, but are more experienced in technical work, and often have to be very experienced in order to work quickly and understand a new photographer's techniques.

TETHERED SHOOTING
Capturing an image with your camera fixed on a certain position and attached to a TV screen or computer. The advantage of tethered shooting is that the monitor or screen on your computer has a much larger screen than the LCD on your DSLR on which to view the shot, offering both an easier way to see what tweaks could be made to composition and framing, or to show an on-site client how the images are working.

Quotes from my creatives:

My creative team in London and New York are people I use regularly on test and commissioned work. Most of the creatives I work with are people I've grown with from when I first started. It's important to grow with your team and equally as important to understand and bounce ideas off one another. Below are a few quotes from my regular team.

"Our first shoot was back in 2007. I knew I'd met someone just as crazy as me when Lara had me climbing a 15-ft birdcage for makeup touch ups in the middle of November. Collaborating with Lara is always inspiring; she has beautiful visions and I love to be a part of bringing them to life."

Leah Mabe, Makeup Artist, London

"I first met Lara on the 'Joan Of Arc' shoot we shot together in New York City. I was a replacement for a makeup artist that couldn't make it that day. Lara is so fun to work with on photoshoots and everything she touches turns to gold!"

Deborah Altizio, Makeup Artist, New York City

"Velveteen Rabbit" editorial shoot, Brooklyn NY, 2011.

Photo: **Nicole de Waal**

Myself and makeup artist Deborah Altizio on-set. Deborah is applying makeup to model Sasha for a studio editorial shoot. When working with a creative team, you should always pay close attention to their work and compliment them when necessary.

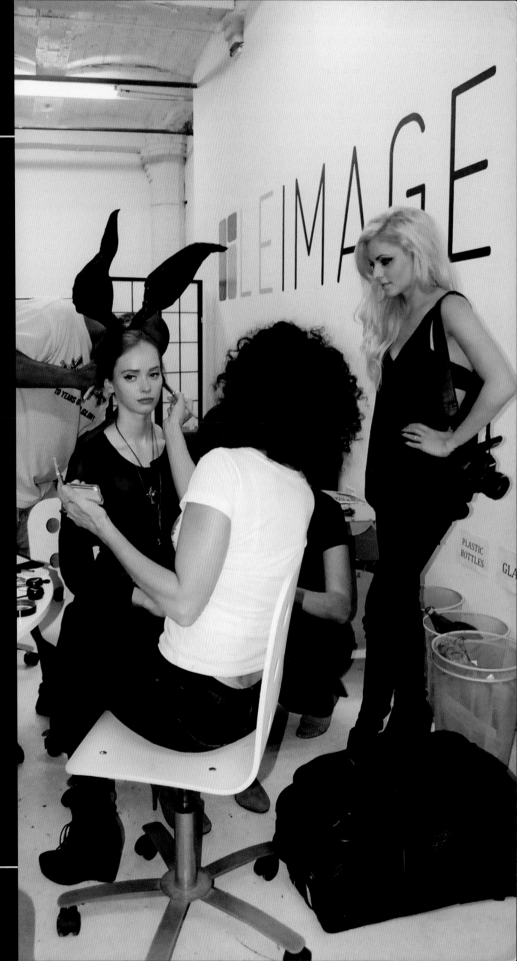

Creative Team

CASTING YOUR MODEL

APPROACHING AGENCIES
In order to build good relationships with model agencies, you need to start "testing" with their models on simple headshot or portrait photoshoots. This enables you to establish a good rapport with the agency, so increasing the likelihood that you will work together on future projects.

PORTFOLIO
Your portfolio is an essential item when you're going for appointments. It should be a collection of images that displays the quality of your work and reflects the kind of work that you want to do. The industry standard size is 11 inches × 14 inches, with no more than 20 leaves, and it should be bound in a good-quality cover with your name on it. It should contain a maximum of 40 images.

TEST SHOOT/TFP
A "test" or TFP (time for prints/portfolio) shoot is a photoshoot in which neither the photographer nor the model are paid. However, both benefit in that they gain invaluable experience and have the opportunity of adding to their respective portfolios—the model gets free prints, while the photographer gets a free model. Testing is useful for photographers and models at all levels, but mainly benefits those who need to build their portfolios.

WHETHER YOU ARE casting a model for a commercial job or for your next personal project, you should always remember that the model is key to a successful fashion shoot. In order to find the model that best fits the shoot's role, you need to assemble a group of appropriate models from which you can make your final selection.

How to find your model
If you're just starting out as a photographer then it will be more difficult for you to find a professional model to work with immediately. I would recommend building a portfolio of ideas and test shoots with friends or starting models before approaching modeling agencies. Model agencies will only let their models test with you if they are convinced that they will get beautiful photos of their models. Your evidence of this will be your portfolio and how you shoot—they are looking for clear, representative photos that will help sell their models' images.

Working with models

Beginning/amateur photographer If you're just starting out as a photographer begin by photographing people you know—they don't always have to be models to give great images—or try using websites such as Model Mayhem (www.modelmayhem.com) or other online model listings. You may find up-and-coming models who are looking to work with photographers.

Emerging photographer If you're an emerging photographer and you're looking to work with professional models for jobs or tests (see page 46 for more on testing) then I would recommend contacting model agencies. Most of the principal model agencies are based in the larger cities, so depending on your location you may have to travel or pay for the model to travel to your location.

When contacting model agencies directly email eight-to-ten photographs that you think best represent your style to the companies' email addresses, or phone around the agencies asking who to contact regarding "testing" with their new faces. You can also make an appointment to meet the agents at the model agencies to see who's available to test. The agent will most likely give you model cards to take home or set up a casting of new models in the office. A full listing of model agencies can be found in the directory of the website www.models.com.

OPPOSITE
Georgie and Anna were perfect models to fit the role of two sisters enjoying a day in an English seaside town. As I wanted the shoot to be vibrant, I opted for two redheads to help them stand out among the bright colors of the location and clothing.

Georgie and Anna were of similar ages, but had completely different personalities. Georgie was leading Anna on poses, and her confidence encouraged the other model. By suggesting poses for Georgie, Anna began to ease up and have fun, which made for an interesting concept.

Anna and Georgie for *Material Girl* **magazine (www. materialgirl-mag.com).**

Models: **Anna and Georgie @ Profile Models London**

Makeup: **Leah Mabe**

Hair: **Craig Marsden @ Carol Hayes Management**

Styling: **Claudia Behnke**

Photography Assistance: **Oscar May**

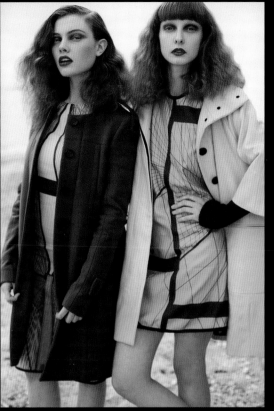

ABOVE
Canon 5D MKII
ISO 500
f/3.5 1/2500

RIGHT
Canon 5D MKII
ISO 500
f/3.5 1/2500

FAR RIGHT
Canon 5D MKII
ISO 500
f/3.5 1/2500

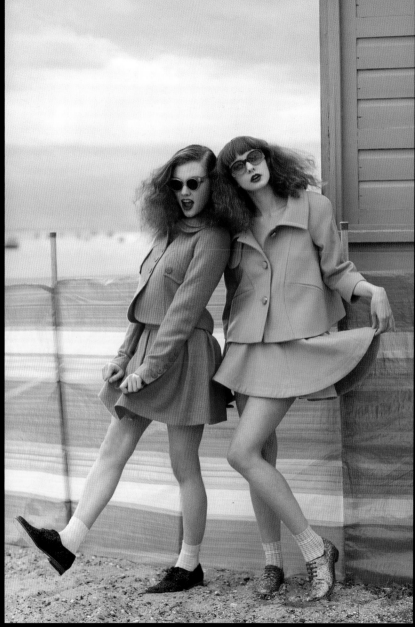

CASTING YOUR MODEL

When a photographer, model, and hair and makeup artist are starting out in their business and developing a portfolio, they are said to be testing. If you arrange a shoot with a model on a "test for pictures" or "time for print" (TFP) basis, it's usually done free of charge. The benefit is that everyone involved in the shoot gets pictures for their portfolios. When you have built up a good relationship with model bookers, they may ask you to do paid model tests.

TFP AND AGENCIES

TFP most often stands for "time for print," meaning the model gives their time in exchange for portfolio pictures. It's important to avoid using internet phrases such as TFP "time for print" and TFCD "time for CD" in agency situations, where the process is referred to as "testing."

Casting

In order to be considered for a photoshoot, models must attend the casting organized by either the model agency, agents, art directors or photographers. The purpose of the casting is to allow the person controlling and planning the shoot, such as an art director or photographer, to see a selection of models that are right for the job. Castings usually take place in either one of two ways:

- The casting is undertaken by the model agency (or company), who will send out an online package of their models they believe are right and available for the job. The model's package will consist of a series of photographs and statistics, such as various body measurements and eye color, as well as relevant details of previous experience.
- Alternatively, the casting occurs in person at a location selected by the photographer, the client, or the model agency. Essentially, whoever is overseeing the shoot is responsible for holding the casting and arranging the details. Models can be interviewed in person and have the opportunity to showcase their portfolios. Most high-profile jobs and editorial shoots are cast in person so that everyone involved can get a better idea of whether a model's right for the job or not.

Casting your creative team Casting your creative team is just as important as casting your model. A creative should be chosen based on their prior experience and skill. Creative agencies have rosters of creatives available for a wide variety of jobs and will test based on the project and the benefit to the artist.

To cast a creative through an agency, you need to contact the creative agency directly. If you're intending to work with a freelance or unrepresented creative, then contact him or her directly.

If you're a new photographer, look for would-be stylists and other creatives on listings such as Model Mayhem. You may also find starting stylists in fashion colleges who are keen to test and build portfolios. If you're a professional you can find a full listing of creatives on the F.Tape website (www.ftape.com), and a list of who is currently testing at www.whoistesting.com.

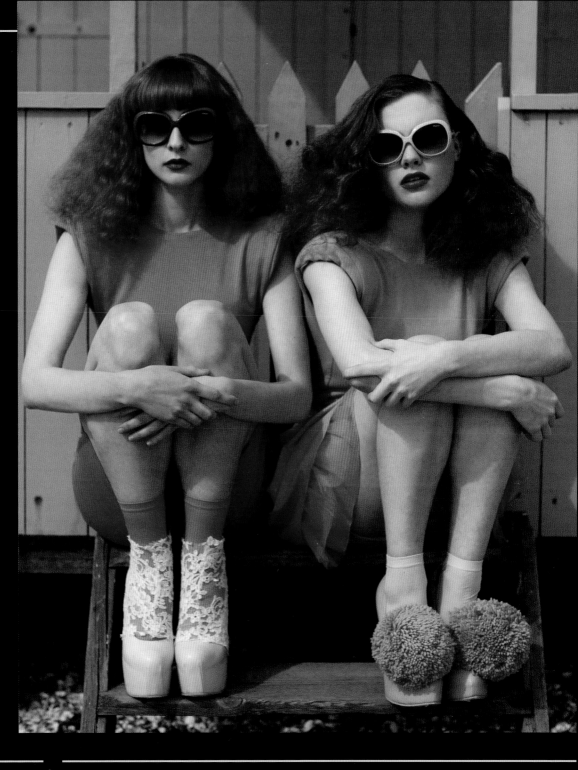

RIGHT
The casting meant
both models had
very similarly colored
hair, which chimed
perfectly with the
pastels of the image
and provided a
unifying, rather than
a distracting, element.

Canon 5D MKII
ISO 160
f/3.5 1/3200

Anna and Georgie
for *Material Girl*
magazine.

Models: **Anna**
and Georgie
@ Profile Models
London

Makeup: **Leah Mabe**

Hair: **Craig Marsden**
@ Carol Hayes
Management

Styling: **Claudia**
Behnke

Photography
Assistance: **Oscar May**

MODEL DIRECTION

SUCCESSFUL MODEL DIRECTION comes down to a few key factors—the professional level of the model, experience, and how comfortable they feel. First and foremost, a shoot's environment should be physically as comfortable as possible for everyone involved, especially as they are usually long days.

In order to get the best out of your models they should understand clearly what is being asked of them. It pays to share your shoot ideas with your models on the day or, if possible, before the day of shoot so that they understand the themes and concepts you want to capture. It is also useful to bring along visual references such as tear sheets or printouts with poses you find interesting.

When I'm planning a shoot, I often create a role for the model, who is then cast appropriately. On the day of the shoot I tell the model who she's going to be and how she should act. A good model will understand your requests and work with you toward your chosen theme.

One of the most important roles of the photographer is guiding the models correctly. You need to constantly encourage their movements or tell them when it isn't working—all models will appreciate this! You should also give them reference points—for example, pointing out the source of light and how this falls on their faces. Keep your requests simple, as small suggestions can work wonders.

If there is a client on-set, or an art director leading the shoot, he or she will also be responsible for how the model is performing. Although care should be taken to ensure that the models don't get confusing direction from two separate sources.

TEAR SHEET
A page torn from a magazine and added to your portfolio. The torn page adds authenticity, proving to your prospective client that you have worked professionally. Tear sheets can also be supplied digitally in PDF form when a print version is not available. Tear sheets of other people's work can be used as useful model or shoot references.

OPPOSITE, ABOVE LEFT
Model Danielle in the studio. Danielle is a great mover on-set, so she doesn't necessarily need direction every step, but I always stop her to give her new ideas, or to change her direction in sync with the light. Here, I used backlighting and soft light to create an ethereal effect behind her.

OPPOSITE, RIGHT
Danielle was made aware of the backlighting so her poses were kept in one position so the lighting would spill through behind her. Adding movement to the shoot also creates an interesting perspective and something we wouldn't see without "freezing" the subject.

OPPOSITE, BELOW LEFT
On the set of the workshop, Danielle would stop between poses for guidance from the attendees. Here, one of the attendees is showing her how successful the images were turning out. When shooting, it's important to encourage your model and show them the images, so they know what they are doing right!

MAKE YOUR MODELS COMFORTABLE
- Show the models your themes/visual direction before the shoot.
- Encourage and compliment the models as they're posing.
- Frequently show the models the images on the back of the camera or the computer.
- Provide refreshment for your models to keep them hydrated and energized.
- Play upbeat music.
- Make sure your location is neither too hot or too cold.
- Mirror the models—show them the poses you want!
- Take regular breaks throughout the day.

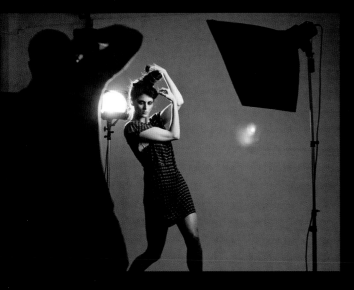

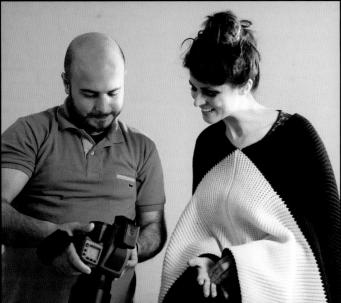

Model Danielle Amber on-set at
one of my London workshops.

Photo: **Oscar May**

STYLING

A GOOD STYLIST WILL HAVE TO have a talented eye to choose the right clothes for a photoshoot, know how to fit them, and work confidently and happily alongside the rest of the creative team on the day of the shoot. If the clothes don't work for the intended theme, the photos are unlikely to work either. When choosing your stylist you want to be sure they're right for the job. For example, a commercial stylist won't be right for a high-fashion creative shoot, and vice versa.

If you're just starting out, it's worth styling your own test shoots. This will give you firsthand experience as a stylist and will help you to understand what styles work in which scenarios.

In my first few years as a photographer I styled most of my photoshoots myself. This isn't to say I couldn't use a stylist, but more that I wanted the styling to fit precisely with my vision. I would search for clothes in charity or thrift stores or even on eBay, looking for specific garments to go along with the theme I wanted to shoot.

If you don't have the option of using a stylist, say for a test shoot, then encourage the models to bring their own clothes. Give them some

reference points and themes before the shoot and ask them if they have any clothes in that specific genre. Don't leave it down to the last minute, however—it will be easier for you and the models if you plan ahead.

On most professional photoshoots (unless there is an art director or somebody controlling the styling), you as the photographer are responsible for overseeing how the stylist is working. It is good practice to be with him or her every step of the way—from handing over a brief, ensuring visual references are being sent back and forth, and even meeting to pull the clothes and to make a plan of how they're going to be shot. It's impossible to be too prepared. The greater the understanding between the photographer and the stylist, the better the shoot will go.

How much of the styling is your input as opposed to the photographer's?

"The styling input to a shoot is very important because I'm helping create a world of characters with the photographer. I work alongside Lara on photoshoots, and also with her on her ideas sometimes even several weeks before the given shoot date. Fashion photography needs to be a team effort from all sides, and both the stylist and photographer have to come together in agreement to negotiate their favorite looks."

Savannah Wyatt, Stylist and Costume Designer, New York City (www.savannahwyatt.com)

BRIEF

The idea or theme of a commissioned fashion shoot. This is usually determined by the client, for example by the editor of a magazine. The brief can be a whole concept, or just one word. You should feel free to discuss with the client how it should be interpreted, though as the photographer it is up to you to decide what the brief means to you and how you will interpret it.

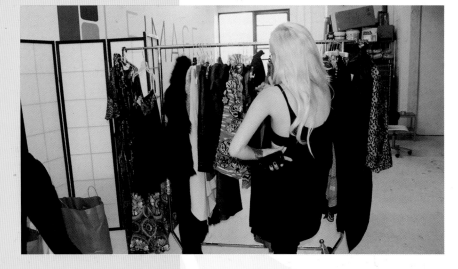

LEFT
As the photographer it's important to work with your stylist every step of the way, and talk through clothing options before and on the day of the shoot to make sure your concept is clear and you have a good idea of how everything is going to work.

"Velveteen Rabbit" editorial shoot, Brooklyn NY, 2011.
Photo: Nicole de Waal

Wardrobe for "The Fold 2011 Lookbook" shoot—a good stylist will organize the looks at the start of the day and walk you through them so you have a plan of outfits.

NY campaign for The Fold clothing

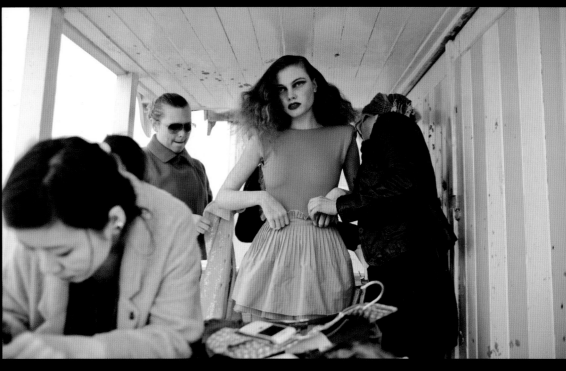

A changing area should always be available on-set, especially when working in public places. Think about taking oversized blankets/clothes or put together a makeshift changing area (like this beach hut entrance) for your model to get changed in.

Material Girl **shoot, London 2011.**

MAKEUP AND HAIR

HAIR AND MAKEUP ARTISTS, like stylists, should be selected based on their skill and experience. A makeup/hair stylist that doesn't understand your vision will most likely ruin the shoot.

As fashion photography requires a wide range of skills and experience (due to the varied themes and styles) you should always choose your artists based on their specialities. Some makeup and hair stylists excel at close-up and detailed work and may work best for a beauty-themed shoot, while other artists might have more experience with costume makeup so may be better for conceptual and artistic shoots.

As with styling, you as the photographer (in the absence of an art director) are responsible for overseeing the hair and makeup created for the shoot. The artists should be briefed and receive visual references well before the day of the shoot so they know what they're aiming for as soon as they arrive on-set. It is a good idea to quickly re-brief them on the day of the shoot so that they're clear on your specific interpretations for the shoot.

Timing

Remember that the entire shoot needs to run to a specific time frame. Always give your makeup/hair stylists a feasible deadline to work to. Expect to be waiting a little longer for more detailed/heavier makeup or hair work, but make sure they're aware of a time when you expect to start shooting. If you're working on a number of looks then agree on a set amount of time for each change.

Touch-ups will be required all through the day and your makeup/hair stylist should be on hand at all times to fix makeup and touch up hair styles.

How important is a makeup artist's input on a shoot?

"A makeup artist's input is important but ideas should be a collaboration involving the entire creative team—ideas should be bounced back and forth so everyone is on the same page. Some photographers like more input than others so, in the end you must understand the balance and come to a mutual agreement. I personally like to reference makeup from backstage at fashion week and whatever is on trend to keep my portfolio up to date. If it's a period theme then I do extensive research to create the look."

Deborah Altizio, Professional Makeup Artist, New York City (www.deborahaltizio.com)

As a hair stylist, how is what you do important to a photoshoot?

"Fashion is about the perfect presentation, right? A huge part of a person's presentation is about how they wear their hair. It can be as expressive to the character of the shoot as the model's face. I think it's been said before, and I wholeheartedly agree, that someone's hair is their most powerful and versatile accessory."

Could you give us a tip for a new photographer working with a hair stylist?

"It's always of utmost importance to have good communication. That applies to all the creatives, but specifically I find it's best to speak to hair stylists in terms of proportion, silhouette and texture. Those are the three defining characteristics of any hairstyle out there. Another good general rule is to make sure your set is always a welcoming place. If I like being around the crew members, even if I'm going to a kind of shoot that's not artistically fulfilling to me, I'll be happy to be at work and will always perform better for it."

Alexander Tome, Professional Hair Stylist, New York City (www.alexandertome.com)

IF THINGS GO WRONG

As there is so much organization involved in a photoshoot, there are going to be times when things don't run smoothly. You should always be prepared for things to go wrong, especially if there's a client or art director on-set. When they do, here are a few tips:

- Always have first and second options for models, just in case your preferred model can't make it or falls ill on the day. The same should go for all members of the team.
- Keep a note of all important phone numbers—studios, creative teams, models, and travel centers.
- Be sure that everyone involved with the shoot has your phone number in case they need to contact you in an emergency or if they get lost.
- Double-check you have everything prepared and that your equipment is well organized prior to the date of the shoot.
- Visit locations/studios prior to the shoot dates to be sure they have everything you expect in terms of facilities and equipment, and that they're ready for your planned shoot.

RIGHT
Hair stylist Nelson Vercher working on-set. When working with headpieces, stylist and hair stylist should work together so they are both happy with the end result. Headpieces should always be attached sturdily so they are not going to fall off when the model moves.

"Velveteen Rabbit" editorial shoot, Brooklyn NY, 2011.
Photo: Nicole de Waal

4 SHOOTING

Gigi and Irena for *Material Girl* magazine.

**Models: Gigi and Irena
@ Wilhelmina Models**

**Makeup: Deborah Altizio
@ Agent Oliver**

**Hair: Damian Monzillo
@ BA Reps**

Styling: Lauren Armes

**Canon 5D MKII
ISO 200
f/4 1/1600**

NATURAL VERSUS STUDIO LIGHTING

LIGHTING IS THE MOST IMPORTANT element for any shoot. There are many forms of lighting—some more accessible than others—and many ways of using various sources of light to create unique and interesting effects.

Lighting tends to fall into two camps: studio lighting, and natural light. When working on location I usually rely entirely on natural light, and when working in a studio environment the set is lit solely by strobes or continuous light. However, many photographers will use artificial lighting when working on location, particularly for "big production" shots.

As a working photographer it is essential that you have a good knowledge of both kinds of light. Your understanding and appreciation of natural and artificial light will shape the style of your work, and will ultimately play a large part in determining whether or not your images are successful. Your clientele are going to expect you to have an extensive knowledge of lighting, so when it comes to them booking you for a photoshoot you should immediately have an idea of what lighting you're going to use.

As lighting is so important to the overall success of a shoot, it's a good idea to consider this, perhaps above everything else, when planning a photoshoot. Having a good plan and idea of how your lighting is going to work will be beneficial to you on the day of the shoot and help keep things running smoothly.

Whenever you're on-set, it's important to feel comfortable and confident with the task ahead of you—give yourself enough time on the day to mentally prepare before your shoot. Use this given time to focus on how you can get the best out of your shoot—do you prefer shooting manually or with autofocus? Which will suit your role better? Will shooting on aperture priority benefit you on this particular task? If you find your time restricted and you're shooting in a variety of lighting situations then maybe your answer will be yes. What about the use of a tripod? You should take into consideration every technique you use in order to complete your task at hand quickly and easily.

Natural versus studio scenarios

Here are two different job scenarios that would shape my choice of lighting.

In scenario A, I am commissioned by a new actor to create a portfolio of portraits. Here, I would favor a location shoot over photographing in a studio. Any new client that hasn't spent time in a studio is going to prefer an open location to being in a boxed room and put on the spot. An outdoor space will be familiar to the client and make them feel more comfortable. Natural sunlight can create several different lighting situations, from photographing in the shade under a tree, to direct frontal, side, or even backlighting. Also accessories such as reflectors or diffusers can help to shape the light.

In scenario B, I am photographing an experienced model and using a creative team for a fashion editorial. Here, I would favor using a studio. Firstly, this allows for preparation of the shoot—a studio or preparation room is vital when working with a large team, and your stylist, makeup, and hair team will appreciate the space to work in—and secondly, using studio lighting gives you much more control and allows for greater lighting creativity.

LIGHTING

Below are some pros and cons of natural and studio lighting:

Natural	Studio
• Easily accessible	• Need to book in advance
• Free to use	• Charge for use of lights
• Harder to control	• Easy to shape and control

OPPOSITE TOP
Model: **Aysche**
@ DNA Models

Makeup: **Anthea King**
@ SEE Management

Hair: **Ronnie Peterson**

Styling: **Lauren Armes**

OPPOSITE BOTTOM
American Indian Shoot.

Models: **Ella @ Premier Models London and Maya @ IMG Models London**

Makeup: **Megumi Matsuno**

Hair: **Fukami Shiny**

Styling: **Krishan Parmar**

DIFFUSER
A photographic prop used to make light appear less harsh.

REFLECTOR
An item used to reflect light toward your subject. Reflectors are either placed on a stand or other support, or held by an assistant to direct light onto a subject.

Studio shooting is
something that comes
more easily to established
professional models than
the less experienced, so
for an editorial shoot that
uses a full creative team I
often opt to shoot in a
controlled environment.

NEAR RIGHT
Canon EOS 5D MKII
ISO 2000
f/4 1/200

FAR RIGHT
Canon EOS 5D MKII
ISO 2500
f/2.8 1/1250

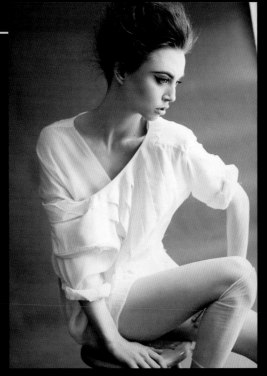

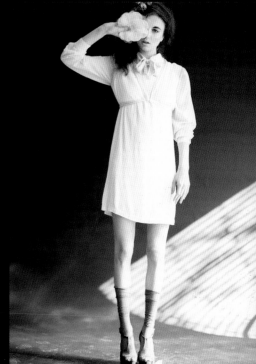

NEAR RIGHT
As the sun went down, the cast
of the lighting gradually became
stronger and warmer. This was
an excellent opportunity to shoot
and gave me the idea of using
he flowers to further enhance
the color in the photograph.

Canon EOS 5D
ISO 400
f/2 1/500

FAR RIGHT
With this single shot, I asked the
model to stand with her back to
the afternoon light and face me
so the light would spill through
the thin material. I overexposed
the shot by 2 stops in order to
softly light her face.

Canon EOS 5D
ISO 400
f/2 1/3200

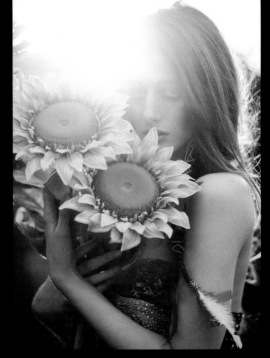

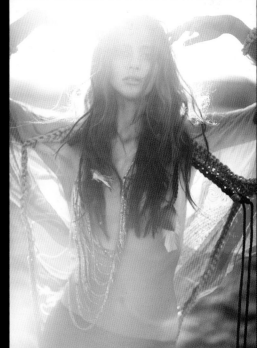

HIGH-KEY & LOW-KEY LIGHTING

BEFORE WE LOOK FURTHER at lighting techniques, I want to introduce the concept of high-key and low-key lighting. As visual artists, it's important to understand how both are created and the impact each has on the viewer's perception.

With a high-key image you'll notice the overall image is intentionally bright and lacks contrast and shadows. When taking a high-key image you should purposely overexpose your image (without blowing out the highlights). High-key images usually create a light, or happy response in the viewer.

With a low-key image the tones are much darker, being composed primarily of shades ranging from gray to black. Additionally, strong contrast exists between lights and highlights. When a photographer shoots low-key images it's usually to convey dramatic scenes or emotions.

When shooting, keep these two principal lighting ideas in mind and they will help to convey your theme better.

It's important to understand high- and low-key lighting in fashion photography as designers, clients, and art directors alike are going to request lighting techniques that complement or emphasize the clothing within the images. By understanding how powerful the use of low- and high-key lighting can be, you'll be able to confidently offer the client what he/she needs to create a certain mood and theme within the images.

There is no set-in-stone way of using high/low-key lighting for your photoshoots (unless it is requested by the client). Try using non-traditional techniques to create different moods and break the boundaries by using high-key lighting on darkly styled images, or by using low-key lighting on shoots with more positive themes.

HIGH KEY
High-key photography is light, airy, and low on contrast. High key is bright, has few shadows, and is useful for positive and upbeat images.

LOW KEY
High-contrast photographs, usually very dark in tone, that have a feeling of brooding.

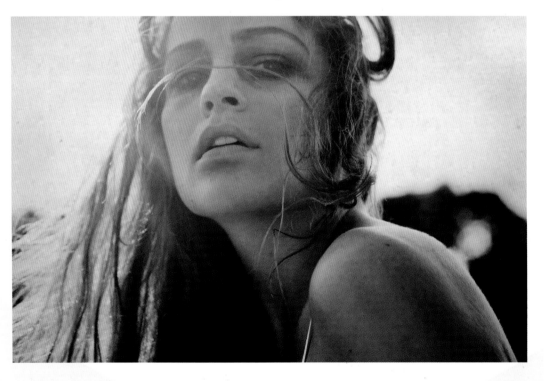

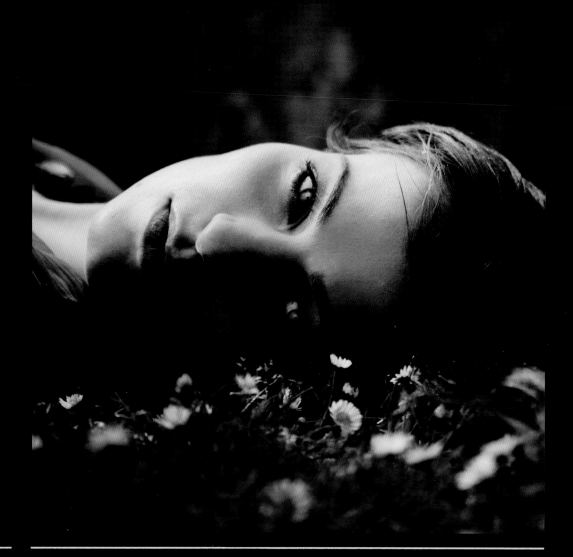

The backlit scene
enhances the theme of
this low-key image, and
makes it timeless. When
choosing your light ideas,
think about how the lighting
will enhance your subject—
do you require soft
lighting? A controlled
environment? Or is it a
requirement that your
shoot have a more rural
environment, which you
can only achieve outside?

Model: **Yasmin Green**

Canon EOS 350D
ISO 200
f/2.8 1/3200

OPPOSITE
With this high-key shot, the
model posed with her back
to the light, facing me so
that the light would spill
through from behind. I
overexposed the shot by
2 stops in order to get
some soft light on the
subject's face. In post-
production I adjusted
the tones of the image,
matching the highlights
to the mid tones to give
less contrast.

Model: **Yasmin Green**

Canon EOS 350D
ISO 100
f/3.2 1/2000

ON LOCATION

LOCATION SHOOTING can be one of the most exciting scenarios for new photographers and professionals alike. The ability to shoot against a wide variety of backdrops, and potentially without the use of bulky studio lights is hugely appealing to most photographers.

Although exciting, you need to be aware of the logistics of shooting away from the studio, and plan ahead. The first questions to ask sound obvious, but certainly need confirming. Do you have permission to shoot in the location? Do you have easy access to the location?

Photographers sometimes think of on-location sets as exotic or expensive—and this can certainly be the case, but not always. Expensive locations are usually negotiated through location houses and used by big production companies. If you are a photographer on a budget or working on a self-funded project, you need to think more creatively. Why not start by looking closer to home. What about a backyard, or the nearest parking lot? How about a park? What about using a field with a cloudy sky scene for a backdrop as your model portrait? Remember, a location doesn't have to be luxurious to make for an interesting backdrop—some of the most iconic photographs of the recent past have been shot in very unlikely places. It all comes down to how you as the photographer interpret the shot and how much of the shot is focused on the styling and the subject.

If you are shooting on location away from your home or studio, having a temporary base is always important. Ideally, your base should have electricity to charge equipment, internet access to upload shots and keep in touch with colleagues, enough space for a styling rack to keep clothes in good order, and somewhere comfortable for your models and creative team to relax and prepare for shoots. If you have a budget, then think about hiring a location van.

TIP
Check the weather. You can't control Mother Nature, so you should always have a backup plan if the weather becomes too extreme to shoot in.

BACKDROP
The background area of a photograph against which your subject is shot.

TIP
Stepladders can be pretty useful if you want to photograph a subject from a unique view. They are also good for hanging clothes on if you don't have a rack available, or even as a makeshift model chair while your styling team are working.

LEFT
Photographer Felix Kunze using a stepladder to capture his subject at a unique perspective.

London workshop, 2011.

Photo: **Oscar May**

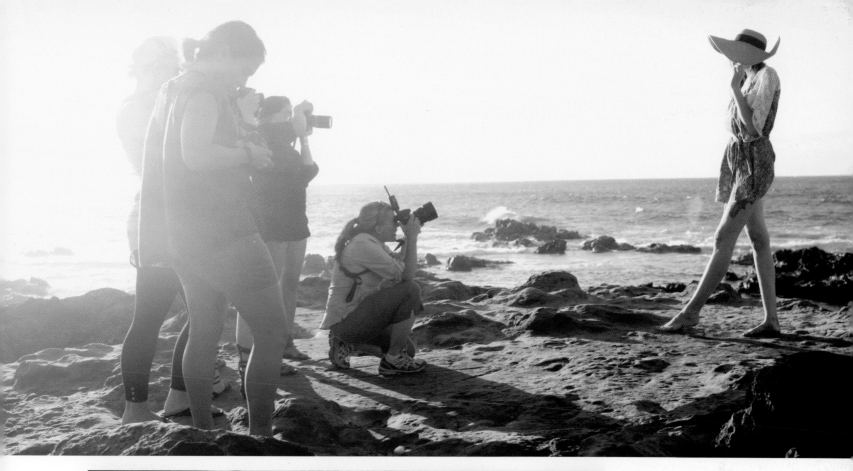

ABOVE
The afternoon light was a perfect opportunity for my workshop attendees to capture timeless images. The warm, falling light cast by the setting sun enabled them to capture a golden cast.

Maui, Hawaii workshop, 2011.

LEFT
Direct midday light is something most photographers avoid, but with certain clothing props and accessories you can create a unique image. Here, the photographer uses an oversized hat to create light spots—great for a beauty photograph!

Maui, Hawaii workshop, 2011.

Model: **Valerie Wessel**

WORKING WITH NATURAL LIGHT

BELOW AND OPPOSITE

Gigi and Irena for *Material Girl* **magazine**

Models: Gigi and Irena @ Wilhelmina Models

Makeup: Deborah Altizio @ Agent Oliver

Hair: Damian Monzillo @ BA Reps

Styling: Lauren Armes

NATURAL LIGHT IS THE MOST UNIQUE and diverse light source there is. Although you can't control the overall natural lighting, you can achieve various effects at different times of the day, during different seasons, or by shaping the light yourself using reflectors and diffusers. There are many iconic fashion photographers who shoot entirely with natural light because of its quality and adaptability.

To master natural light you need to understand how color temperature, direction, and brightness work, as well as when it's best to shoot.

Getting the best out of natural light

Certain times of day can bring out the unusual and dramatic in your photographs and make for beautiful backdrops, not only for landscape photographers, but also for us as fashion photographers.

The best time to shoot in natural light is the first hour after sunrise and the last hour before sunset—often referred to as the "golden hour" by landscape photographers. The light source during these hours is soft and diffused, the angle low, and the color warm. Even though the sun sets or rises quickly, the golden hours should provide you with enough time to capture a variety of images from hazy backlit shots, through natural flare, to direct warm frontal light.

Many location shoots can last all day, and as natural light changes so quickly throughout the day, you will need to use various accessories to shape or fill the light. Here are two important accessories location photographers should always carry with them:

Reflector: The most common location reflectors are circular collapsible pieces of equipment with either gold or silver reflective surfaces used to "bounce" or redirect light onto a subject. They are used to fill in areas of shadow, especially when working in direct, unflattering light.

Scrim: A scrim is a piece of transparent gauzelike material (often stretched out on a collapsible frame) to diffuse strong light. Photographers use scrims in much the same way they would use a softbox in the studio.

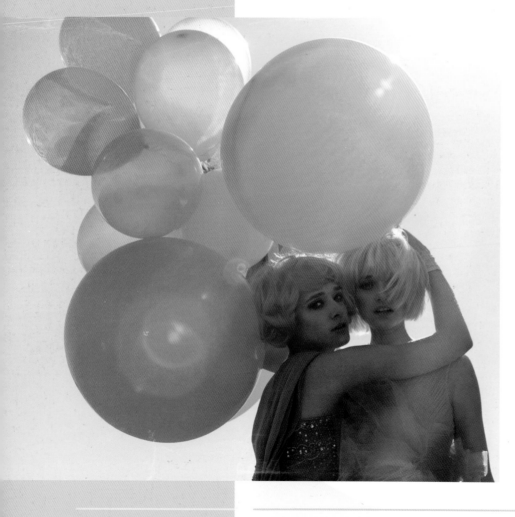

LEFT
I deliberately added flare to this shot. It looks great against the colorful balloons.

Canon 5DMKII
ISO 200
f/4 1/3200

Natural light scenarios

Backlit: When the light source—in this case the sun—is behind the subject, the subject is said to be backlit. Backlighting works best during the golden hours because the sun is less bright and has a warm-colored tone. As the sun gets higher in the sky and grows brighter, backlighting will produce featureless silhouettes. Golden-hour backlighting will usually provide a soft, hazy, ethereal effect.

Adding flare: When shooting a backlit model, the sun is shining directly into the front of your lens and can create interesting flare effects. You'll get the best results with flare when the sun is at its lowest and you shoot with a wide aperture.

Direct to the light: To achieve a strong, contrasting light, pose your model so that he or she is facing the sun. During the golden hours direct lighting will create high contrast with warm tones. Add reflectors to remove harsh and unflattering shadows on the face and body. You should always encourage your model to keep his or her chin to the light if the light source is higher in the sky to eliminate obvious harsh shadows.

Weather permitting: One thing you can't shape and change on a shoot is the weather. In most temperate climates you should always be prepared for rain or even extreme weather when in an open environment. Here's how to cope with some weather scenarios—you can even use them to your advantage.

Overcast: Clouds are your natural softbox; they help diffuse strong sunlight. Overcast days are really useful for certain shoot themes. If it's a gray day and light levels are low, try using a high ISO and a wide aperture to recreate grainy-looking movie scenes. The light will be even on your subject and very flattering on the skin. If there's a lot of cloud cover, think about how you could use it as a backdrop to your scene. Maybe you could use it for a powerful, moody conceptual piece?

Raining/snowing: Among the hardest weather scenarios to cope with are rain and snow (and everything in between). You should only work with either if your shoot requires it—which is extremely rare. However, if you have to, look around your location for areas under which you can shelter to prevent you having to cover the entire scene—this could create for interesting results, especially if you can capture rain drops.

BELOW LEFT
To add an interesting perspective to the story I asked models Gigi and Irena to lie together on the floor. With help from our stylist, we made a "set" on the ground and I used a stepladder and a wider angle on my camera lens to get an interesting perspective. The afternoon light was direct on the models, so I purposely decided to underexpose by 1 stop to avoid any blown out highlights.

Canon 5DMKII
ISO 200
f/4 1/2500

BELOW RIGHT
I love the effect of the backlighting here along with the texture provided by the grasses.

Canon 5DMKII
ISO 200
f/4 1/400

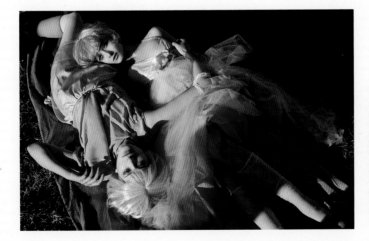

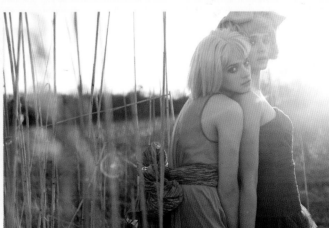

WORKING WITH NATURAL LIGHT

BELOW
If you have extreme sun (a photographer's nightmare!) consider an area where you can find shade, such as under a tree or the side of a building. If shooting in this situation is your only option, then use a scrim or white diffuser to create soft, diffused light.

Model: **Danielle Foster**

Makeup: **Keiko Nakamura**

Canon EOS 5D
ISO 800
f/4 1/160 sec

Rim lighting: Rim lighting emphasizes the subject's outline, and can give a wonderful halo effect. When working with rim lighting on-location, it's important to understand exactly how it should be captured and what settings you will need for the correct exposure.

The best time to capture this kind of lighting is when the sun is at its lowest point in the sky (early morning or late afternoon), specifically during golden hour. To get the best out of rim lighting, you may want to consider the way your subject is styled—light colored pastel crepe or sheer fabrics work beautifully with rim lighting (as well as with backlighting), and fine, loose hair is captured beautifully in this light and emphasizes a majestic, dreamy theme.

Rim lighting is most noticeable when you slightly underexpose your photograph (usually by 1–2 stops), resulting in a low-key image. You may also want to consider the background of your shot—dark tones will emphasize the highlights even further. However, if you're shooting portraiture and your only light source is natural, you may want to consider using the gold side of a reflector to reflect light back into your subject's face, or consider mixing natural and artificial lighting for something slightly more powerful. Another technique is to set your camera on a tripod, and take two shots (with your model staying in a set position); taking one slightly overexposed image, and one slightly underexposed image. This way you're capturing the rim lighting, but can later combine the two photographs and retouch so your subject is also in the light.

Working with the environment: Making sure you've got the right exposure is tricky when working with purely natural light, so consider using elements in your environment (natural and man-made) to shape the light. Whenever I am shooting on a rooftop, I find that reflective silver surfaces are perfect to help expose the whole of my subject's features. If I'm working near water, such as a lakeside, or on the beach, the water's reflection can place a nice emphasis on the subject's skin, or help highlight colorful eyes. Or if I'm working near a forest or trees, I use the canopy of trees to create shade away from the sun, use the shadows of leaves on my subjects' skin, or capture backlit leaves. This creates lovely speckles using a wide aperture.

Intentional underexposure or overexposure: Many photographers are told to "hold the highlights" when shooting overexposed images. However, I don't believe that specific shooting scenarios have a perfect exposure—it differs for every shot. Sometimes you may want a high-key shot to blend into the background and achieve glowing tones, or to deliberately overexpose your shot to eliminate background clutter (like trees in a park or people in the busy street scene). Try it out! The best way of understanding whether overexposure/underexposure works for your shot is to try it in the set-scenario; sometimes you won't know this until you start shooting!

RIGHT
The low setting sun was a perfect opportunity to capture the milky effect I love for portraits. I intentionally overexposed the image by 2 stops and pulled back the contrast in post-production.

Model: **Vick @ Elite Models NY**

Canon EOS 5D MKII
ISO 800
f/4 1/160

BELOW LEFT
The mid-afternoon sun provided a lovely natural light on the scene. I placed the model inside a tree branch to emphasize her styling and overexposed by 1 stop.

Model: **Dominika @ Premier Models London**

Makeup: **Amy Sachon**
Styling: **Ihunna**

Photography Assistance:
Steven Read

Canon EOS 5D MKII
ISO 160
f/1.4 1/1000

FAR RIGHT
The sun setting on the horizon made a beautiful scenic backdrop for the model Danielle in her mystical gown. I raised the ISO to 500 to emphasize the glow of light and overexposed the scene.

Model: **Danielle Amber**

Makeup: **Leah Mabe**

Canon EOS 5D
ISO 500
f/4.5 1/400

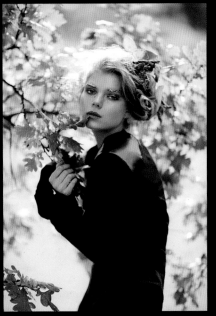

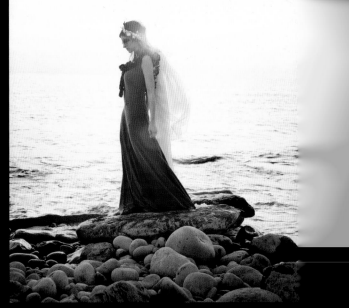

WORKING WITH ARTIFICIAL LIGHT

ALTHOUGH WE'LL MOVE on to discussing artificial lighting in more detail later in the Studio section (see pages 68–81), while we're looking at on-location shooting it's worth mentioning that some photographers use such lighting outdoors. Artificial lighting is either continuous or flash lighting (often referred to as strobe lighting), and can be combined with natural lighting for a variety of reasons.

Photographers will often use artificial lighting on location because it enhances what is already there and/or produces results that natural light on its own couldn't achieve. For example, sometimes natural light isn't strong enough to set a narrow aperture for a wide depth of field in order to keep the model and the background in focus, or the light source isn't bright enough to allow for a fast shutter speed in order to freeze movement. For other photographers it's all about artistic value. Combining artificial and natural lighting has an appeal for some fashion photographers who want to create an almost otherworldly or striking appearance.

As fashion photographers we always need to be aware of how we photograph the garments on a shoot. On editorials or campaigns we are booked specifically to capture and show the clothes in their best light and finest detail so that they appeal to the magazines' readers and advertisement viewers.

If you're just starting out in photography, look at an array of magazines to see how clothes are lit, and how flattering they appear on the model. The shape and structure of the garment is also important—you should photograph the garment the way it's meant to be seen. For example, if there's a lot of detail at the back of the dress then you should shoot the model from behind, or in a pose where you can clearly see the detail. In this respect, we need to consider how well our lighting works with the clothes and how much it flatters the garments.

NEAR RIGHT
Taken on my Maui, Hawaii, on-location workshop by balancing direct natural sunlight and one strobe (with no accessories). The strobe light was positioned on a stand to the right of the model and slightly behind her, this gives the effect of a highlight on the right-hand side, and helps her stand out against the background.
Photo: **Kim Akrigg**

Nikon D300S
ISO 160
f/11 1/160

FAR RIGHT
My workshop in Maui, Hawaii. The setup for the final shot. The "golden hour" where the sun sets and rises allows us to work with a number of light situations—from backlighting, direct light, side lighting and the use of mixing artificial and daylight together.
Photo: **Kim Akrigg**

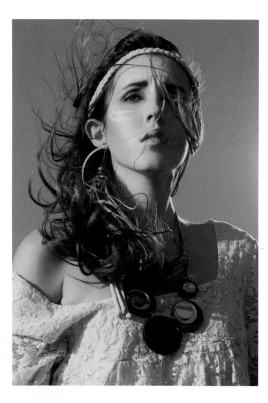
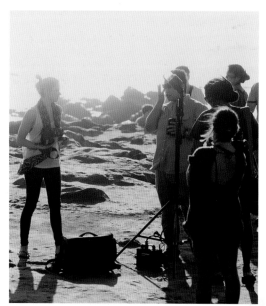

Using flash units outdoors

On-camera flash units can be a useful light source for portraits or creative scenes when on location. Favored by wedding and event photographers due to their inconspicuous size, they are often overlooked by portrait or fashion photographers. Using a flash unit is a cheap way of working on location and it's always worth having one in your kit in case there isn't enough natural light. Be aware, however, that flash units have a limited power source and the lighting can be harsh unless controlled with a flash diffuser—an opaque plastic fixing that sits over the end of the flash.

The advantages of working with lights on location are:
• Unique lighting source.
• Interesting backdrops.
• Stronger light source to capture movement/set wider depth of field.

The disadvantages of working with lights on-location are:
• Having to travel with bulky equipment.
• Moving them around the location, setting up the lights for each shot.
• Electricity/battery is needed to power them.

If you can afford to travel with bulky equipment and are willing to do so, then it's worth experimenting with using studio lights on location. Here are some considerations:
• You will need an electricity source for the lights, either a generator or an on-location source. Most brands that offer location kits also offer small generators or battery packs for hire.
• If you're planning to shoot in the rain then consider the dangers of working with studio lights. Some more expensive brands such as Broncolor offer waterproof lights (also useful if you're using around a pool environment).
• If you're traveling with lights you'll need to have protective casing for your equipment. Pelican casing (www.pelican.com) make

excellent protective cases for camera and lighting equipment.
• Consider renting equipment. Many companies offer good day rates or reduced weekly rates.

BELOW
Workshop attendees working on-set in Toronto, Canada.
Photo: **Kim Akrigg**

ON-LOCATION LIGHTING EQUIPMENT CHECKLIST

Here's a small checklist if you're shooting on-location with lights:

• Studio strobe/continuous light kit.
• Trolley or hand-cart for transporting equipment.
• Protective casing for lights.

• Pocket wizards/sync cable for lights.
• Light meter.
• Reflector or scrim for shaping artificial light.
• Tripod if needed.

• Accessories if needed: umbrellas/softboxes/beauty dish or grids.
• Covers/tent for all equipment and team in case of rain.

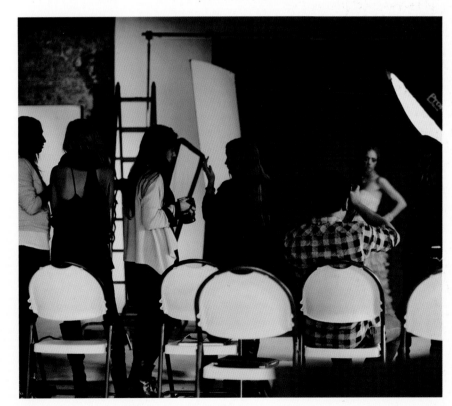

IN THE STUDIO

KNOWING YOUR WAY around a studio is essential for any fashion photographer. A studio offers an environment that can be fully controlled—from lighting, through to specialist equipment, to entire set building if necessary. For up-and-coming photographers, a studio is a place where you can experiment and create a diverse portfolio through the use of different lighting setups, techniques, and styles, all while having a comfortable environment for models and creative teams to work in.

Studio equipment explained

Naturally individual professional studios will vary slightly, but you'll find certain equipment is common to most:

Continuous lights: Continuous studio lights, as the name suggests, are lights that are on all the time. They are either tungsten, fluorescent, or HMI arc lights. The main advantage with continuous lighting is that you can see exactly how the light falls onto the subject (although most strobes have modeling lights that work in a similar way). The drawback is that tungsten lights are very hot, use a lot of power, produce less light than strobes, and create a yellow color cast (although this is easily fixed in editing software). Fluorescent and HMI lights produce less heat and more light, making it more comfortable for the models; although they can end up squinting under constant bright light.

Strobes: A strobe light is a studio light that produces short flashes of light (around 1/1000th second)—thus capturing fast movement. It has a daylight color temperature. Strobes are popular with professional photographers because they use less power, are safer, and generate more light than continuous lights, and so offer greater creativity.

Backdrops: A backdrop consists of a roll of paper or cloth on a stand. They provide a neutral, flat background in front of which models pose. They are available in a variety of sizes, lengths, and colors.

Reflector: A circular or square reflective surface that is used to redirect light back onto a subject.

Umbrella: Shoot through or reflective umbrellas either diffuse or bounce light onto the subject. They are attached to the end of or at the back of a strobe.

Softbox: Usually a square box that fits over a studio light or strobe. It comprises of reflective back and side walls and a diffuse cloth at the front. It is used to diffuse and soften light falling on the subject.

Octobox: Similar to a softbox but octagonal in shape. Octoboxes also create soft, diffuse lighting but generally they are available in much larger sizes and used for bigger setups.

Beauty dish: A large reflective dish that attaches to a strobe and provides a diffused but directional light that falls away quickly.

Ring flash: A circular flash that fits around the camera lens or a reflective circular dish attached to a strobe. It is popular for creating donut-shaped catchlights in the subject's eyes and for creating a halo-like shadow.

Grid: There's a wide choice of grids available on the market for different types of lights. Grids shape and control the light coming from the strobe and can be used to direct and/or diffuse the light.

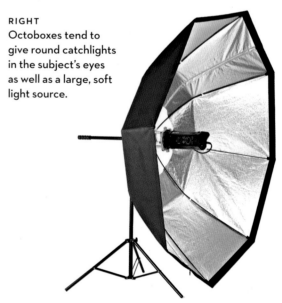

RIGHT
Octoboxes tend to give round catchlights in the subject's eyes as well as a large, soft light source.

HMI LIGHT

An abbreviation of Hydrargyrum Medium-arc Iodide. An HMI uses an arc lamp rather than an incandescent bulb in order to produce light. This makes HMIs cooler-running than incandescent lamps and more energy efficient.

BOUNCED LIGHT

Light that is reflected back on to the subject or scene, rather than being used directly. Bouncing a light increases how diffused it is, creating a softer light and less harsh shadows than direct light. With a hotshoe flash, a common practice is to bounce the flash off a ceiling or wall. With studio lighting, the same effect can be achieved, although if the area you are shooting in is large, a reflector can be used instead. Shooting with an umbrella is also a form of bounced light.

DIFFUSE LIGHT

A softened light that typically gives more even coverage and less shadows. Softboxes, umbrellas, beauty dishes, and reflectors all help diffuse a light, as will shooting through a gauze or mesh scrim.

Snoot: A snoot is a tube that fits over a strobe and makes a circular light beam on your subject; it is used to prevent light spill.

Barndoors: Barndoors comprise four adjustable doors that fit over a studio light and allow you to control where and how the light falls onto your subject or scene.

Gobo: A Gobo (meaning go between) is a device placed in front of a lighting source to shape or manipulate the emitted light. Gobos are often used on film sets.

Scrim: A strong, collapsible diffusion accessory useful for studio and location shoots. They are available in a variety of sizes and shapes and usually come with frames, so are useful to place above your subject in strong lighting.

Sync cable: A sync cable is used to synchronize the camera to the strobe lights so that they flash when the shutter release is depressed.

Wireless transmitter: A wireless transmitter syncs a camera to a strobe unit or units, but wirelessly, giving the photographer more freedom to move around.

Light meter: A light meter is a device used to measure the amount of light on your subject. The use of these was more widespread with film photography, but remain useful to today's studio photographer in order to set up a scene quickly.

Lightstand: A stand that supports a strobe or continuous light.

Light boom: A boom is sturdier than a normal lightstand and gives you the option to position your light in more creative ways, such as above the subject.

Reflectors

Reflectors come in a wide range of colors.

Gold: Useful for creating a warm healthy glow in images. The best time to use a gold reflector is on-location when there is a strong lighting source. It is also useful when your subject is backlit and you want to fill the light slightly—but not too much! Too much reflection can look obvious and will cast unflattering shadows on the subject.

White: White provides a soft, clean light to your subject and is useful in the studio and sometimes on location if you need to fill shadows. Remember that you need to be close to your subject in order to see the changes.

Silver: The silver side is more reflective than the white side and is great for using in low-light situations outdoors. As with gold, be aware of how much light it gives your subject and use it only to boost natural/other sources of light.

Black: The black side of any reflector is an anti-reflector and doesn't reflect any light at all—in fact it does the opposite. This is useful when you don't want to take light away from your subject.

BELOW LEFT
Ring flashes are popular in fashion photography for the softened shadows and circular highlights they create in the model's eyes.

BELOW CENTER
A softbox is a popular choice for every type of photographer to achieve soft, flattering light.

BELOW RIGHT
Reflectors come in all sizes and colors and are essential for every type of photographer to use in the studio and on location.

FINDING THE RIGHT STUDIO

STUDIOS COME IN A VARIETY of shapes and sizes, with varying amounts of equipment. The size and level of equipment combined with location and additional services, such as internet, bathrooms, kitchen facilities, and so on, will determine the studio's rental price. As a starting photographer finding your first studio rental can be a daunting task. Remember to be realistic: if it's your first shoot, you don't need to spend a lot of money on a large studio that offers anything more than a blank space, a backdrop, and a basic level of equipment.

Research your options

1. Decide what you need: How big a space do you require? What level of equipment do you need? What sort of facilities will you need? Is accessibility an issue?

2. Look at online reviews: Without any previous experience, consumer reviews are the best way of figuring out if the studio is right for you. Websites such as YELP (www.yelp.com) review services in detail and can help you make a decision.

3. Read reviews from other photographers: Many photographers share their experiences from studios they love. If there are photographers that you know or you admire, then there's no harm in asking for their recommendations!

4. Don't be afraid to ask if you can look around: Studios want your business, so ask if it would be possible to visit them.

Renting photo equipment

Renting photography equipment is a cost-effective way of using professional lights, cameras, lenses, or other equipment for a one-off project or photoshoot. Many photographers rent equipment simply because they can't justify the cost of owning it outright. For example, buying a medium-format camera with a digital back would be pointless if you're only going to use it once a month.

One disadvantage of renting is that most companies require a deposit (usually equivalent to the cost of the equipment) before renting and/or a credit check.

EQUIPMENT RENTAL CONTACTS

- **Calumet** www.calumet.com (US and Europe)
- **CSI Rentals** www.csirentals.com (US)
- **Adorama** www.adorama.com (US)
- **Peartree** www.peartreerental.com (UK)
- **Pro Centre** www.procentre.co.uk (UK)

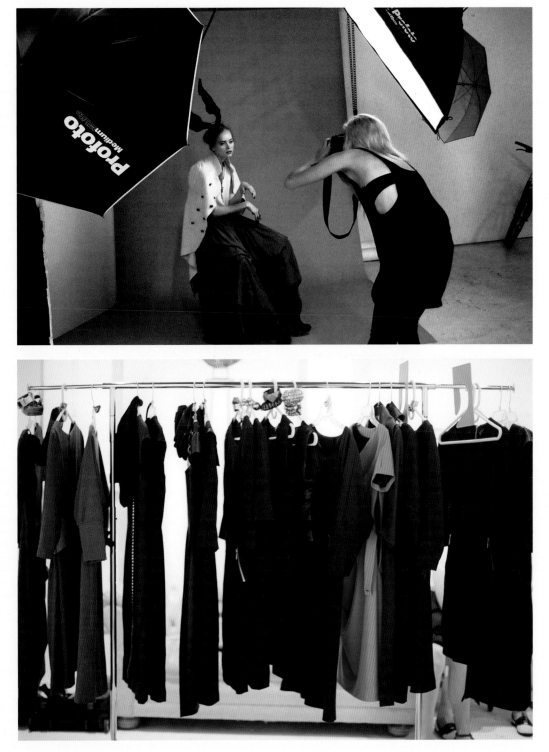

LEFT
Studio requirements depend on what you need on the scheduled day. Smaller shoots, such as this editorial shoot I did, only need a certain amount of space.

"Velveteen Rabbit" editorial shoot, Brooklyn NY, 2011.
Photo: **Nicole de Waal**

LEFT
As the creative director of many of my own personal shoots and contributing creative director of my editorial shoots I play a big part in helping chose the styling and garments used. In this studio in Brooklyn our stylist Kim Johnson was more than happy to have me lend a hand in choosing the clothes—in the end, we were both extremely happy with the results!

When working with a large editorial team, you may want to consider the facilities that are available in the studio to them—such as a dressing room, steamer (for clothing), mirror and adequate lighting to complete styling work in.

NY campaign for The Fold clothing.
Photo: **Kait Robinson**

SETTING UP A HOME STUDIO

A SUCCESSFUL STUDIO doesn't have to be a large commercial work space—it can be as simple as a spare room at home with a studio backdrop and some basic lighting equipment. Photographers often forget that when it comes to making interesting and memorable photographs, creative ideas and a good eye count for much more than a studio packed with equipment.

Space: Although you don't need a vast amount of space, your home studio should be big enough to allow you to work comfortably with your model. Paint at least three walls white (but if you have walls with strong textures such as brick or wood and/or colors, leave one untouched as it could make for an interesting alternative backdrop). White will allow light to bounce off easily and act as your studio background if you don't intend to use backdrops.

If your intention is to replicate a professional studio and you're planning to use it to shoot clients having their portrait taken then you need to think about the appearance of the studio and how accessible it is. If the studio is part of your home you may want to think about separate access so clients can visit the studio without interrupting your home life. Additionally, you should consider getting chairs, perhaps a fridge and kettle, and creating a separate area for makeup and styling. Also remember models and clients may need to use the bathroom, so ensure that you have one that is easily accessible.

Lighting: Lighting is just as important in the home studio as it is in a professional one. However, you're unlikely to be able to afford all the lights and accessories you want straightaway, so for most starting photographers it's a case of buying a basic starter kit and adding to it as you go. Although the temptation may be to go for a less expensive brand that offers more in the way of equipment, this may in fact be a false economy, as the equipment will be of inferior quality compared with known brands such as Elinchrom, Bowens, and Broncolor, and not last anything like as long. Better to start off with good-quality lights and accessories—just fewer of them.

Natural light studio: If money is very tight, you can always begin with a natural light studio. Window light is great for portraits, just make sure your window or windows are close enough to the backdrop so that enough light spills onto your subject, but far enough away to give you enough space to shoot.

A good starting kit: If you have got a bit of money to spend on lighting, first decide whether continuous or strobe (flash) lighting is more appropriate for your needs (see pages 56–67), and then follow the guidance here for the sort of equipment you should think about obtaining. This section ends with popular lighting setups and will give you a good idea as to what you can achieve with just one or two lights.

START-UP KIT SUGGESTIONS

- 2 lighting heads (strobe or continuous) with stands
- 1–2 umbrellas (silver/white)
- 1 medium softbox
- 1 gold/white reflector
- 1 sync cable/wireless transmitter
- 1 backdrop stand with white backdrop

Suggested additional equipment:
- 1 stepladder (to shoot at different angles)
- Props/clothing rack
- Boom arm for more versatility when positioning lights

As you develop your own style of photography, you'll find that experimenting with some of the other equipment covered earlier will help to achieve the results you want.

CONTINUOUS LIGHTING
Continuous lighting uses a constant light source to light the subject, which means that your lamps will remain on during the whole shoot. It is particularly useful for beginning photographers as it offers easier anticipation of where light and shadow will appear in photos, is easier to set up, and is typically less expensive.

RIGHT

The common confusion with home studios is that you need an extensive light and accessories kit in order to successfully shoot—this isn't true! Some of the best photographers are known for their technical simplicity. Here I used my apartment wall and one light (with a medium-sized softbox) at medium power, placed slightly to the right of my subject and looking down, to flatter the highlights on her skin.

"Joan Of Arc" for *SHEER Magazine.*

Model: **Daniela @ Re:Quest Models NY**

Makeup: **Deborah Altizio @ Agent Oliver**

Hair: **Lydia O'Carroll**

Styling: **Deborah Ferguson**

ABOVE LEFT
**Canon 5D MKII
ISO 100
f/16 1/200**

ABOVE CENTER
**Canon 5D MKII
ISO 100
f/14 1/160**

ABOVE RIGHT
**Canon 5D MKII
ISO 100
f/16 1/200**

FAR LEFT
**Canon 5D MKII
ISO 100
f/16 1/200**

LEFT
**Canon 5D MKII
ISO 100
f/16 1/200**

LIGHTING SETUPS

**Photos: Images in
this series courtesy of
Thomas Cole Simmonds
(www.tomsimmonds.com).
Model: Stephanie Linda
Pause**

FILL LIGHTING

A light used to "fill in" shadows rather than provide the overall illumination. The fill light can be a lamp, or simply a reflector that is used to lighten shadow areas.

IN THIS SECTION I'm going to cover various vital lighting setups that every photographer should be familiar with. Understanding lighting setups is essential in the studio. Experiment with lights whenever you get the chance to see how different setups impact on your images— that way you'll improve your lighting technique.

Portrait setups

Portrait lighting setups are the best practice for beginners to learn and something established pros perfect. As portraits require simplistic light to bring out the best in the subject, it's important to understand what accessories we need to use to enhance and shape the light.

HIGHLIGHT SETUP

To give the subject more form and to visually pull them from the background, add one more accessory to the mix. Introduce a white reflector to the other side of the subject—this will reflect the light from your main source back to your subject. Place the reflector at the same angle to the subject as the softbox.

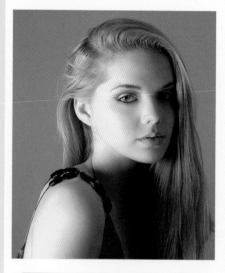

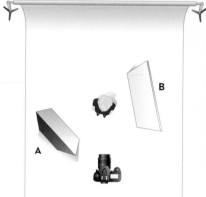

A Position your softbox in the same way as the portrait shoot.
B Add a white reflector to the left/right hand side to "bounce" the light back and slightly highlight your subject. It will also remove shadows so the light is balanced in the frame.

ONE SOFTBOX

When lighting my subjects, I often only use a single light with a softbox. This simple, uncomplicated setup provides light that is soft and flattering. A softbox is a versatile tool that can be used to create both the key (principal) light and fill light. I usually place the softbox to the left of my subject, and facing down at a slight angle so that the light falls softly on the subject's features.

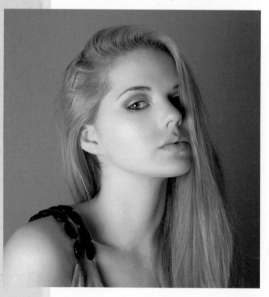

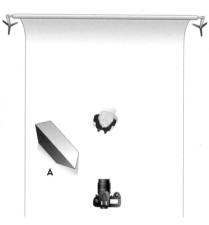

A Place the softbox to the left/right of your subject.
B Change the angle of the head of the light so it's facing down at your subject, and the height is slightly above them.

ADDING CONTRAST

Placing a black reflector on the right side (as opposed to a white reflector) has the opposite effect. The dark color absorbs the light and prevents it bouncing back onto your subject. This is useful if you only want one side of your subject lit to create extra contrast.

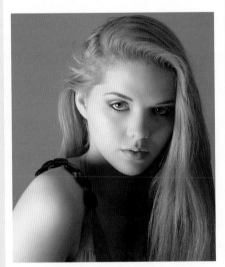

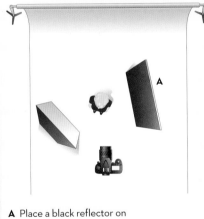

A Place a black reflector on the right side.

FOR EVEN GREATER CONTRAST

To create a more dramatic scene, surround your subject with black material to prevent light bouncing from the walls of the studio or room. You can do the same thing but with white to get a high-key result.

A Surround your subject with black material.

TIP
Take it to the next level by adding a black gobo or reflector for the yellow light, to manipulate the shape of the light!

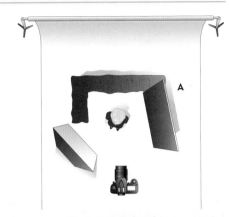

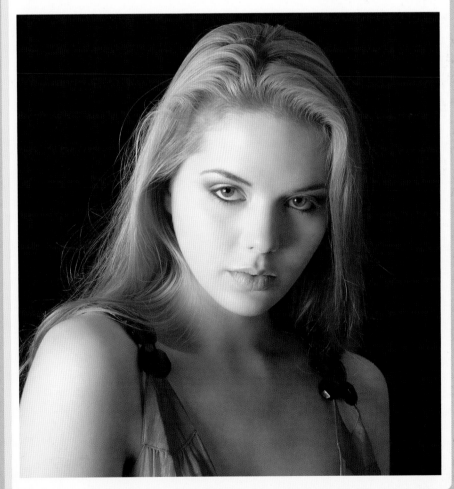

GETTING CREATIVE

Adding different colored gel lights can create interesting backdrops. In order to clearly see your colors you need to consider your background color (black, white, and colored backgrounds will change how colors are seen) and how you can balance the light source to work with your intended subject. In this diagram the softbox provides the key light. The red light is lighting the backdrop only, and by adding the black reflector this stops the red from spilling onto my subject. The yellow light is slightly spilling onto my subject from behind, adding color to the back of my subject's head and helping light the background.

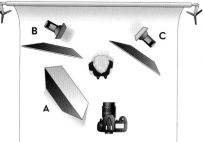

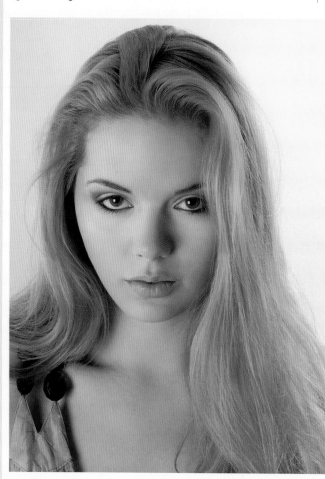

A Add your main source of light (the use of the softbox works well here) by placing it slightly to the side of your subject and on an angle facing down toward them.

B Add each colored light and test the effect, before creating the whole setup. Introduce one color first (red light, if desired) onto the background. This will be your "background color."

C Now add your second light, which will highlight your subject (yellow works well here. This will create the effect of the scene being divided into two colors, and the light spilling onto your subject.

TIP
Experiment with colored lighting to try out different combinations of contrasting color—red/green, yellow/ blue. You should also consider how the lighting will enhance the clothes and styling and whether it works with your overall theme.

KEY LIGHT
The primary light in a lighting setup, which is providing the overall, or "key" illumination on the subject and usually creating the most distinct shadows.

SIMPLE CLEAR PORTRAIT WITH UMBRELLA

Use a reflected silver umbrella with a white backdrop if you want clear detailed high-key images that show the subject's features. Try adding a white reflector to the right of your subject to reflect the light back onto your subject for more even lighting.

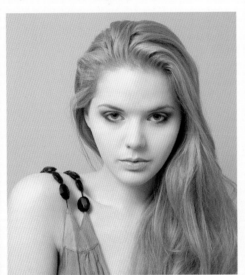

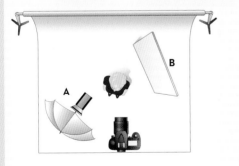

A Set up one light with the head of the light facing away from the subject and the silver umbrella open toward the subject.
B If needed, add one reflector to the right of your subject at an angle to help them stand out against the background.

BEAUTY

Beauty photography uses clear lighting to emphasize the makeup, styling, and model's features. Most is classed as high-key, as the lighting is bright and low contrast. In this diagram the beauty dish is our only light source. It is face-on to the model and angled slightly downward to diffuse any shadows. Try using white reflectors to create the ultimate light box—this way the subject is evenly lit and shadows eliminated.

TIP
You might want to consider adding a simple hand-held gold or silver reflector underneath your subject's face (at a flat angle) so the light reflects away shadow under the face.

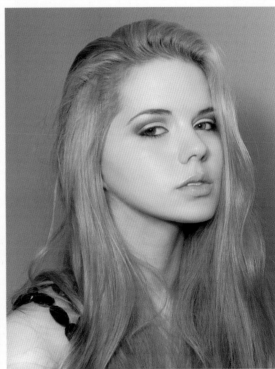

A Add a beauty dish onto a single light facing toward your subject. For a more flattering light make the light higher than your model's height and then angle the light head down toward your model.
B Add a white reflector around your subject for the light to bounce back at them and highlight areas of the face (this is handy for diminishing unwanted shadows).

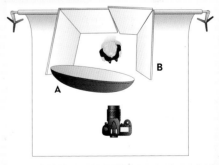

LIGHTING SETUPS

Backlit setups

Backlit setups make for beautiful and visually dramatic images. I am constantly shooting with backlit scenes on location and always attempt to recreate the look in the studio.

SIMPLE BACKLIT PORTRAITURE

To add a boost to a standard portrait setup, include a second light hidden behind the subject. Please note that this setup works best for close-up portraits as the lightstand is out of the frame. When working with two lights, experiment with the different levels of light emitted from each head to see if you prefer a stronger backlight or stronger main light.

A Add your main source of light to the side of your subject.
B Add a second light hidden behind your subject.

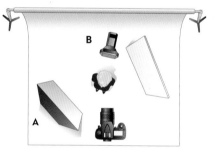

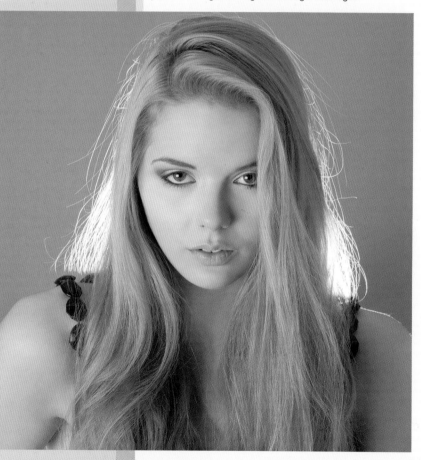

TIP
Don't be afraid to have the lightstand visible in the images, especially if you want a stronger flare coming through. The lightstand can always be removed afterwards by using the Clone tool in Photoshop.

SIMPLE RIM LIGHT SETUP

Here's a simple rim light setup. The light to the right is lighting the side of the subject and pulling them out from the background, and illuminating their outline. The softbox on the left acts a fill-in light and flatters the subject. Experiment with different levels of light on both heads. Also try including a second light to add a rim from behind your subject or to the opposite side.

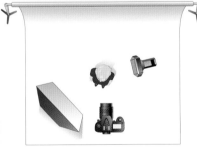

Always make sure your model is aware of the key light so that they know where to pose and how they are going to look their best within their space. If you have more than one light, this may confuse your model so it's a good idea to tell them where the light works for them. If the light works better with their chin up, or turned slightly to the left, then tell them!

ADVANCED RIM LIGHT

Here is a more advanced rim light setup for added drama. The light on the left is shaped so that it doesn't fall on the subject's face—it is purely lighting the subject from behind (and also the background, if needed). The strip lighting on the right-hand side is lighting the subject, and creating an ethereal glow or flare. Finally, the reflector in front of the subject is adding light to the subject's face if needed. Getting the subject to face the strip light is great for capturing the profile.

A Shaped light placed the subject's left.
B Strip lighting placed on the subject's right to create a glow or flare.
C Reflector placed in front to add light to face.

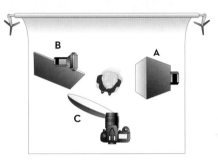

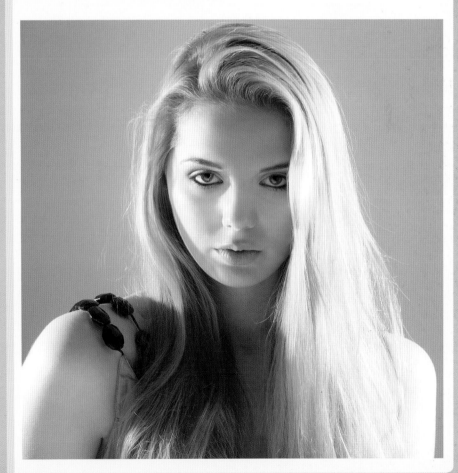

LIGHTING SETUPS

Natural light in the studio

Working with natural light in the studio is a great way of making use of one of the most beautiful sources of available light and provides results that are almost impossible to replicate with artificial light. Some of the biggest names in photography favor using just natural light on plain backgrounds and get stunning results!

If you're looking to achieve a soft focus in your images and favor using a wide aperture then this is something you should try. Some of the biggest names in the photography industry use this setup and are able to create stunning results. Here are a few natural light suggestions . . .

NATURAL LIGHT AND REFLECTOR

If your natural light source is to one side of your subject (best very early in the morning or later on in the day when the sun is low) you could try boosting the light by adding a gold (warm) reflector. This will create more even lighting and add warmth to the shot.

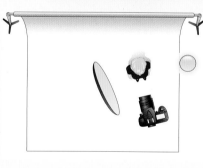

TIP
When working with reflectors, introduce the light subtly. If you reflect too much light you'll create unflattering shadows.

ONE SOFTBOX

Try enhancing natural light with the use of reflectors. This simple setup features two white reflectors at either side of the subject to bounce the light back. You may also want to consider boxing your subject inside a white box for a high-key image.

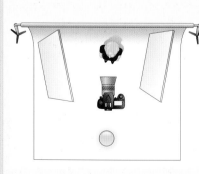

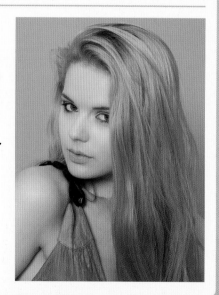

Combining natural and studio light

SOFTBOX AND NATURAL LIGHT

Another way to balance natural light is to add an artificial light source. In the diagram, the natural sunlight is lighting the model from the side but the softbox is my main source of light, creating a rim lighting on my subject. The sunlight fills in potentially unflattering shadows.

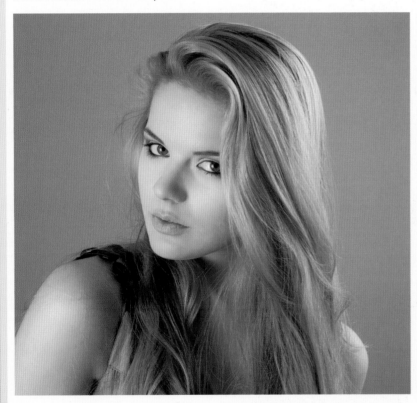

TIP
When combining natural and artificial light you may end up with an unusual color cast. To fix this either use a gray card to set a custom white balance or use Auto. Remember, if you're shooting in Raw, this can easily be adjusted later in editing software.

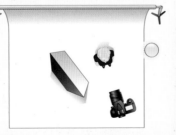

OVERHEAD LIGHTING

When working with groups or single-subject images, overhead lighting can be a powerful lighting technique to work with. This particular lighting source is great for capturing dramatic scenes, since the lighting source is angled down at your subject's face. When working with overhead lighting, consider how you may want to shape the light. Large softboxes or octoboxes work great since they diffuse the light, but you way want to opt for something more dramatic or powerful such as a large beauty dish or a snoot. Since you're working with strong overhead lighting, you may want to consider using other accessories, such as reflectors, to reduce shadows on clothing or your subject's features.

SHOTS WITH PROPS

As well as wardrobe styling, themed shoots strongly rely on the use of props (such as stage or wardrobe props) to emphasize a certain mood or feeling on-set. Set designers and prop makers are the people to call when working on a client shoot. However, when you're working with a budget you may want to consider your options—there are many recently graduated set designers or artists that are willing to work on a test basis for their portfolio! Try looking at online advertisements for recent graduates, or artistic individuals looking for a break! Model Mayhem (www.modelmayhem.com) may also have artists listed.

 If you're interested in gathering props yourself (like I usually am) then search local flea markets, thrift stores or charity markets. You'll be surprised by what you can find!

5 SCENARIOS

'50s Shoot for
Content Mode
(www.contentmode.com).

Model: **Te'sa @ Wilhelmina
Models**

Makeup: **Jen Myles**

Hair: **Anthony Nader @
Atelier Management**

Styling: **Deborah
Ferguson**

**Canon EOS 5D MKII
ISO 800
f/1.2 1/50**

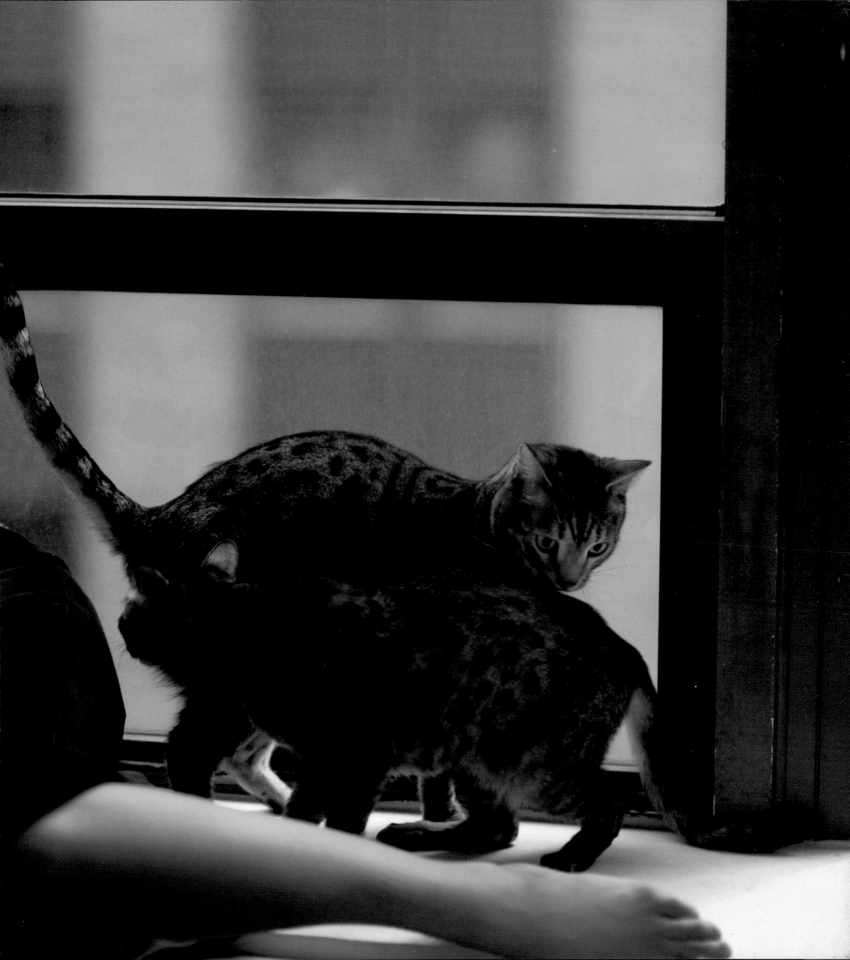

EDITORIAL

A FASHION EDITORIAL SHOOT is a photoshoot that is published in a magazine, newspaper, or some form of online delivery, usually to accompany a story or article. In this respect, editorial shoots differ from advertising campaigns in that there's often a strong sense of narrative running through the series of images (although this could also be said of the more creative advertising campaigns).

While on the one hand it's important in an editorial fashion shoot that the clothes are captured in their best light—most photographers place more emphasis on the clothes than on the concept of the editorial—the most successful editorial shoots capture both the essence of the clothes, and also work creatively to illustrate the story.

Although as a fashion editorial photography is not hugely rewarding in purely financial terms, as you are not going to get paid very well to shoot an editorial story, it can be invaluable in terms of exposure. Your images could end up on the covers of some of the biggest magazines. Shooting editorials will give you experience and help grow your portfolio, both invaluable things to working photographers who wish to move into campaign and commercial work.

What makes a good editorial story?

An editorial shoot needs to be cast very well in terms of the model and styling, and the concept of the editorial—its story, if you like—should be clear to everyone involved. I cannot stress enough how important a creative team is to a photographer when shooting an editorial, as the success of the photoshoot relies heavily on the styling.

When you photograph an editorial story, framing and shot variation are very important. In terms of layout, you should be shooting most of your images in portrait format, and then one or two ideas in landscape, which you can run across a double-page spread. One thing to watch out for is to avoid putting the subject of an image in the center, as if the shot is featured in a magazine it will get lost in the gutter.

Planning in advance is vital for any photoshoot, and this is particularly true with editorial shoots, where you as the photographer are investing your time and money into the shoot. Travel arrangements and shoot times should be agreed upon at least two-to-four weeks in advance. Everyone on the team should be briefed and provided with a call sheet stating the meet location, shooting times, team details, contact emails, and phone numbers.

DOUBLE-PAGE SPREAD
A DPS, or a double-page spread, refers to a horizontal image that is used across two pages in a magazine, newspaper, brochure, or other publication.

MOODBOARD
Photographers, designers, and other creatives use moodboards to develop their design concepts and to communicate to the rest of the design team. This could be a physical pin board, a shared digital space like a Google Docs document, or a Facebook wall.

ALL RIGHT
The "Birthday" shoot was an idea brought to life after hearing about *Papercut* magazine's theme. It was their anniversary issue and I immediately had the idea of shooting a playful birthday theme. I thought of the model, Eva, and then the rest of the shoot was organized around the concept. In order to cast the right team members I had to consider who was best suited to the playful theme we were trying to achieve.

I created a moodboard for the photoshoot and a folder of reference images, which I sent out to my creative team. We then worked closely together to create a story and source the right shoot location.

This was a perfect example of successful casting. The model, Eva, had acting experience and would act out her role during each outfit change. That way, the stylist Janine could more easily and successfully interpret the theme or narrative of the outfit and style for the next shot.

"Birthday" shoot for *Papercut* magazine (www. papercutmag.com).

Model: **Eva Doll @ Premier Models**

Makeup: **Keiko Nakamura**

Hair: **Limoz Logli**

Styling: **Janine Jauvel**

Retouching: **M. Seth Jones** (www.msethjones.com)

Canon EOS 5D
ISO 800
f/4 1/160 sec

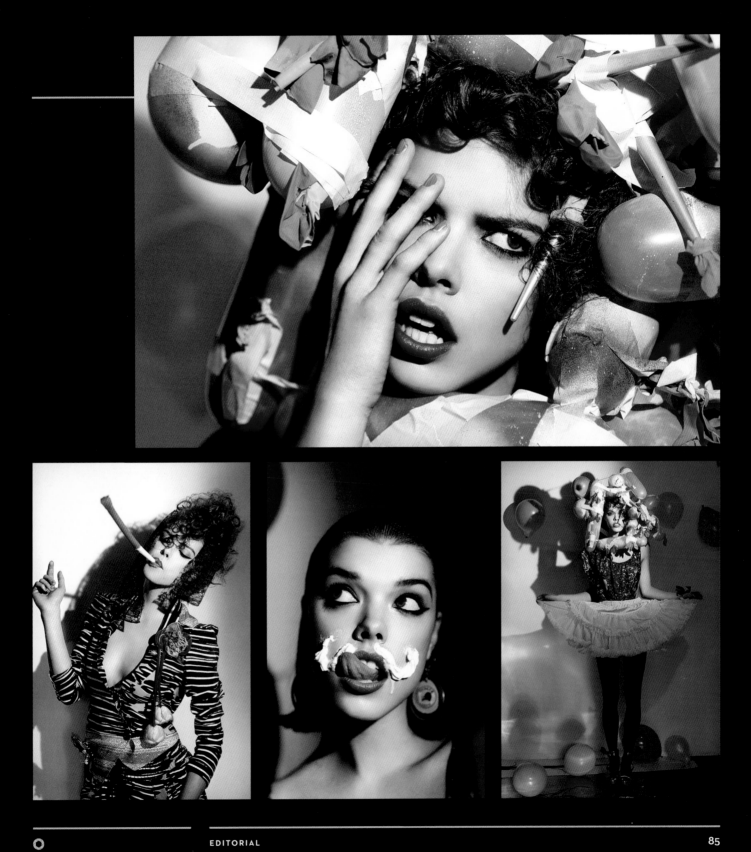

BEATY

A BEAUTY SHOOT is a shoot in which only the model's face is visible—the frame is tightly cropped to emphasize the makeup, hair, or model's expression.

Shooting a beauty shot is challenging, and the photographer always needs to be wary of blemishes and bad light; the aim is to capture a perfect image in perfect lighting that enhances the styling work. If there's a single hair out of place or the makeup is wrong, it will become immediately apparent, ruining the image. Beauty shoots require patience from everyone involved as preparation is key and can take a long time.

As a beauty shot relies heavily on the makeup artist, it is important that he or she has plenty of beauty experience—a good makeup artist will showcase your photography, and in return your photos will be a welcome addition to his or her portfolio. If you are planning on casting a makeup artist, then be sure that he or she understands the requirements of close-up beauty shooting.

"As a makeup artist, a beauty shoot is one of the most important shoots to complete—beauty involves a lot of preparation because it's 'all in the detail.' Preparation is mainly storyboarding, as there are so many ways beauty can be approached. Once an idea is agreed on, then I use the chosen storyboard on the day as a reference while I am working. Although planning is good, improvisation is sometimes used to make small adjustments and can sometimes give the most exciting results!"

**Deborah Altizio,
Professional Makeup Artist, New York City
(www.deborahaltizio.com)**

MODELING LIGHT
This is a secondary, continuous light source that is used to provide a "preview" of the effect the flash/strobe will have.

OPPOSITE, ABOVE LEFT
This shoot was a recreation of vintage portraiture so everything needed to be kept within the era—the casting, the makeup, hairpiece, and even the lighting, which was simply done using the modeling light.

**Canon EOS 5D MKII
ISO 1000
f/1.2 1/200**

OPPOSITE, ABOVE RIGHT
Model Billie was a perfect candidate for a beauty shot with her flawless skin and unique features. The intention was to create something quite atmospheric, even almost supernatural, so we kept everything as simple as possible and let the makeup and styling speak for itself.

**Canon EOS 5D MKII
ISO 640
f/1.2 1/640**

OPPOSITE, BELOW LEFT
Shaded natural lighting is great for beauty shoots because it's very flattering on the skin. Lera was encouraged to keep her chin upwards in each shot for the light to flatter her facial features.

**Canon EOS 5D MKII
ISO 250
f/3.2 1/800**

OPPOSITE, BELOW RIGHT
This was shot with a single beauty dish in the studio—the clear light flatters the model's features and makes this shot slightly commercial.

**Canon EOS 5D MKII
ISO 125
f/10 1/160**

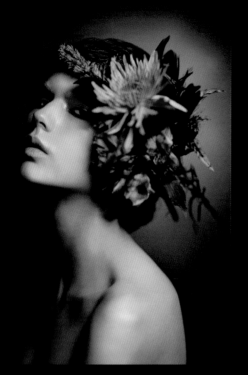

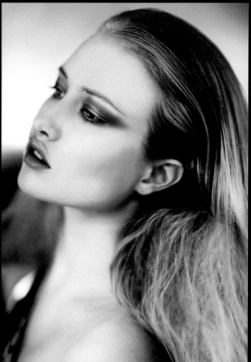

FAR LEFT
Model: **Sonia @ Wilhelmina Models**
Makeup: **Deborah Altizio @ Agent Oliver**
Hair: **Lydia O'Carroll**
Styling: **Aminah Haddad**

LEFT
Model: **Billie @ Premier London**
Makeup: **Keiko Nakamura**
Hair: **Limoz Logli**
Styling: **Ihunna**

BELOW LEFT
Model: **Lera @ FM Agency London**
Makeup: **Leah Mabe**
Hair: **With thanks to Neil Cornelius Hair Salon**
Styling: **Janine Jauvel**

BELOW RIGHT
Beauty Image of Ashlyn
Model: **Ashlyn C**
Makeup: **Deborah Altizio @ Agent Oliver**

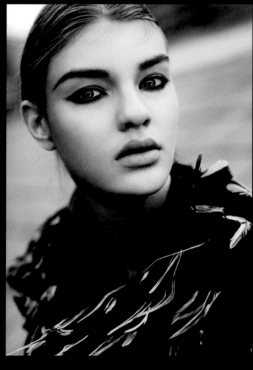

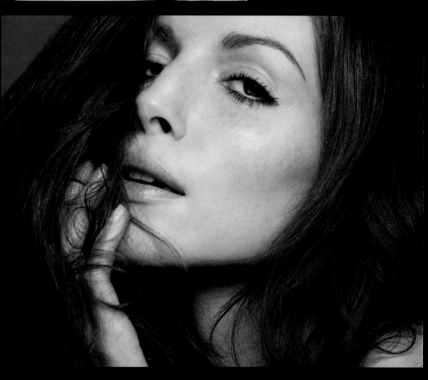

FASHION PORTRAITURE

SUCCESSFUL FASHION PORTRAITURE requires a good relationship with the subjects in order to bring out character, mood, and emotion. Visually, portraiture is often simple, with frames cropped tightly in from mid-body to the face, or from the shoulders to the face.

The subjects of your portraits don't necessarily have to be models, but the way in which they are lit and portrayed will have parallels with general fashion photography—you're looking to bring out the best in your subject and convey a theme.

How do you capture fashion in portraits?

When shooting fashion portraits, the main focus is the clothing rather than the look of the model—the models' appearance only enhances the product. Although this approach is very different from that of a traditional portrait, where the aim is to capture the essence of your subject's personality, you need to remember that in order to get a great fashion portrait, the garment and model need to be lit and styled correctly for the shot to work. Create a story around the garment and use a location and styling to fit it.

What if the subject isn't a model?

Editorial and advertising photographers are often asked to use a certain celebrity or non-model for main fashion features. This is usually harder than capturing a model because you really have to work at posing your subject and bringing out his or her character in order for the shoots to succeed. Many celebrities or known faces are shot by experienced photographers because they understand how to get the best out of people who might not be natural models. The best approach is to keep everything—styling, lighting, and background—simple. This keeps the focus on the subject and helps to showcase his or her personality or character.

CROPPING
The process of removing sections of an image in an editing program to alter the composition of a photograph.

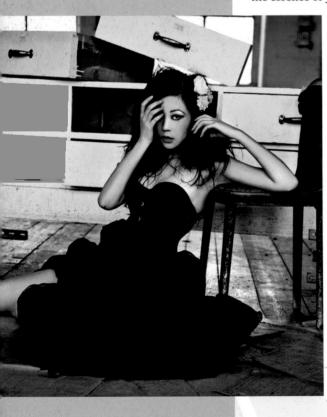

OPPOSITE, ABOVE LEFT
Interesting locations can enhance your fashion portraits—like this field of sunflowers found in North London. Note the relaxed hair and styling that fits with the story created around the garment.

Model: **Agata Mazur**

Makeup: **Keiko Nakamura**

Clothing and Styling: **Kay Desmond**

**Model: Canon EOS 5D
ISO 500
f/1.8 1/1250**

OPPOSITE, BELOW LEFT
This impromptu fashion shoot turned into something magical when we came across this carousel in Brooklyn, New York. When choosing the backdrop to your shoots, research the local areas for interesting locations that you and your team can access easily.

Model and Styling: **Ashlyn C**

**Canon EOS 5D MKII
ISO 1250
f/4 1/640 sec**

LEFT
This old warehouse worked well with the model's attire—mixing the old with the new can lead to interesting visual effects.

Model and Styling: **Nhuc Tran**

**Canon EOS 5D
ISO 500
f/4.5 1/80**

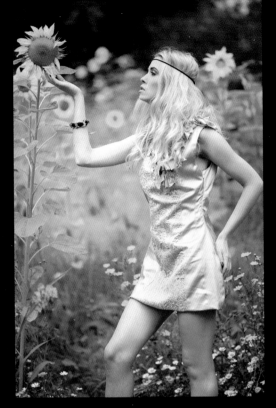

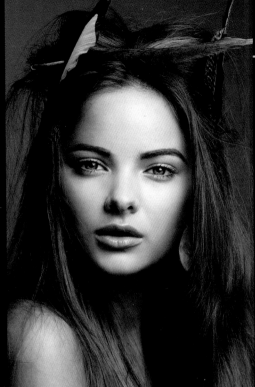

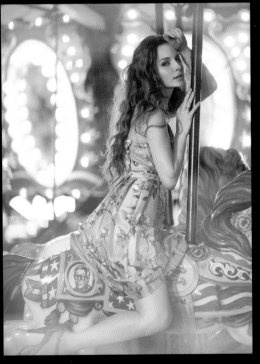

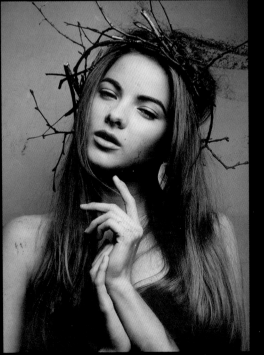

NEAR LEFT
When shooting portraits and casting models, I always look for an interesting appearance or arresting style to boost the visual interest in the image. In this case, the model Anastasia fits the theme perfectly—with her beauty and ethereal style all that was needed was simple soft lighting and a styling accessory.

Model: **Anastasia**

Makeup: **Christie Lee**

Styling: **Lauren Armes**

Canon EOS 5D MKII
f/13 1/160
ISO 400

NEAR LEFT
As this was purely a test shoot, I decided to get slightly more creative and try out some of the stylist's more extravagant headpieces. In this particular shot, everything is the same as it was previously, but the change of headpiece and perspective make the model look more dominant. By changing these simple things she has now transformed from an angelic subject into a strong character.

Model: **Anastasia**

Makeup: **Christie Lee**

Styling: **Lauren Armes**

Canon EOS 5D MKII
f/13 1/160
ISO 400

GROUP SHOTS

WHEN PHOTOGRAPHING GROUPS, it's important to remember the four fundamentals: positioning, clothes, lighting, and camera angle.

It's very easy for group photos to go wrong, primarily because there are so many people to organize. In order to create a successful group shot you should consider your environment and concept. A group shot requires much more styling, and therefore more time to create successful images than an ordinary shoot; planning then is paramount. It is a good idea to plan your concept ahead of time and focus on positioning your models in the studio or location later. When shooting, focus on the individuals rather than the group, then work from that.

As successful group photographs go hand-in-hand with great composition, it's important to consider exactly how you plan to go about photographing your subjects. Your camera angle is very important here; if you're shooting wide, you need to consider how close your subjects will be to the camera so there's no distortion, and you may also want to consider how close you are to your subject. Using a 50mm or 85mm lens might mean that you have to be far from your subjects in order to get everyone in-shot.

Styling is extremely important in group shots because there needs to be an element of consistency. When working with more than two people (especially an odd number) there will need to be an element of similarity—whether this is in the casting of the models to have a similar appearance, or similar clothing, hair styling, and makeup, so that everything ties together.

Photographing groups is particularly intimidating for even the most experienced photographers, but there are a few steps you can take to help you get some successful shots:
• When working on location, planning is key—be sure to scout your location beforehand and figure out whether you need certain lighting to achieve the planned theme. If you're happy to work with natural light, then you will need to consider the time of day you're shooting at, the quality of light, and whether you need accessories such as reflectors to achieve equal lighting across your shot. If you're working with artificial lighting, you need to consider what lighting accessories you will need to light your frame, such as a large softbox/octobox, or two lights.
• When in the studio, consider how you're going to light your group beforehand by testing various light ideas (a perfect opportunity for this is when models are in hair and makeup). A group made up of two or more people may require more lighting or larger accessories and the creative positioning of lights (such as a large softbox placed horizontally instead of vertically) so that the light is equal across your frame and doesn't fall off unevenly at either side of the shot.
• Casting: When casting models for group shots, look at their portfolios to see if they already feature group photographs. If so, do they look comfortable alongside the other models? It's important with group photos to use models who have the right personality and will get on well with other individuals.

OPPOSITE
This shoot was based on the film *The Lost Boys* and was cast according to each model's role. Often when I'm working with groups I place them into a role or story in which they can act. The backdrop was an old cemetery in Brooklyn and enhanced the mood of the shoot.

"Lost Boys" shoot.
Models: **Chloe Norgaard, Romain, and Adin @ Re:Quest Models NY**

Makeup and Hair: **Meagan Shea**

Styling: **Lauren Armes**

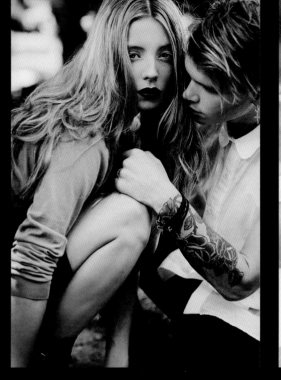

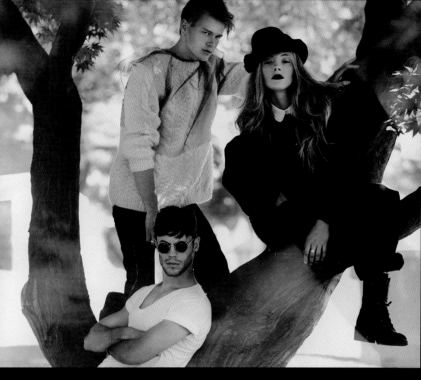

TOP LEFT
Canon EOS 5D
MKII
ISO 200
f/2.8 1/320

TOP RIGHT
Canon EOS 5D
MKII
ISO 200
f/2.8 1/160

ABOVE
Canon EOS 5D
MKII
ISO 200
f/2.8 1/80

RIGHT
Canon EOS 5D
MKII
ISO 200
f/2.8 1/400

ASSIGNMENT

SETTING YOURSELF personal assignments is important no matter what level of photographer you are. Whether you're starting out or an experienced professional, you should always be setting yourself new personal challenges, as these are an effective way to improve your technical knowledge and creative skill.

This section is designed to inspire you as the photographer to go out and shoot self-initiated projects from the tasks I set. It is up to you to interpret them as you want, but use my reference and tips as a guide to help you.

Self-portrait

Challenge: Self-portrait "Alter-Ego"
Time frame: Two weeks
Requirements: Five images
Research inspiration: Cindy Sherman, Frida Kahlo, Diane Arbus, Nan Goldin.

Assign yourself to complete a series of self-portraits to show your alter-ego. Try to create something unique through styling, composition, color, and post-production.

Most photographers prefer to stay behind the camera, so for many of you this may be a challenging and intimidating exercise. In order to be comfortable, use the challenge to figure out something new about yourself and your work! Perhaps try a new concept or lighting idea that you can use later in a client shoot.

When I first started photography I would use myself as a model purely to gain experience and knowledge of how to light and shoot a shot. It enabled me to practice in my own time and also gave me the confidence to put personal emotion into my own work. Even today I see elements of my original inspirations in my fashion and commercial work, so it's definitely an exercise I'd recommend for new fashion photographers.

PHOTOGRAPHING YOURSELF

• Practice holding the camera at arms' length and put your lens on auto-focus: this can be an interesting angle for close-up portraits.
• Use a remote trigger to easily photograph yourself.
• Manually focus your camera where you will be in the photo or on a set object, set your timer for 10 seconds, and then position yourself by the object. Using a relatively narrow aperture, say f/8, will also help to keep you in focus.
• Use a disguise to create interesting concepts. Wigs, makeup, and styling will all add to the mood.
• Through your five photographs try either to develop a concept, or focus on fine detail—this could be a close-up of the clothes you're wearing, or your features and expressions.

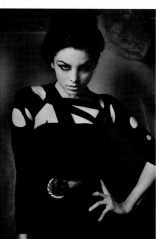

LEFT
Self-portraits 2007—2009. Modeling, hair, makeup and styling all by me.

FROM LEFT
Canon EOS 5D
ISO 400
f/4.5 1/400

Canon EOS 5D
ISO 400
f/4 1/640

Canon EOS 5D
ISO 160
f/2 1/40

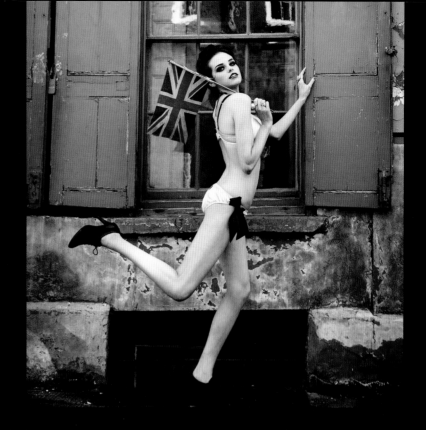

Editorial story

Challenge: Fashion editorial
Time frame: Four weeks
Requirements: 8–10 images
Research inspiration: Richard Avedon, Steven Meisel, Annie Leibovitz, Ellen von Unwerth, Patrick Demarchelier, Helmut Newton.

Put yourself in the position of an assignment photographer who has to create an eight-to ten-page fashion story for a big city magazine. Create a brief for which you must put together a complete plan, including visual reference and storyboard, and cast your creative team and model.

Setting personal editorial shoots is second nature to any fashion photographer and often makes up 60% of a photographer's portfolio. It is good practice to set yourself new editorial challenges so you build your technical knowledge and learn how to work professionally on-set with models and creatives.

PREPARATION

- Set yourself an idea based on your interests. Think about what currently inspires you, and look for further inspiration in books, magazines, or on the internet. Create a story or theme for the images to illustrate.
- Cast your creative team and model. Look at model agencies or on modeling websites to find the right team for your shoot.
- Plan your images and work out the running order. Remember that you'll need a selection made up of full-length and portrait shots and perhaps a landscape image to fill a double-page spread.
- Find a suitable location or studio, and make a visit beforehand or, if this isn't possible, do your research thoroughly so you know how long it's going to take to get there. If on location, have a plan B in case of bad weather or something else going wrong that is out of your control.
- Brief your creative team and model. Send them a call sheet explaining the shoot, and all the practical information they require.
- Make sure all your equipment is ready the day before the morning of the shoot.

ON THE DAY

- Arrive early to make sure the set or location is as you expect.
- Re-brief your team and go through the theme of each image.
- Give yourself a time frame in which to complete each shot and give your creative team a time frame which they have to style the model.

POST SHOOT

- When selecting your images, think about how the shots work together. Remember you want shots that complement one another and give the shoot a narrative.
- Make sure there's a good selection of garments—this is what fashion is all about after all!
- Once you've assessed all of your images, place your final selection together for post-production. Keep in mind that your retouching needs to complement your shots (don't over-do the retouching) and be sure that you can still see the details in the clothing.
- Once your shots are complete, put them all together in a magazine format to see how they flow.
- Use a disguise to create interesting concepts.
- Above all, have fun! Experimentation is about learning and having fun in the process.

Uliana for *FAINT Magazine*
(www.faintmag.com).
Model: **Uliana @ Storm
Models**
Makeup: **Leah Mabe and
Keiko Nakamura**
Hair: **Tomoyuki**
Styling: **Krishan Parmar**
Retouching: **M. Seth Jones**

BELOW FROM LEFT
Canon EOS 5D MKII
ISO 125
1/200 f/9

Canon EOS 5D MKII
ISO 125
1/160 f/8

Canon EOS 5D MKII
ISO 125
1/200 f/9

COMPLEMENTARY COLOR
Complementary colors are
those colors that work well
together. They are often found
180-degrees opposite each
other on a color wheel, and
when used together give a
naturally pleasing contrast that
enhances the quality of both
colors and creates harmony in
the image.

ASSIGNMENT

Color portrait

Challenge: Color portrait
Time frame: Two weeks
Requirements: Five images
Research inspiration: Tim Walker, Sølve
Sundsbø, Greg Kadel, Craig Mcdean, Steven
Klein, Guy Bourdin.

Color will have a big impact on portraits and
fashion stories—the wrong color choices can
make or break a shoot. In fashion, color blocking
(grouping complementary colors together) can
be used to push color boundaries while holding
a theme together. In this challenge assign
yourself to shoot five images that mix color and
style in a creative way—whether this is in the
wardrobe, makeup choice, subject matter,
lighting color/saturation, or even the color of
the background. Most importantly with this
challenge, think about the colors that inspire
you and how you see them working together.
You may want to think of a theme that will tie
your ideas together, or you may just want to
experiment purely with color on its own.

PORTRAIT SHOOTING

• Research color theory and see how certain
colors work together—think about how they
could complement each other in your portraits.
• See how others have used color in portraits and
fashion stories—it may surprise you to discover
how certain colors and styling mix together.
• Think about our responses to color and how these
could relate to your theme. For example, red for
danger/anger, green for rebirth, white for innocence.
• Note that your choice of lighting is important in
order to record your colors correctly. Artificial
lighting and natural lighting both capture colors
differently because of the variable color cast they
can produce. Use your camera's white-balance
settings to counteract any color cast, or shoot Raw
and adjust the white balance in post-production.

BELOW
This shoot was a self-initiated assignment (as I
often do with fashion photoshoots) and was shot
with a specific theme in mind. I wanted to create
a contrast of dark styling with fun elements, so the
shoot was organized around those keywords and
cast accordingly. After the shoot was finished and
retouched, I submitted it to the editor of an online
magazine since it fit their monthly theme. This is
often called "shooting for spec."

"A day in the life" doesn't have to be a documentary style shoot—you could consider shooting a fashion story with a set character playing a role. For example, in this set of images my model Te'sa was playing the role of a '50s housewife living in the financial district of Manhattan.

'50s Shoot for Content Mode.

Model: Te'sa @ Wilhelmina Models

Makeup: Jen Myles

Hair: Anthony Nader @ Atelier Management

Styling: Deborah Ferguson of Content Mode

A day in the life

Challenge: Documentary project: "A Day In The Life"
Time frame: One month
Requirements: Ten images
Research inspiration: Steve McCurry, Elliott Erwitt, Dorothea Lange, Mary Ellen Mark, Sally Mann, Henri Cartier-Bresson.

In this challenge, I hope to impress upon you the importance of drawing inspiration from other genres of photography. As fashion photography is a mixture of many different forms, challenging yourself by shooting in a different genre will help you to develop skills and knowledge in composition and style.

Think of someone whose job you find interesting and photograph him or her at work. This will help you gain confidence working in an environment and capturing a story you're not familiar with. The main inspiration for this challenge comes from the old masters of documentary photography. Research to see how they captured their subjects—you'll find that all of them have a personal documentary style.

- Pay close attention to how photographers prefer to work. Some shoot in a detached, observational way, while others like to set up situations.
- Be respectful of your subject and their environment. Figure out when it is best to shoot and how long you can photograph them for.
- Shoot a lot of images from different angles and viewpoints. The more images you shoot, the more likely it is you'll catch the decisive moment.
- If pure documentary photography doesn't inspire you, then try to put a fashion photography perspective on the shoot. Think about how you would shoot if it was a model in front of your lens.
- If you're setting up a scene, try not to make it too obvious. The unexpected moment usually makes for the most interesting images.
- Many street photographers have the camera set up in manual mode so that they can take photos instantly. Work at a set distance from your subject (say 10 feet) and set your lens to manual focus at this distance. Next, in manual mode set a narrow aperture (and appropriate shutter speed for the light) that will cover a wide depth of field. Now you can shoot quickly as the camera won't refocus and set the exposure with every shot.
- Shoot "from the hip" style photos. Remember, if you are capturing unexpected moments you want to remain as discrete as possible.

FROM LEFT
Canon EOS 5D MKII
ISO 1600
1/60 f/2

Canon EOS 5D MKII
ISO 400
1/640 f/1.2

Canon EOS 5D MKII
ISO 640
1/640 f/1.8

5
THE WORKING **PHOTOGRAPHER**

NY campaign for
The Fold clothing.

Models: **Caroline Codd @ Wilhelmina Models and Maritza**

Makeup: **Jenny Kanavaros @ Agent Oliver**

Hair: **Alexander Tome**

Styling: **Erin O'Keefe**

Canon EOS 5D MKII
f/8 1/6400
ISO 800

WORKING WITH CLIENTS

IN ORDER TO BE A SUCCESSFUL fashion photographer, not only do you have to be great with a camera, but you also need to be able to work closely with people. Every part of a fashion photographer's job involves mixing with other industry professionals or new clients, so it's important to remain positive, patient, and inspired by what you do so that you can deal with the demands of your job.

The shooting style of fashion photography is varied, so the people you work with will be varied too. Don't be too shocked if you get approached by certain individuals asking you to work with them on a job you wouldn't usually do. Sometimes photographers get booked because the art director of a magazine loves a certain photographic style, or simply because they were in the right place at the right time.

At the end of the day, photography is a job to most of us, and not all of our jobs are going to be the most enjoyable—but they are what pay the bills. It is your choice whether such shoots go in your portfolio, but paid-for shoots are what keep us going and help us fund the shoots from which we can make a great portfolio—it's the nature of the game!

Tips on how to work successfully with clients

Have a positive attitude. Having a positive attitude on-set can work wonders—it makes clients and creatives enjoy working with you.

Be confident. Show that you know what you're doing. If you're confident about your technical skill and what you can produce, you're half way to pleasing your client before they even see the final result.

Give feedback. Depending on the job, you should always inform the client when things aren't going right and when they are. If a job's not running smoothly be prepared to try a different approach.

Be resourceful and versatile. If something isn't working then you need to think on your feet and put things right immediately. For example, if it rains on a location shoot, then put into place a second option. The main thing is to stay calm and not to make anyone panic. The clients need to believe the shoot is worth their investment and time.

Listen. One of the most important things is to listen to your clients—they know what they want. If you don't agree with their concept, then politely suggest a different direction and remind them of your experience in doing what you do.

Don't be too insistent. If a client doesn't want to do something, don't force them to do it!

Get a contract. Having a contract will help clarify any issues or disagreements later down the line. This is an essential for wedding or similar jobs where you've been booked directly (rather than through an agent or ad agency for example). A contract should cover such things as number of images, how they will be used, provision of prints, and also how much your deposit and final payment is.

If there's a problem, then offer an alternative. Not all clients are going to be happy with what you do. If there's something you can do to resolve a situation then do it—you want to be seen in the best light even in bad situations.

Client meeting

When you're working on an important job with a large budget or a shoot that is heavily reliant on you, you'll usually find that the client will want to meet beforehand. Dependent on the job, you'll be expected to meet and discuss the arrangements prior (usually a few weeks, sometimes a few days) to shoot date.

Instigating a meeting yourself with your intended client is great if you require a level of personal engagement from them—for example, if you're shooting their wedding, engagement party, children, or even their portraits. Meeting people face to face usually helps them to trust you before the day of the shoot and gives them the opportunity to ask questions they wouldn't have asked via email or over the telephone. It also helps you, as the photographer, to get to know your client better and how they're likely to behave on the day of the photoshoot.

Often shoots are organized with clients who are located all over the world, so sometimes it's not possible or necessary to meet the client in person. With the world of digital media, Skype and email make this possible! We organized this shoot through email—all of the casting, location and reference ideas were approved beforehand by the editor of *Papercut* magazine and the shoot was set!

"Last Rose Of Summer" for *Papercut* **magazine.**

Model: **Tegan @ Storm Models**

Makeup: **Amy Sachon**

Hair: **Tomoyuki**

Styling: **Ihunna**

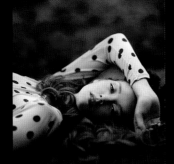
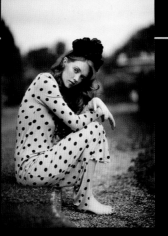
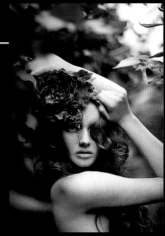
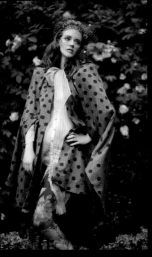

TOP LEFT	TOP CENTER
Canon EOS 5D MKII	Canon EOS 5D MKII
ISO 250	ISO 250
f/1.2 1/8000	f/1.2 1/5000

TOP RIGHT	RIGHT CENTER
Canon EOS 5D MKII	Canon EOS 5D MKII
ISO 800	ISO 250
f/1.2 1/3999	f/1.2 1/640

NEAR RIGHT	FAR RIGHT
Canon EOS 5D MKII	Canon EOS 5D MKII
ISO 250	ISO 1000
f/1.2 1/640	f/1.2 1/80

WORKING FROM A BRIEF

WHEN YOU ARE COMMISSIONED by a client, you will often be provided with a work brief—this is a set idea or other visual reference that you will need to work to. A work brief will usually consist of some or all of the following:

• Visual references/inspiration.
• Sketches of the scene or idea.
• Model cards or photographs of models; potential creative people.
• Styling options.
• Brainstorm ideas based on location, styling, and or theme.
• Proposed date/location or ideas.

As a fashion photographer working on a magazine editorial, the magazine editor or creative director will assign you a theme for the shoot. The commissioned idea will be discussed beforehand with the team and there will be follow-up meetings and discussions so that everyone involved is clear on how the theme will be interpreted and created on the day.

As the photographer, it's your job to interpret exactly how you foresee the set idea in a fashion photograph. On most photoshoots you are booked for your visual interpretation and creative eye, but sometimes you can be booked to shoot a job at the last minute and you may just be there to complete a technical brief for a simple idea.

It is important that the creative team, client, and anyone else closely involved in the project feels confident that the shoot idea is understood and that they will get results on the day. Remember that it is not uncommon for the original set idea to morph into something else—there are a number of factors for last minute changes, including budget and a disagreement of ideas.

OPPOSITE
When you're working with a brief (like this particular lookbook created for NY/London office clothing brand The Fold) it's important that the client stays up to date every step of the way—from the first initial meeting, to the references, then later the casting and even when the client is on-set the day of the shoot. Not only is this going to make everything run a lot quicker—it's also going to be better for the client to see mistakes firsthand so that you can avoid reshoots and major adjustments in post-production.

Lookbook for The Fold.

Models: **Caroline Codd @ Wilhelmina Models and Maritza**

Makeup: **Jenny Kanavaros @ Agent Oliver**

Hair: **Alexander Tome**

Styling: **Erin O'Keefe**

OPPOSITE, ABOVE LEFT
**Canon EOS 5D MKII
ISO 800
ƒ/8 1/1000**

OPPOSITE, BELOW LEFT
**Canon EOS 5D MKII
ISO 250
ƒ/4 1/320**

OPPOSITE, FAR RIGHT
**Canon EOS 5D MKII
ISO 200
ƒ/7.1 1/400**

MODEL CARDS
Also known as a Z-card or "comp card," a model card will have a shot of the model, along with their name and physical details. Fashion photographers often also have their own Z-cards to use as a marketing tool.

TIP
If you're unsure of what is required from the brief you have been given, it is better to check with the client immediately before proceeding with the organization rather than adjusting things later on. The client will appreciate the honesty, and you will save time doing so.

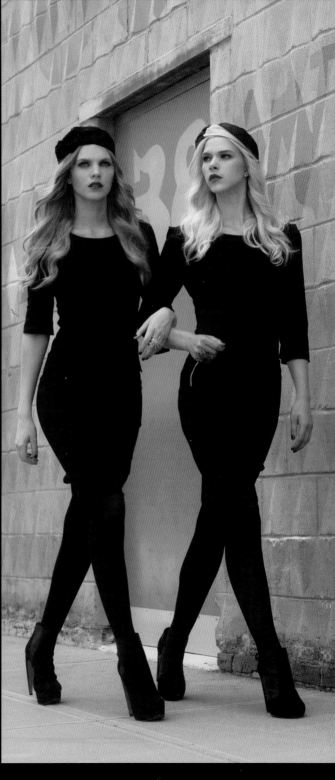

HOW A PRODUCTION SHOOT WORKS

**NY campaign for
The Fold clothing.**

Photos: Kait Robinson

BELOW LEFT
Clients and creative team are usually on-set on larger shoots to make sure things are running smoothly. This means they can look over the shots as you go.

BELOW CENTER
Here I am shooting in Dumbo, Brooklyn for the campaign. With any location shoot you need to be aware of the public using the area—this is something you always have to work around. Confident models and teams will help with this!

BELOW RIGHT
When working on advertising shoots, try hard to put into perspective all the things you usually do on project shoots and tests. For example, I always shoot with backlighting on tests in simple images, so it came naturally to me to try it out on this shot when the sun was low.

COORDINATING A HIGH-PROFILE fashion shoot can be overwhelming even for the most experienced photographers. However, when working on big production shoots, there are often experienced contacts at every corner including art directors, producers, the client, a client's representative, and your creative team and model, so you are not working alone. Their task is to make sure everything is running correctly on-set and behind the scenes, and to help solve any problems as you shoot. Larger production shoots are orchestrated for one reason: to please the client. You are present to complete the task, whether you have had a large amount of creative input or not. Depending on the job, the hours of larger production shoots range from several hours over one day, to up to a week on the larger end of the scale, and varies from studio days, to location work, or a combination of the two. One thing is paramount when working on a big production shoot—this is to be fully aware and prepared for all contingencies preshoot and during. There is no time for mistakes and everybody has to be aware of their role. When you're juggling your role as photographer you also have to take the initiative and liaise with the client (or their representative, the art director), in addition to your assistants and styling team, to make sure everything is going according to plan.

A typical day shooting in the studio will usually start with an early call time, breakfast served and everybody briefed while models or talent are in hair and makeup. During this prep time, the photographer and client contacts or representative will go through the shooting set and approve lighting techniques, crops and so on, and the digital assistant (if on-set) will make sure the camera and lighting is in sync and ready to go.

Once the set is ready, the first shots are taken (usually the camera is tethered to a digital screen so the clients or reps can approve the shots) and final preps are done to the styling. Once everything is signed-off and everyone is happy, the shoot takes place and continues for a few hours. During this time, a quick midday lunch is served and the team liaises between the client/art directors about the shots (sometimes shots are sent by email to the client if they are not present) to be approved. Shooting continues until the final shot has been completed and/or the client is happy with the results.

At the end of the day, some clients will want to see a brief edit of the final shots or layout, which should be taken into consideration, so make sure you plan the allotted time to allow for this. When working on days like this, there are limited breaks when there's a lot to be completed in a certain time frame. Location houses and studios often have a time restraint that has been prebooked and any overtime will require hourly rates. Photographers and styling teams are usually aware of the importance of wrapping up a shoot at least 30 minutes before the end time, so that there's time for the assistants or studio representative to clean the studio.

When you're shooting for a
lookbook or fashion campaign,
it's important that the clothing
is captured in its true form. If
you plan to shoot with natural
light, then consider use of
reflectors or other accessories
to highlight the detail on
seams or important details
of the garment's structure.

**Lookbook for
The Fold clothing.**

Models: **Caroline Codd @
Wilhelmina Models and
Maritza**

Makeup: **Jenny Kanavaros @
Agent Oliver**

Hair: **Alexander Tome**

Styling: **Erin O'Keefe**

Canon EOS 5D MKII
ISO 800
f/8 1/1250

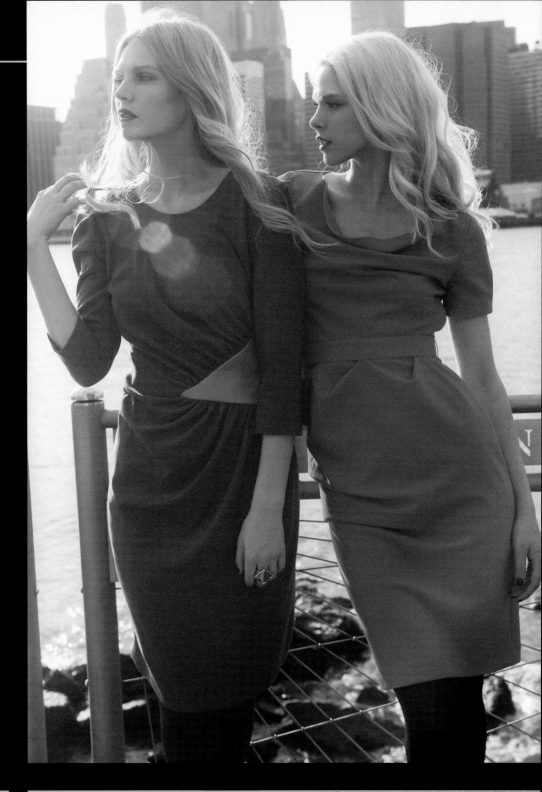

PRICING

MANY PHOTOGRAPHERS get stuck when pricing their services. At some stage we've all felt that we're either charging too much or too little. My own recommendation is to charge what you believe is a fair price for your time. Don't price your services the same as your closest competition, because no two photographers work in exactly the same way and in the same style.

In fashion photography the way you get paid differs slightly from other types of photography. Usually the client will give you a set budget if you're shooting for a known editorial or advertising client, and although this may not seem much, I recommend that you take the job because it will be beneficial to your portfolio and will provide experience. If you're being asked to work for a really low fee or even for free, consider how much the shoot benefits you before you take the job.

TO PRICE YOUR SERVICES THINK ABOUT

- How much it's costing you in expenses: is there travel, equipment, or prop hire involved? Are you paying your creative team for their services?
- How experienced you are. Do you have any awards, clients, or sponsors to put to your name? If you're more well-known in the industry and have more clients under your belt, chances are you can charge more.
- If you're starting out, you may even consider what the minimum wage is, then dividing it between the time you're shooting and processing. As an artist you're entitled to be earning at least that.
- Offer package deals. This is more popular with wedding and portrait photographers, but you could consider offering a day rate and a set amount of images rather than being paid by the hour or per image.
- Supplement your fee with extra services. Most people don't want to pay for a full package deal up front, but are more inclined to buy extra services once they see the images. These services could include framed enlargements, canvas prints, printed CDs, or photo books.

It is not uncommon for some clients to expect more than they paid for, or to expect free services, especially if this is their first experience with a photographer. To protect yourself in this situation remember to draw up a contract—something that clearly states to them what you'll be providing for the fee. It's essential that this is agreed before the day of the shoot, as this avoids any problems further down the line.

Payment

Deposits: As with any creative service, it is always best to take a nonrefundable deposit (of between 30–50% of the fee) before the shoot. That way you protect yourself if the client doesn't show up or cancels unexpectedly. It also helps to show that the client is serious about their booking! Final payment should be on delivery and acceptance of the images and any other services stipulated in the contract.

Type of payment: Make it clear to your client what your preferred methods of payment are—this should be written in an email or contract. If they are paying by bank transfer, check, PayPal or any other money-sending service, be aware of payment clearance and any fees involved.

Invoices: When sending an invoice make sure it's dated, that you have included your billing address, your client's details and address (if needed), the job number, a breakdown of the payment, the correct amount total that they are being billed for, and also any other payment requests—such as wire transfer details, international pay details, or checking account details. You should also include a payment deadline (usually between 15–30 days).

Receipts: Keep receipts of all business-related purchases and services so that you always have everything on file for tax return expenses or billing-related queries. Check with your advisor to see what counts as business related, such as travel expenses, accommodation, and so on.

Even when you're working on your own personal work, like these three images, a budget is necessary for the shoot to happen. Whenever I plan the shoot, I always make a note of how much it's going to cost me (travel, location/studio fee, food) and keep receipts for my business expenditure.

Model: **Danielle Amber**

Makeup: **Leah Mabe**

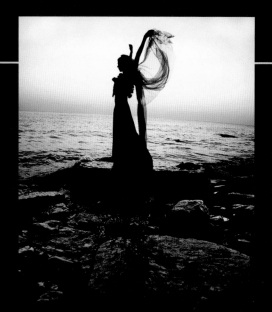

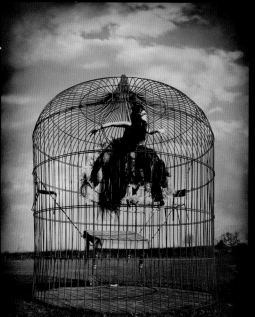

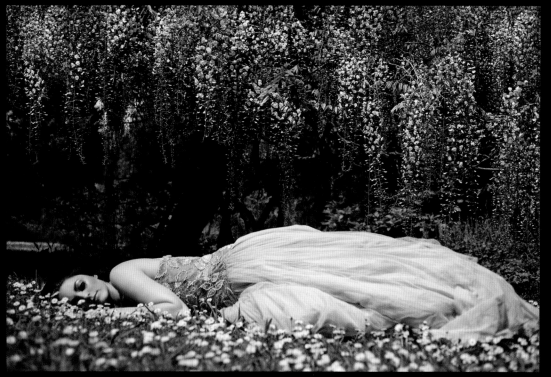

ABOVE LEFT
Canon EOS 5D
ISO 500
f/4.5 1/1000

ABOVE RIGHT
Canon EOS 5D
ISO 250
f/3.5 1/8000

LEFT
Canon EOS 5D
MKII
ISO 800
f/8 1/6400

IMAGE LICENSING & GUIDES

IMAGE LICENSING can be a complicated process. There are many ways in which images can be licensed, so to understand licensing you must first be clear about the options available to you.

The copyright holder (usually the photographer) has the right to control the use of his or her work. Companies choose to license images because it's a cost-effective way for them to purchase an image. By finding an image on a photographer's portfolio they are saving themselves the cost of producing a shoot from start to finish and any extras involved.

License options

To keep things simple you should understand that in photography there are two main ways of licensing images—royalty free or rights managed.

- Royalty-free photography is cost effective for clients who are on a budget or for individuals who want a cheap option for design. The drawbacks are that the clients share the image with potentially many other companies who will have found it online and that your work is therefore not unique to a brand. As a fashion photographer this isn't a particularly profitable way of marketing your work. Stock photographs and lifestyle photographs are easy to create and sell at a small price, but fashion photography is more expensive to create. For this reason fashion photographers tend to prefer rights-managed licenses.
- Rights-managed photographs are images that are exclusive to an individual or company; a company buys them safe in the knowledge that no one has used the images in the past or will use them in the future. Rights-managed licenses give the photographer much greater control over issues such as terms of use. The drawback for clients is that this is a more expensive option (sometimes just as expensive as commissioning a shoot) but most companies will pay for an image that is unique to them.

Companies can also choose to buy an image and the full copyright along with it. If a client asks for this, you have to consider that the buyout cost has to cover all possible uses of that image worldwide for it's entire life. This is an expensive option, but it's beneficial for large companies that are interested in the long-term advantage owning the full copyright gives.

Fees

Licensing fees range from country to country, so wherever you are based, you should research how copyright affects you and what rights you have as a photographer before considering the fee involved.

To quote a fee to a client you need to consider:
- How the image will be used.
- How big the image will be used.
- How many copies of the image are going to be distributed.
- How many years the image will be used for.
- What changes they are making to the image, if any.
- The time and artistic skill involved in creating the image.
- The fees you will have to pay your model/creative team.

Once you've put a fee idea together, you should provide your client with a breakdown of the fee to help them understand how you arrived at that number. A written contract should always be put together (if the client doesn't give you this) so that the terms are legally binding.

TIP
If you're having a hard time coming to a fee conclusion, try using one of various image-license calculators that are available online. There is a free and accurate calculator online at www.featurepics.com to help you.

Elin for *Papercut* magazine.

Model: Elin @ New York Models

Makeup: **Deborah Altizio**
Hair: **Damian Monzillo @ BA Reps NY**

Styling: **Lauren Armes**

BELOW AND RIGHT
Occasionally a client will ask to "buy out" the full copyright to your images, for example to use them for advertising purposes. More often though, they will license the images from the photographer who retains the copyright, as on this shoot for *Papercut* magazine.

RIGHT
Canon EOS 5D MKII
ISO 320
f/2.8 1/499

BELOW
Canon EOS 5D MKII
ISO 200
f/2.8 1/1600

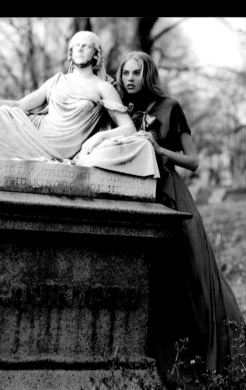

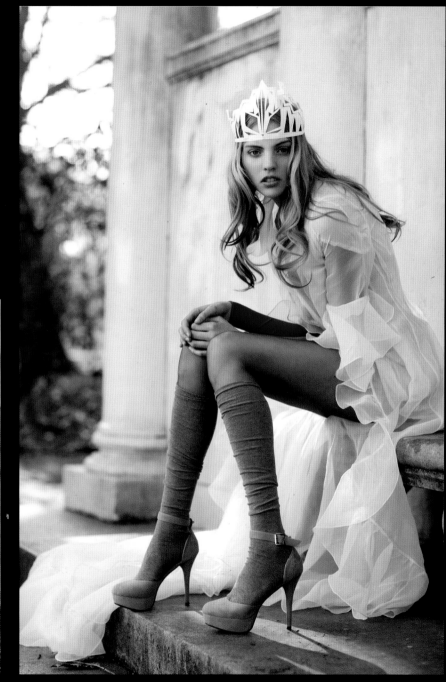

COPYRIGHT

IN MOST COUNTRIES the general law of copyright protects the author's original works and exclusive rights. When this is violated, the author can pursue legal action against the offender.

Copyright law varies from country to country in terms of specific practice. For example, in some countries you may need to register your works, while in other countries the law may protect you automatically. Copyright only lasts for a certain period of time, after which the work enters the public domain. However, this varies from country to country. In the United States copyright usually lasts for 120 years, while in the United Kingdom the period is usually 50 years.

Generally, the photographer retains the copyright to their original work unless the photographs have been produced for a company that retains the rights (for example, many magazine contracts work this way), or a contract has been signed that assigns the work to a third party.

How to protect your work online

Copyright infringement is the unauthorized use of an image that is covered by copyright law. Discovering that your work has been used by a company to sell a product online would be an example of copyright infringement.

Advertising your work online is one of the main areas a photographer gains status and client contacts within the industry. Before a client hires you they'll want access to your portfolio—which can often mean showcasing your work in high resolution online. The downfall to this is that there's a large portion of people online that don't understand copyright or chose to ignore a photographer's exclusive rights.

While most companies and individuals stick to the rules, there are many who will copy a photograph to advertise their services and try to avoid paying to use it. With this in mind, you need to be aware of the various ways in which you can protect your images.

Watermarking: A quick and easy way to add your signature to an image. The advantage of this is that it will deter some people from copying the image, but the downfall is that watermarks can often be removed by somebody familiar with Photoshop, and they can spoil the look of your photos.

Extra file data: One common way in which people use images without a photographer's permission is "finding" it on the internet with no credit and using it as an orphan work. By adding your contact information to the EXIF data or the file properties this makes it easier for people to track you down and ask permission.

The old-fashioned way: This applies to film photographers more than digital photographers, but if you are printing a lot of imagery—always sign and date your printed photographs so that if they are found, you can be contacted.

Online description: Adding an online description mentioning the photograph is under copyright deters thieves because it shows them you are aware of copyright infringement and your rights. I always add the copyright symbol to the descriptions when I post my work online and have a copyright notice at the bottom of my website.

Post low-quality images when high-quality images are not needed. Encourage clients to only post low-resolution images also.

Always read the website descriptions on image copyright before using a site's services. There are many social media websites out there that have controversial descriptions on what they can do with your work once you've posted it. Be careful and make sure that rights aren't transferred to third parties by using their services. Remember: you do not lose your copyright by posting your work online. Your work is still protected under copyright law.

EXIF DATA
The standard format for storing interchange information in digital photography image files using JPEG compression. Short for "exchangeable image file."

ORPHAN WORK
A work for which the copyright holder cannot be found.

Be aware

There are practical and legal steps a photographer can take to protect their work. If somebody violates your copyright, always be polite on the first approach—it may be an unnoticed mistake on their part or they may be open to negotiating on your terms. If not, then you can contact the site's ISP and file a report (quite common practice on social media websites), or in more serious cases you should seek legal action with a copyright lawyer.

Evidence is the key in copyright infringement cases. Make sure you screenshot evidence, emails, and any other important factors when approaching a lawyer. Ultimately, you need to be sure that the infringement case is worth your time and money and that you will come out better on the other side.

BELOW
Watermarking your images is always a good way to keep control of your copyright.

Georgie for *Material Girl* magazine.

Models: **Georgie @ Profile Models London**

Makeup: **Leah Mabe**

Hair: **Craig Marsden @ Carol Hayes Management**

Styling: **Claudia Behnke**

Photography Assistance: **Oscar May**

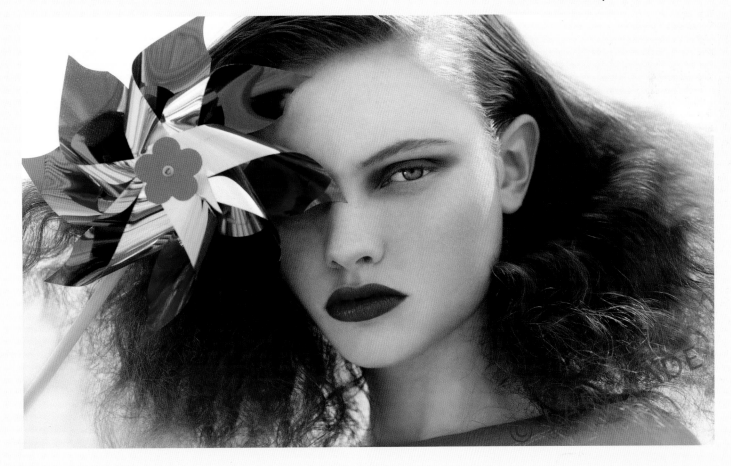

MODEL RELEASES

A model release form bestows the individual concerned with certain rights on the use of his or her image. The specific details will vary depending on the details of the model release form itself and the country, although almost all countries protect against using a person's image in a slanderous, or offensive manner.

As a photographer and business owner you should always be sure you have valid release forms for the type of image you will be producing. Usually, if you're shooting a project for personal or editorial work, there isn't a requirement for a model release beforehand. When working on commissioned jobs, the client handles the required releases needed for the assignment.

However, if you're planning on selling images to companies or to use them in exhibitions, for example, you will need a valid model release to cover you against any legal comeback. These can generally be obtained at a later date from the model agent or the individual in question.

There are many different general model releases that can be found online (adult and minor releases), which can be tailored for your specific use.

ADULT MODEL/PERFORMER AGREEMENT RELEASE

Release _____

Details of production _____

Model _____

Address _____

Phone No: _____

Model's Age (at time of production)_____

Model's Ethnicity (optional) _____

Description of production _____

Place photo of model in box

THIS MODEL AGRERREMENT AND RELEASE ("Agreement") is dated
and is between the undersigned photographer ("Photographer") and the under-
signed model /performer ("I"). Agreement as follows:

For good and valuable consideration of I hereby
grant the undersigned Photographer permission to photograph me. I further give
my irrevocable consent to Photographer and his/her direct or indirect licensees
and assignees to publish, republish or otherwise transmit the images of myself in
any medium for all purposes throughout the world. I understand that the images
may be altered or modified in any manner. I hereby waive any right that I may
have to inspect and approve a finished product or the copy that may be used in
connection with an image that the Photographer has taken of me, or the use to which
it may be applied. I further release the Photographer and his/her direct or indirect
licensees and assignees, from any claims for remuneration associated with any form of
damage, foreseen or unforeseen, associated with the images.

I am of legal age and have the full legal capacity to execute this authorization
without the consent or knowledge of any other person.

AGREED BY THE MODEL PERFORMER

Signature _____

Print Name _____

Date _____

AGREED BY THE MODEL PHOTOGRAPHER

Signature _____

Print Name _____

Date _____

Adult Model Release Agreement

Model releases are an essential part of a professional shoot. There are a variety of different kinds available, and again they can be tweaked to fit your needs, but make sure to use one from a reputable source. This one is courtesy of *Professional Photographer* magazine, and can be downloaded from the following link: www.professionalphotographer.co.uk/Magazine/Downloads/Model-Release-Form

TIP

If you are uncertain as to whether or not a general model release form is right for your specific business and think it wise to create a specific form, then hire a legal firm to draft one for you.

BELOW
Whenever you're working on personal or test shoots, always think about having your model sign a model release for image licensing on future publications, even if you have a good relationship with the model. Better safe than sorry!

Model: **Danielle Amber**

Makeup: **Leah Mabe**

LEFT
Canon EOS 5D
24mm lens
ISO 500
f/4.5 1/3200

BELOW
Canon EOS 5D
35mm lens
ISO 250
f/2 1/2500

7

ORGANIZATION

Makeup artist Leah Mabe
is sharing her visual makeup
and illustration ideas with
the workshop team. This
enables them to envision
them and how to photograph
them in the best light.

London workshop, 2010.

Photo: **Oscar May**

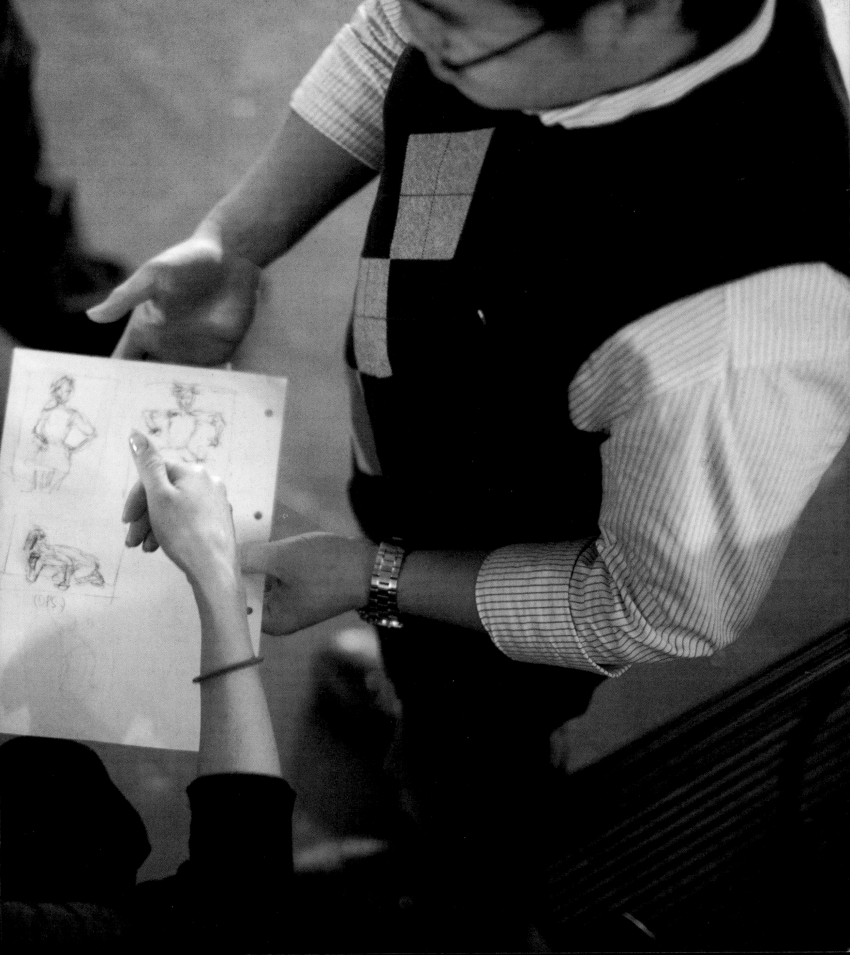

ORGANIZING FILES

BELOW

On this particular shoot there were many versions of this photo manipulation so it was important to organize each one by date, title and newest version.

Model: Anais Wosnitza

Makeup and Hair: Diane Dakin

THE DIGITAL AGE HAS MADE it possible for photographers to shoot thousands of images on one single shoot. And when you're constantly downloading images onto your desktop or laptop, you start to notice how disorganized everything can become and how quickly your hard drive fills up! If you start getting into the habit of organizing your files at an early stage in the workflow you'll notice it becomes much easier when you need to find something.

Here's how I organize my files. First the year, then the month, then the shoot name, and then three separate folders. One for the unedited Raw files, one for the edited high-res TIFF files, and finally one for the web versions of the finished TIFFs—600 pixels along the longest edge and saved as JPEGs. This makes it very easy for me when I need to send files to clients and also easy for them when they want to upload or print files for their own requirements.

Of course, this is just one way of organizing that works for me; set up your folders and files in the way that works best for you.

ORGANIZING FILES

1 The date by year.
2 The date by month.
3 The name of the shoot.
4 Three separate folders: unedited Raw files, edited TIFF files, and JPEGs for internet publishing use.

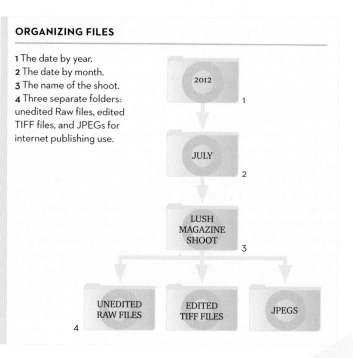

ADDING KEYWORDS

TO MAKE IT EVEN EASIER to find images stored on your hard drive or external drives, add keywords to each specific image. Whenever you save your retouched or final images you should add keywords that relate to the image. For example, for a fashion editorial image I would add a small description of the shoot in words, the names of people on the shoot, the date, and other words that will help the client or me to easily find the images.

You can add file descriptions and organize your files through the Lightroom interface easily, but if you want to do this manually then try the following steps for your OS.

Changing your keywords on your OS:

On a Mac, change an image's filename by selecting the image, then right-click (Ctrl-click) and select Get Info from the menu. If you have spotlight enabled on your Mac you simply have to type in the filename you've given the image and it will appear.

In Windows, click All Programs and then select "Windows Photo Gallery" (Vista) or "Windows Live Photo Gallery" (Windows 7), Next, select the picture you want to tag—the Info panel should be displayed (if not, click the Info tag on the toolbar). Finally, click Add Tags to add tags to the image, then press Enter to finish.

Labeling

Labeling allows you to filter your photos, usually by the use of a color or star rating. This is helpful for photographers who want to organize their work into sets and want to easily find them all at once when searching.

In order to label your photos, follow the same directions as adding a keyword or label (above). The options for any file changing should be under the information of your chosen image.

ABOVE AND RIGHT
When you're working with many different models and teams it's easy to lose track of your files. I always keyword my shoots in Lightroom by model name, date and a brief description of the shoot.
Model and Makeup: Sohui
Styling: Krishan Parmar

TIP
If you have Adobe Lightroom, then labeling is an easy way of accessing all of your files inside a program and grouping them as a set (see the Lightroom section on Filters, pages 122–23, for more information on this).

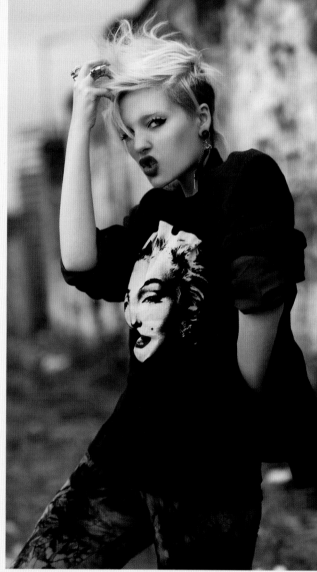

ABOVE LEFT
Canon EOS 5D MKII
ISO 100
ƒ/2.8 1/800

ABOVE
Canon EOS 5D MKII
ISO 100
ƒ/3.2 1/1999

BACKING UP

NONDESTRUCTIVE
This refers to an edit made in a post-production program where the changes take place only within the program, and the original image file remains unedited.

AS A DIGITAL PHOTOGRAPHER your image files are extremely valuable, so you need to ensure that they are safe at all times. Nobody wants to risk losing months, or even years, of image data and other information! And this is where backing up comes in. In addition, however, not only does backing up help to prevent you from losing files, if done properly it will also help you to organize your files so that you can find them easily.

Another point to consider is that a computer's OS runs faster and more reliably the more free space it has, so you should consider buying external hard drives on which to store your photographs. Consider also making a backup copy on DVD in case the external hard drive unexpectedly becomes corrupted or loses data.

How often you run a backup depends on your backup procedure. In terms of manually backing up images to DVD, consider backing up your work weekly or monthly (depending on how many shoots you complete in the given time frame).

Methods of backing up files

Backing up is a quick and thorough way of making a "second copy" of your entire system or a selected part of your system. The benefit of doing a system backup is that it gives you the opportunity to go "back in time" to retrieve important files or information.

Mac OS: time machine: Included with all Macs running OS X, Time Machine enables you to make an entire (or selected) backup of your system automatically. The software is designed to work with the Time Capsule as well as other external drives, and works in the background making hourly backups.

Windows OS: backup and restore in system: If you have Windows, there is an automatic backup and restore feature available on selected versions. This can be accessed from the Start Menu from *Control Panel > System and Security > Back Up and Restore.* It is a basic program that enables you to backup and restore individual files, or your entire computer. You can back information up to an external hard drive or DVD.

External hard drives: External hard drives are disk drives that are connected to a computer usually via either Firewire or USB 2.0 cables. They are a popular way of storing and backing up your data and will usually work in the background when connected to software such as Apple's Time Machine. External hard drives offer good value for money, and how much space you need depends on how much you shoot and what file size you shoot at.

WHAT HAPPENS IF I LOSE MY IMAGES?

First, don't panic! This has happened to most photographers at some point. If you haven't backed up any of the files or information and suddenly the drive is corrupted or no longer loads, then there are a few options you can try to in order to restore your images.

- First things first—try the obvious. If you know your file extension or file name, try searching for that as it may have accidently been dragged into the wrong folder or saved somewhere unknown. You should also try looking under "recent files" on your OS. If your files were loose on your memory card, try another camera first or on a different card reader to see whether your images can be read somewhere else.
- Recovery programs: There are many free programs on the web that are able to recover your files free of charge. There are also programs that do extensive recovery for external hard drives, memory cards, and even deleted files on your computer. However, most of the best ones you need to pay for—but they also prove on the program that they can find your files (through a preview) before you pay. You may need to try out a few different programs to find the right one for you.
- In the unfortunate event of not being able to recover your images by yourself, your best remaining option is to ask for the advice of a professional. There'll be numerous companies quite near you who specialize in disk image recovery, though this service will come at a price. Research the companies available to you in your area (usually computer/laptop specialists and dealers) and ask for advice. They should provide a quote on how much it would cost beforehand or give you advice on where to get help.

ADOBE LIGHTROOM

ADOBE LIGHTROOM is one of the leading workflow and editing programs. It is an essential tool for any working photographer and is highly capable of performing tasks such creating image selects, organizing catalogs, Raw processing, basic edits, making contact sheets and saving for web or print output. It is a popular tool with photographers of all levels because it offers so much in the way of developing and processing images quickly and easily.

While Lightroom is a fantastic tool for assisting a logical workflow, it shouldn't be considered by fashion photographers as the only program in which to edit photographs. To carry out more comprehensive retouching, particularly if compositing several images together, then Adobe Lightroom should be used as a support system to organize and prepare photographs before working on them further in Adobe Photoshop.

Lightroom is an essential part of my workflow. I turn around about 600–1000 photographs per shoot, and Lightroom makes it easy and quick for me to make those important file comparisons and choices so that I can take them into Photoshop or organize for my client to view.

WHAT ARE THE BENEFITS OF USING LIGHTROOM?

• All of the adjustments you make to an image are "nondestructive," so whatever you do to the image, you'll still have the original image data.
• The Lightroom interface is designed in a very simple, easy-to-navigate layout so that the program's tools and options quickly become familiar.
• It is a great support tool (similar to Adobe Bridge) to use with Photoshop: within a few clicks you can convert your file from Raw so that it is ready to work on in Photoshop.

• The file organization system is extremely useful—giving you the opportunity to flag, star, and color selected images so that you are able to sort and organize them quickly for final edits or for a client.
• The "catalog" system can mimic your entire hard drive, so that you no longer have to go into your computer's folders—you just have to use Lightroom to organize, rename, and select your files.
• The batch-editing function is great for photographers who wish to quickly add the same process to many images at once.

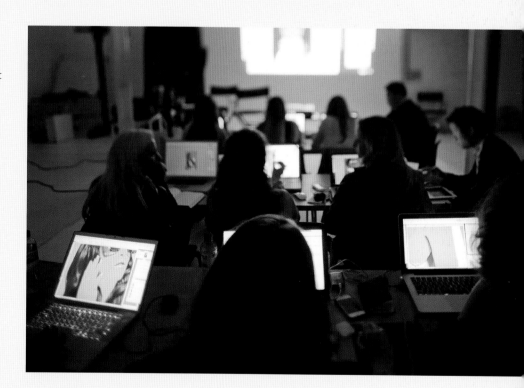

RIGHT
Attendees at my two-day
London workshop in April 2012.

Photo: **Oscar May**

ADJUSTMENTS IN LIGHTROOM

BARREL DISTORTION
The effect when straight lines appear to curve, as if they've been stretched over a sphere or barrel. This is seen when using wide-angle and fish-eye lenses.

PIN-CUSHION DISTORTION
The opposite effect to barrel distortion that causes straight, parallel lines at the edges of the image seeming to bow inward.

CHROMATIC ABERRATION
Refers to a "fringe" of color that appears in images due to the lens focusing different wavelengths of light at slightly different distances.

IN THIS SECTION I'm going to show you some of the basic yet essential image adjustments that you can apply in Adobe Lightroom and exactly how they are beneficial to your workflow.

Local image adjustments
One of the first adjustments that any image requires (unless perfectly composed in-camera) are changes to the exposure and white-balance settings. By clicking on the Develop module (at the top right of the screen), you'll reveal several work panels (accessible by clicking on a small white triangle). We'll look in more detail at each panel later, but essentially they provide tools for adjusting white balance, the overall tone of the image, color saturation, and ways of fine-tuning specific color/tonal changes. Other adjustment options include sharpening, noise reduction, fixing chromatic aberration, and applying or removing vignettes.

As you make adjustments in Lightroom, the program keeps a record of the settings in the History panel (on the left-hand side), which you can clear at any stage. You can also set the photograph to its original state by clicking the Reset button at the lower right of the Develop screen. In the same place, the Previous button allows you to go back a step.

Here's a brief explanation of the adjustment settings available to you in the Develop module. Although, compared with Photoshop, the tools may look cursory, you can make a surprisingly large number of adjustments—pretty much all you need unless you're intending to combine images, add special effects, or edit down to pixel level.

HISTOGRAM

The histogram is a visual guide of the tonal distribution of the principal colors in the image, and can be set to show shadow (blue) and highlight (red) clipping.

Underneath the histogram, Lightroom displays the histogram, Lightroom displays key image exposure data—shutter speed, aperture, ISO, and focal length.

DEVELOP TOOLS

 Crop tool: In this section, you'll find the Crop Overlay tool, Crop Frame tool, Straighten/Rotate tool and the Constrain Aspect Ratio Lock button. In this mode a bounding box appears over the image, which you can adjust to make your desired crop.

 Spot removal: In this section, you'll find the Clone/Heal brush and sliders to adjust the brush size and opacity. These tools are required for removing spots or blemishes quickly from a subject in the image.

Red-eye correction: This tool will automatically remove unwanted red eye in photographs.

 Graduated filter: The Graduated Filter allows you to make a variety of adjustments, through the use of sliders that control elements such as exposure, contrast, saturation and sharpness, to large parts of the image. The tool was originally intended to replicate the effect of graduated filters that fit over the end of the camera lens (for darkening skies, for example).

 Adjustment brush: This tool allows you to make similar adjustments available to the Graduated Filter but to more localized areas of the image.

BASIC PANEL

Below the Develop Tools is the Basic panel, where the principal image adjustments are made.

Treatment: Black and White: This adjustment allows you to quickly choose between a color and grayscale version of the image. As this is nondestructive, it's a great way of converting to black and white, or even to preview your image with the chosen adjustment before full conversion later on.

White balance temp/tint: This adjustment allows you to tweak the white-balance setting if you feel the image looks too "warm" (red) or "cold" (blue). If you shoot Raw, you can retrospectively set whichever white-balance setting you like using the pull-down menu. Alternatively, you can use the White Balance Selector dropper to select a neutral gray. The Tint slider permits further color correction.

TONE

Exposure: Controls the overall exposure of the image.

Contrast: Increases/decreases the overall contrast of the image.

Highlights: This slider controls the brightness of the highlights in the image allowing you to ensure highlight detail is visible.

Shadows: This slider controls the brightness of the shadows in the image, allowing you to control shadow detail.

Whites: Use this slider to set the white point.

Blacks: Use this slider to set the black point.

PRESENCE

Clarity: This slider increases contrast in mid tones and adds depth to the image. This is a great tool if your image is slightly out of focus.

Vibrance: This slider has the effect of enhancing more muted colors.

Saturation: The saturation slider increases/decreases the overall color saturation within the image.

Tone curve: The Tone Curve panel allows for localized and/or global tonal adjustment using either the curve/line or the sliders.

Color adjustments (HSL/color/Black and White): In this panel you can refine color adjustment. There are eight sliders corresponding to eight key colors.

Split toning: The Split Toning panel allows you to create special effects within the tones in your photograph by selecting and adjusting specific colors. Split Toning also enables you to colorize monochrome photographs.

- **Detail:** In the Detail panel you can use sliders to sharpen images and fix both luminance and color noise.

- **Lens corrections:** This panel allows you to fix some of the more common lens distortion issues such as barrel or pin-cushion distortion, as well as addressing minor alignment and convergence issues.

- **Effects:** Use this panel to reduce vignetting (dark corner), or add it for creative effect.

- **Camera calibration:** This panel allows you to apply standard camera settings such as Landscape, Portrait, and so on retrospectively, as if you shoot Raw, no setting is embedded in the photo. You can also create your own camera profile using a color chart and the DNG Profile Editor and apply it here to ensure colors are consistent throughout the workflow.

Basic Panel

Tone Curve

Color Adjustment and Split Toning Panels

BATCH EDITING

BATCH EDITING is one of Lightroom's most powerful features. It is an extremely useful tool as it allows photographers to apply the same adjustment or even series of adjustments on more than one image at a time, yet still retain the ability to fine-tune them afterward.

While there are many other programs on the market (Aperture or Adobe Camera Raw, for example), that can perform batch processing, Lightroom is a personal preference of mine because of how quickly you are able to do this, and because I like to keep all of my file organization in one place.

To batch edit your photographs, click on the Develop panel in the Lightroom interface—this will open the library of your images ready to be adjusted. If you haven't already, select all of the images you want to adjust by selecting your album within the catalog library at the left of the screen, then highlight them all (go to *Edit > Select All* at the top of the Lightroom screen). Now, with all the images still selected, adjust one of the images to your desired style using the various adjustment sliders. Once you are happy with the edit simply click the sync button at the bottom left of the screen or go to *Settings > Sync Settings* as a menu option. This will bring up the Synchronize Settings dialog box. Unless there are some specific settings you don't want to apply to your images, select Check All and click Synchronize. Now all the adjustments you made to the first image will be applied to all the other images.

SYNC

Lightroom's "Synchronize Settings" option is invaluable when batch editing, making it easy to apply the same edits to every photograph in a set.

Underwater Shoot, Hawaii. With thanks to Lahaina Divers, Maui.

Model: **Valerie Wessel**

Styling: **Polly's Closet**

Canon EOS 5D MKII
ISO 100
ƒ/2.8 1/800

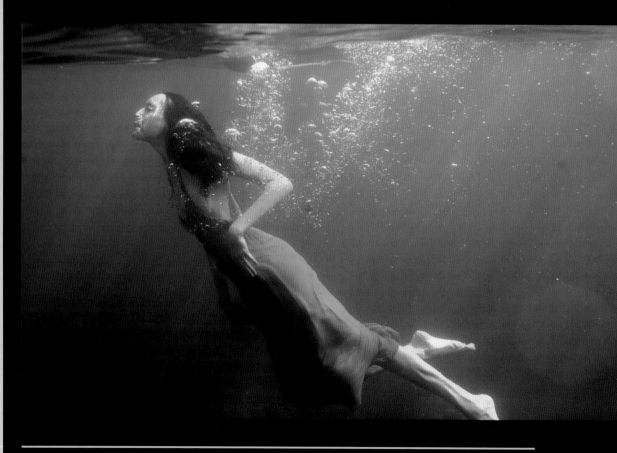

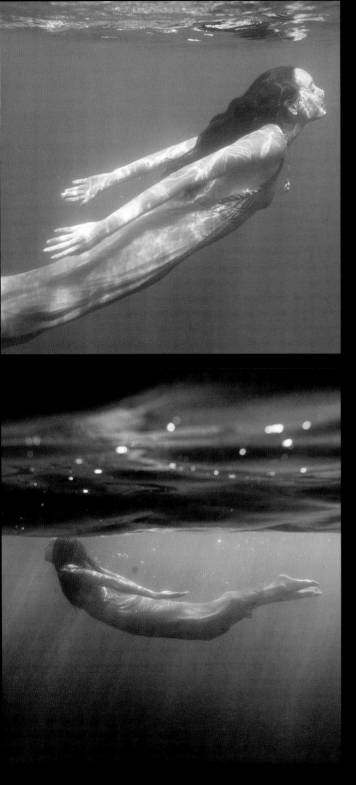

As the lighting quality, color, and tone were similar in all of these underwater shots, it made sense for me to add a batch edit to all of the images, instead of adjusting each image individually.

The batch edits I made to this set included some white-balance adjustments, a red photo filter to enhance the depth of the photos, and boosting the contrast and the clarity/vibrance.

CATALOGS AND FILTERS

Catalogs and filters

One of the most useful aspects of Lightroom is the way it manages images using its own catalogs. The Lightroom catalogs contain all the metadata associated with your images and make it easy to keep track of where images are and the adjustments that have been applied to them.

When you're working with thousands or even tens of thousands of images, you need to be able to categorize your images quickly. Lightroom makes image selection incredibly easy through a number of Filter tools. Lightroom filters allow you to apply a rating or label to your images, indicating, for example, those images that need further editing, or to flag up those that you want to delete. The three following filters are available to use together or individually, so that you can precisely arrange a series of images.

RETOUCHER
A digital editor who specializes in image retouching. A magazine or clothing company will generally employ a retoucher, whom it will often be necessary to liaise with.

OPPOSITE
Batch editing can be useful if your lighting is consistent throughout the shoot. I used batch editing in this book to adjust the contrast to each of the shots before sending them to the retoucher.

"Fallen Angel" shoot.

Model: **Diana R
@ FM Agency London**

Makeup: **Leah Mabe**

Hair: **Tomoyuki**

Styling: **Krishan Parmar**

Retouching: **M. Seth Jones**

**OPPOSITE, TOP LEFT
Canon EOS 5D MKII
ISO 500
f/2.8 1/320**

**OPPOSITE, TOP RIGHT
Canon EOS 5D MKII
ISO 320
f/2.8 1/249**

**OPPOSITE, CENTER RIGHT
Canon EOS 5D MKII
ISO 320
f/2.8 1/320**

**OPPOSITE, BOTTOM LEFT
Canon EOS 5D MKII
ISO 640
f/2.8 1/320**

**OPPOSITE, BOTTOM CENTER
Canon EOS 5D MKII
ISO 800
f/2.8 1/200**

**OPPOSITE, BOTTOM RIGHT
Canon EOS 5D MKII
ISO 1000
f/2.8 1/200**

CATEGORIZING IMAGES

Flagging: Flagging an image enables you to "flag" your favorite images for selection or those that you want to reject. You can flag an image by simply using the shortcuts P for "Pick" (Flag) and X for "Reject," or by clicking the appropriate flag icon at the bottom of the screen. Pressing U will remove any flag associated with an image.

Star ratings: Rating your images with stars from 1–5 will help you organize your favorite images for selection. This option is great for in-depth image selection. You can set a star rating by simply clicking the shortcut numbers 1–5 on your keyboard or by clicking the appropriate star at the bottom of the screen.

Color labeling: As well as flagging and rating images, you can also assign each image a specific color. The colors can represent whatever you like. This is a great tool to use on its own or with the other rating systems for in-depth image choices. You can set a color rating simply by clicking the keyboard shortcuts (6 = red, 7 = yellow, 8 = green, and 9 = blue) or by clicking the appropriate color at the bottom of the screen.

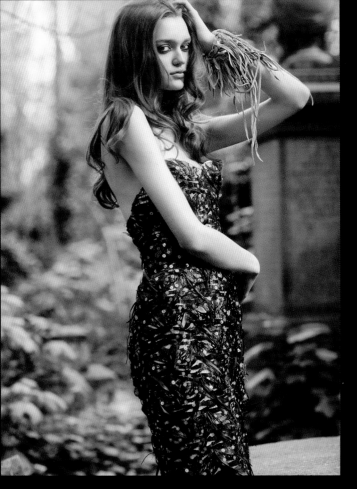
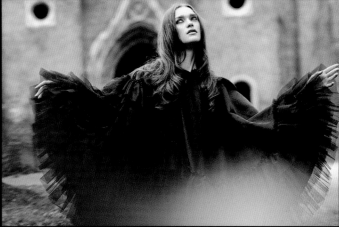
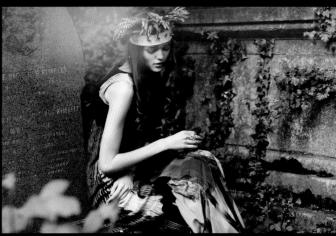
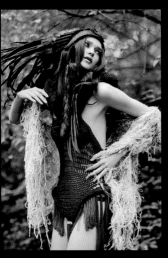
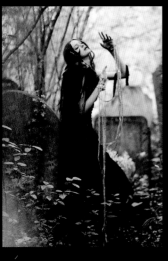
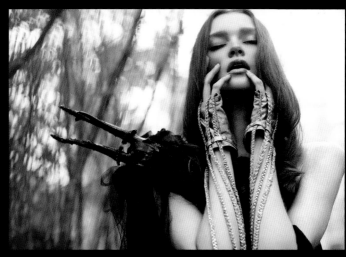

CHOOSING THE "RIGHT" SHOT

ONE OF THE MOST challenging parts of a photoshoot is not the shoot itself, but the work that goes into selecting your images for retouching. It's the middle of the road between the shoot and the final product. If the clients are making the final selection they will expect to see a contact sheet (see pages 126–127). The content and extent of a contact sheet all depends on the client's preference and how many images they want to see in order to make their choice.

Here is a selection of images from one of my fashion editorial shoots and how I approached the selection process.

Raw Lightroom selections
In Lightroom I always do batch selections, or "selects," though you can perform similar actions in other software. The first select flags bad compositions and odd poses; these will be rejected. The second select is usually organized using a star system, as described earlier. In this select I rated my favorites as 3. You can also order your selects further by color—this is often helpful when you've shot a lot of images.

Final selects
In my final selects I had to organize the story around the clothes—it was very important to get at least one different outfit in each shot. So even though my primary choices were two shots of almost the same pose, the main criteria for selection was based on what the model was wearing and not how she was wearing it.

TIP
When using textures, don't be afraid to play around with different blending modes, Curves, inverting, and opacity modes. Each image will look different with varying textures.

Uliana for *FAINT* Magazine.

Model: Uliana @ Storm Models

Makeup: Leah Mabe and Keiko Nakamura

Hair: Tomoyuki

Styling: Krishan Parmar

Retouching: M. Seth Jones

CONTACT SHEET
A page of thumbnail images from which images are selected for further work. In the past these were static prints representing a roll of film, but can now be more interactive, in the form of software like Lightroom.

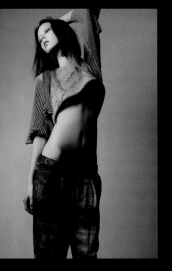

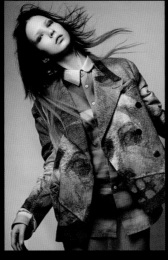

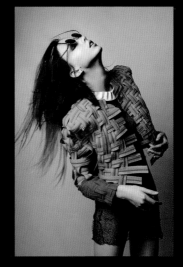

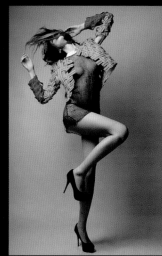

1 In this particular image the lighting falls well on the model—showing the clothes in the best light and adding shadow appropriately. Her pose works with the theme of the story.

2 One of my favorites of the story—the movement in the shot really makes it stand out from the rest and the clothing is clearly visible.

3 If this image was standing alone it would not have worked. However, teamed with the other shots it adds interest. The colors of the clothing work well against the background and the weird pose works alongside other images.

4 It is always important to add a full-length shot and get in the shoes! Even though you can't see her face the pose works with the story.

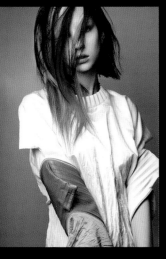

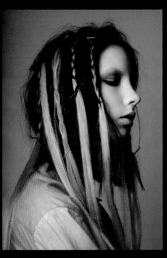

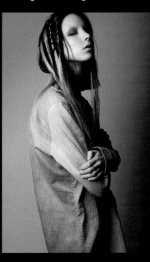

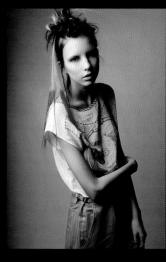

5 To balance out the story I decided to add a "neutral" image (an image that is quite plain in comparison) that breaks up the visual appearance of the story as a whole.

6 Even though the clothes aren't seen this is my favorite image. If hair and makeup are strong, use "different" shots in your editorial to keep things unique.

7 This shot was a "safe" one with the clothes clearly visible.

8 Another "neutral" shot to add to the story, as the images either side were more quirky in style—this breaks the story up a little.

MAKING A CONTACT SHEET

A CONTACT SHEET is a selection of images on one page from which clients can choose their favorites, either for final editing or for print. It is often better to create a contact sheet rather than show individual images as it allows for easy comparison between images, making the selection process easier. Underneath each photograph there is an identifying number or name.

The first step when making a contact sheet is to ensure all the images you want to include are in one folder, or if you're using Lightroom, that they are flagged appropriately. This will make it easier for you when you come to select your files later on.

Creating a contact sheet in Bridge

More recent versions of Photoshop no longer feature the contact sheet plugin, however, it's still available to download from Adobe. Rather than using the Photoshop plugin, though, you could use the contact sheet facility that Adobe have added to Bridge. To create a contact sheet in Bridge, go to *Windows > Workspace > Output*. This will open the contact sheet window. From here you can navigate to your image folder and select the format of your contact sheet, the layout, background color, and typeface. You can choose to save the contact sheet as a PDF and select a low or high image quality depending on whether the PDF is be viewed on-screen or printed.

You also have the option of creating a web-friendly gallery of your images, onto which you can put your name, contact details, and any information about the images.

Creating a contact sheet in Lightroom

In Lightroom, select the print module then select Single Image/Contact Sheet under Layout Style. Then simply select all of your images by clicking *Edit > Select All*. Once all of the images are selected, choose one of the preset templates from the Template Browser on the left-hand side. You can then use the tools in the Layout panel to fine-tune your contact sheet. The margins, page grid, cell spacing, and cell size can all be adjusted for easy viewing. Experiment with these settings until you are happy with the page layout.

• If want to print the contact sheet then scroll to Print One at the bottom of the window.

• If want to save the contact sheet for future printing or for web/email use, go to Draft Mode Printing box in the Print Job panel, then click on the Print... button at the bottom of the window, and in the Print dialog select PDF. When you press Print, Lightroom will create and save a PDF of the contact sheet.

OPPOSITE

Here are the Raw files from an editorial shoot (seen on page 123). When working with a client or a retoucher it's essential to give them the files to chose from, or for them to view a small sample of the works before approving the second stage of the editing.

Model: **Diana R**

Makeup: **Leah Mabe**

Hair : **Tomoyuki**

Styling : **Krishan Parmar**

PLUGIN

Software produced by a third party intended to supplement a program's performance.

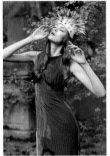

5

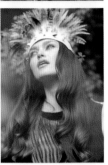

1

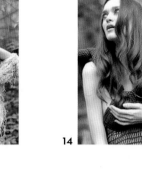

2

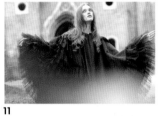

6

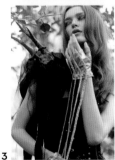

7

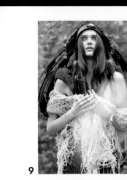

3

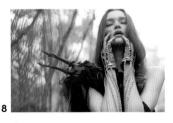

4

8

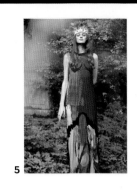

9

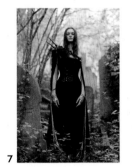

10

11

12

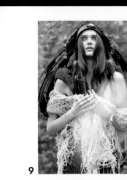

13

14

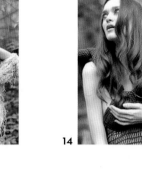

15

16

8 RETOUCHING

Me at one of my London workshops in April of 2012.

Photo: Oscar May

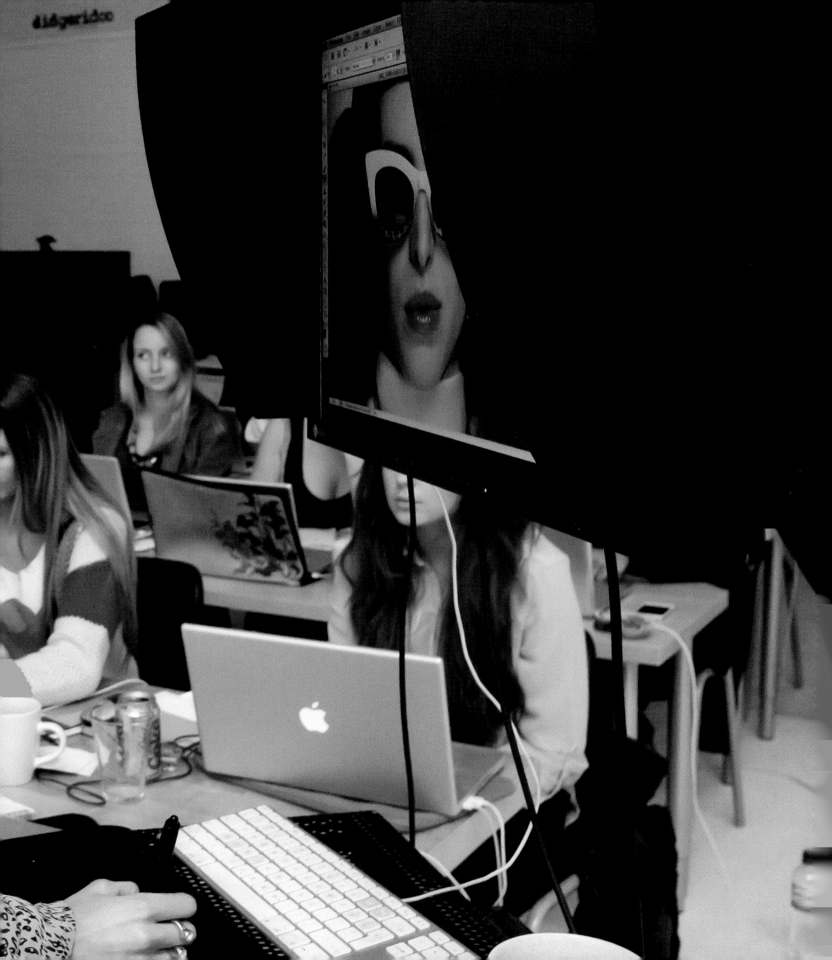

RETOUCHING

IN TODAY'S FASHION photography industry, the digital darkroom is key to producing striking images that "pop" off the page. Almost every fashion photograph you see has been digitally retouched or manipulated to a greater or lesser degree before publication.

Although there are specialist retouchers who work on high profile jobs, they are usually expensive—and if you're a starting fashion photographer it's unlikely that you can afford to pay for this service, on top of all the other expenses you'll incur on photoshoots. Instead, familiarize yourself with an editing program so that you can process your own images. Even if you're planning to use a retoucher's services at some point in your career, you should be familiar with most of the retouching and editing processes so that you can tell them exactly what you want and have an idea as to how feasible it will be for them to complete.

In this section, I'm going to run through some of the more popular retouching techniques using Adobe Photoshop, one of the most recognized photo-editing programs on the market.

OPPOSITE
These images were shot using a projector facing the model and background and lit using one single softbox light facing down toward the model at a slight angle. The creative retouching was used to enhance the vintage theme and was achieved using stock images of Polaroid borders and scratched textures.

Canon EOS 5D MKII
ISO 250
f/1.2 1/640

POLAROID BORDERS
Vintage camera effects such as Polaroid's can add an interesting period or otherworldly feel to a shot. Avoid using effects like this gratuitously: always use them to enhance a theme or to tell a story.

Model: **Teresa @ Storm Models**

Makeup: **Mira Parmar**

Hair: **Limoz Logli**

Retouching: **Lara Jade and Solstice Retouch**

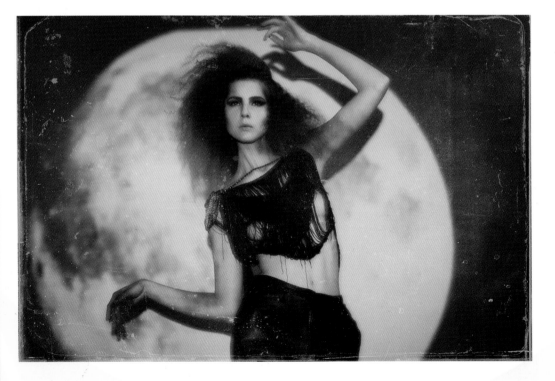

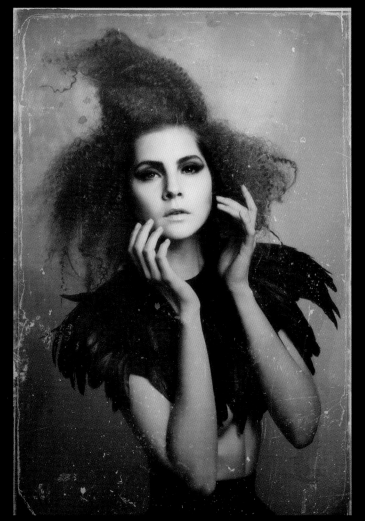

ABOVE
When working with textures
it's important that they appear
different in every photograph
and large details are not
noticeable throughout the story.

Canon EOS 5D MKII
ISO 250
f/1.2 1/640

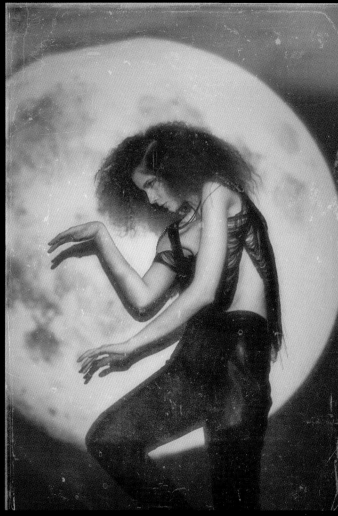

ABOVE
As there was so much detail
in the photograph, I chose
to change the colors to a
desaturated hue. This makes
it much easier to view as a
single image and as a set.

Canon EOS 5D MKII
ISO 250
f/1.2 1/640

LAYERS

MASK
A grayscale template that hides part of an image. One of the most important tools in editing an image, it is used to make changes to a limited area. A mask is created by using one of the several selection tools in an image-editing program; these isolate a picture element from its surroundings, and this selection can then be moved or altered independently.

TO MASTER PHOTOSHOP you need to understand how to work with layers. At first glance the Layers palette may seem confusing, but the concept is simple.

Layers are often described as behaving like clear acetate sheets placed on top of each other. You can stack them together, rotate, rearrange, and organize them so that some elements on one layer are covered by other elements on another layer. Layers give you control over the adjustments you make to an image, all while leaving the original background image untouched—this makes it easier for you to retrace your steps during the editing process if you need to. Most importantly, with layers you can add interesting effects by making the layers relate to each other in different ways, and by adding elements from several images—a process known as compositing. To display the Layers palette, go to *Window > Layers* or simply press F7 on your keyboard.

Adding a layer To add a new blank layer on top of your background image, either press Shift+Cmd (Ctrl)+N, click on the Create a new layer icon at the bottom of the Layers palette or go to *Layer > New Layer*.

Adjustment layers Unlike an adjustment layer, a standard layer is different in that it doesn't contain any actual visual elements or pixels. It's more like a set of instructions that are applied to the layer beneath. Adjustment layers are used to alter exposure, contrast, and color saturation, and can be adjusted at any time during editing without affecting the original layer. To add an adjustment layer, go to *Layer > New Adjustment Layer* or click the Create new fill or adjustment layer icon at the bottom of the Layers palette and choose the adjustment you want.

Layer masks A layer mask allows you to temporarily erase (mask) regions of a layer. Layer masks are essential for complicated compositing. To add a layer mask, select the layer you want to mask and click the Add layer mask icon at the bottom of the Layers palette. A small blank box icon will appear next to the thumbnail image in the relevant layer. Click in the box to activate it (an outline will appear around the box). Now select the Brush tool, and with Foreground Color set to black at the bottom of the toolbox (press X), paint over part of the image. The part you're painting over will start to disappear as you build up the mask. You'll also notice in the layer mask icon a small area of black that corresponds to the area you're painting on the image. Right-click (Ctrl-click) on the layer mask icon to bring up a context menu and select Delete Layer Mask. The mask will be deleted and the portion of the image you erased/masked earlier will reappear.

Fill layer A fill layer is a great way of adding a solid color to an image to introduce tone. Like an adjustment layer, a fill layer doesn't affect the pixels of the layer beneath it. To add a fill layer go to *Layer > New Fill Layer > Solid Color* or click the Create new fill or adjustment layer icon at the bottom of the Layers palette.

Duplicate layer You'll often find that you'll want to make a duplicate of a specific layer. This can be useful in certain situations such as retouching skin, where you need to create separate layers. To duplicate a layer press Cmd (Ctrl)+J or go to *Layer > Duplicate Layer*.

Delete a layer If you make a mistake and want to delete a layer, simply drag it to the Trash icon at the bottom of the Layers palette.

Flatten layers Once you've finished editing you can either save your file as a Photoshop document (PSD), which will keep all the individual layers intact for further editing, or you can flatten the image so that you're left with only one layer with all your edits incorporated. Flattening an image keeps the file size to a minimum, but you can't go back and make any adjustments as the layers will have been deleted. To flatten layers go to *Layer > Flatten Image*.

CURVES & COLOR ADJUSTMENTS

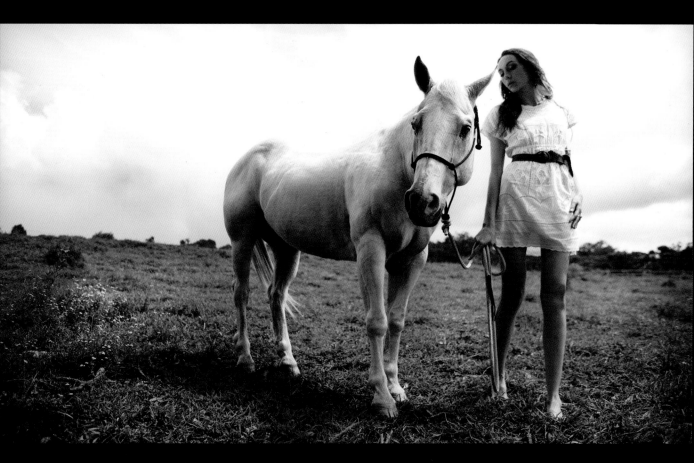

ONE OF THE GREAT things about Adobe Photoshop is that there's many ways in which one user can process their color and tonal adjustments. Over the last few years I've discovered that one of the most easiest and flexible ways to adjust the tones in your image is to use the "Curves" function. Although initially confusing to many users, this tool enables you to adjust points throughout the tonal range of an image and selectively choose what colors work for your image with immediate results.

Adjustments are made in the Curves dialog box by dragging and altering the shapes of the Curves line and/or adding new anchor points to further enhance the tones.

The best way to work with Curves is to process it as an adjustment layer, that way you can experiment with the effect without affecting the original image. Either go to *Layer > New Adjustment Layer > Curves* or click the adjustment layer icon at the bottom of the Layers palette and select "Curves" from the menu. The Curves dialog box will appear in the new window above the Layers palette.

ABOVE
Curve adjustments can be as simple as enhancing a mood in a photograph, like this photograph shot in Hawaii, or it could be the start of a combination of edits used to enhance your photograph into a more complicated photo-manipulation.

Model: **Valerie Wessel**
Styling: **Polly Cocilobo**
Hair and Makeup: **Ry-N Shimabuku**

CURVES & COLOR ADJUSTMENTS

Adjusting overall brightness and contrast

When referring to the Curves dialog window, the straight line that passes diagonally across the box represents the various tones within the image: the bottom of line is the shadows, the middle section represents the mid tones, and the highest and furthest point on the right represents the highlights. Moving the line upwards increases the overall brightness of the corresponding tone and vice versa.

For example, click on the center of the diagonal line and drag the line upward slightly. You'll notice the image becomes lighter as you're increasing the brightness of the mid tones. Now drag the bottom of the line downward. This will reduce brightness in the shadow region while increasing the brightness in the highlight region, resulting in an overall increase in contrast.

Experimenting with this tool is the best way of understanding how it works for you to process a specific image. Start by dragging the lines to new positions and adding new "anchor points" to hold the tones in certain regions. For ease of use, you can also use the pull-down menu at the top of the dialog box to select one of the preset (such as Increase Contrast) or try replicating these presets to fully understand how this tool can work within your own workflow.

Adjusting individual color channels

All color images are made up of a red, green and blue (RGB) channel. The "Curves" function allows you to adjust each channel individually using the RGB pull-down menu. To correct a red color cast, for example, try increasing the overall brightness of the green and/or blue channels. By adjusting colors individually or in sync with "masking," you can improve skin tones, ensure clothes are colored accurately or even further enhance your images to a cross process look. (see "Cross Process" example on page 144 for more information on this). In this section, I'm going to show an example of how Curves can work within a specific image and how it enhances the final appearance.

Model: **Lera @ FM Model Agency**

Makeup: **Leah Mabe**

Hair: **Janne @ Neil Cornelius Salon**

Styling: **Janine Jauvel**

CHANNEL

Commonly, a color image will have a channel allocated to each primary or process color, and sometimes one or more for a mask or other effect.

ORIGINAL IMAGE

The top third of the curves and color graph corresponds to the image's highlights, the center third the mid tones, and the bottom third the shadows.

WORKING ON THE RED CHANNEL

In the red channel, I have decreased the color of the reds by decreasing the mid tones of the overall image and increased the stronger reds in the image by enhancing the highlights (as seen in the example). This makes the image a lot colder, and the strongest part of the photo (the red outfit) stand out.

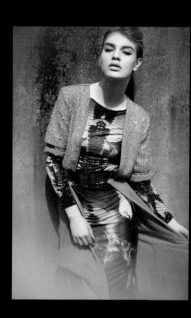

USING THE GREEN CHANNEL

In the green channel, I have increased all highlights, mid tones and shadows subtly to add an overall green tone across the entire tonal range.

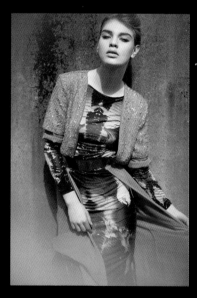

CHANGING THE BLUE CHANNEL

In the blue channel, the curve added increases the "blue" tone on the shadows but is slightly decreased on the mid tones and highlights. This keeps the tones within the skin and ensures I don't lose too much color elsewhere.

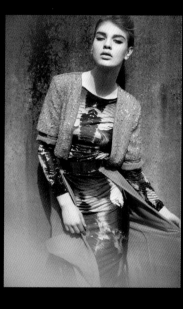

FINAL IMAGE

Now we've gone through adjusting the R, G and B tones individually, we can see how subtle the changes can be made to the overall image. Whenever I process an image, I combine the use of RGB curve enhancement together (see example) to get my desired color tone. After processing using each individual curve, I realized that a colder tone would suit the image better and enhance the garment's color. An important thing to remember is that your color processing should always suit the theme of the shoot and help enhance the mood or product within the photograph, and not overpower it.

FIXING SPOTS & BLEMISHES

IN THIS SECTION we're going to look into the best ways of retouching skin and removing imperfections. These techniques can also be used to remove other unwanted elements, such as clothing tags, or for makeup and styling adjustments.

Skin retouching is an important part of fashion photo editing. A spot or blemish is distracting to the viewer and most clients will ask for such imperfections to be removed.

Healing Brush

The Healing Brush is ideal for removing or correcting imperfect areas of skin. It works by applying a user-determined source sample of blemish-free skin to the targeted area. The tool is often referred to as "intelligent" as it will take into consideration the luminosity, texture, and color of the source and targeted areas and blend them together for an invisible mend.

1 Before using the Healing Brush duplicate the Background layer (click *Layer > Duplicate Layer* or use Cmd (Ctrl)+J and work on a copy). This not only preserves the original image should anything go wrong, but by duplicating the Background layer you are also giving yourself the option of adjusting its opacity (by using the Opacity slider at the top of the Layers palette) so that you can blend the new skin with the original layer if necessary.

2 Select the Healing Brush tool from the toolbox and select a small (20-pixel) hard-edged brush using the Brush picker in the tool options bar at the top of the screen. A hard brush prevents textured surfaces from blurring, but experiment with a soft brush with other surfaces.

3 Zoom into the part of the image you're going to work on using the Zoom tool. Place the Healing Brush over an area of blemish-free skin and while holding down the Alt (Opt) key (the brush will become a target symbol), click to sample the skin. Now start painting over the problem area. Work on small areas, and sample often to avoid an unrealistic uniform appearance. When sampling, select a patch of skin that has the same texture as the area you want to replace.

4 Finally, reduce the opacity of the new layer in the Layers palette. I would recommend between 70–75% opacity to avoid a plastic appearance. Once you're happy with the image go to *Layer > Flatten Image* and save.

OPACITY
Refers to how opaque, as opposed to transparent, something appears to be.

Spot Healing Brush

The Spot Healing Brush, as its name suggests is designed to remove small spots and blemishes. It differs from the Healing Brush tool in that you don't have to select a sample source—all you need to do is place the brush over the problem area, click, and Photoshop does the rest! When using the Spot Healing Brush, try to remember that this tool is used for small blemishes only—if you use it on large sections it will be noticeable.

1 Duplicate the Background layer as before.

2 Select the Spot Healing Brush tool from the toolbox, and select a small (12-pixel), hard-edged brush from the Brush picker (remember to keep the brush size small for successful healing).

3 Zoom into the area you're working on, ensure the brush fits neatly over the spot or blemish (use the [and] keys to change the brush size) and simply click. Photoshop will automatically replace the spot with skin sampled from around the edge of the brush.

4 Finally, set the opacity of the duplicate layer to 70-75% to avoid a plastic appearance, then flatten and save the image.

Clone Stamp

The Clone Stamp tool differs from either of the healing brushes in that it doesn't assess the source and target areas and attempt to blend them together, it simply replaces the target area with whatever has been copied or cloned. If you want to replace part of an image with exactly the same detail from another part of the image then this is the tool to use. Perhaps you're working on an image that has a distracting wall close to the edge of the photograph. You can simply clone an area of grass or sky, for example, and paint it over the distracting wall.

1 Duplicate the Background image.

2 Select the Clone Stamp tool from the toolbox and select an appropriately sized, hard-edged brush from the Brush picker. Remember you can always resize the brush using the [and] keys.

3 Zoom into the image, taking into account the area from which you want to clone. Next, while holding down the Alt (Opt) key (the brush will become a target symbol), click on the area you want to use as your cloning source. Now paint over the problem area to replace it with the cloned pixels. The Clone Stamp tool will duplicate that exact area.

In the tool options bar you'll notice a small box labeled Aligned Sample. Clicking this ensures the sample is taken from the more recent clone source with each new painting stroke. If you want the cloning always to start from the original source point leave Aligned Sample unchecked.

4 Finally, if you're trying to blend the cloned and target areas reduce the opacity of the duplicate image. However, if your intention is to entirely replace the target area with the cloned region, leave Opacity set to 100% as you don't want the underlying area to show through.

TIP
Try these workflow tips to make your retouching faster
1. If you make a mistake, just press Cmd (Ctrl)+Z to undo the adjustment and try again.
2. Use the History panel (*Window > History*) to retrace your steps further if necessary.

RETOUCHING SAMPLE

HERE I AM GOING to walk you through a retouching process using all three of the techniques described earlier to achieve a finished image.

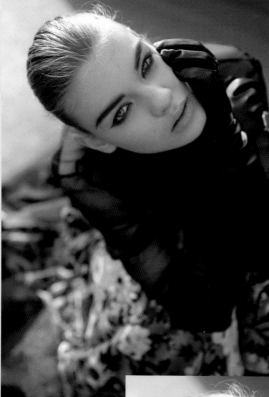

ORIGINAL IMAGE

Model: Lera @ FM Agency London

Makeup: Leah Mabe

Hair: With thanks to Neil Cornelius Hair Salon

Styling: Janine Jauvel

1 Open the image and assess it for problem areas. On this particular image, the areas that need attention are her face and the stray hairs.

2 Having assessed the image, let's start by creating a duplicate of the Background layer by clicking *Layer > Duplicate Layer*. I have renamed this layer "Clone Layer."

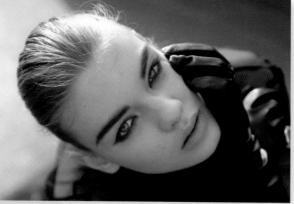

3 Next I'm going to use the Clone Stamp tool to fix the hairline and tackle those stray hairs. In the Brush picker I have set a brush radius of 60 pixels to start with, and set hardness to 0%, as I want to try and seamlessly retouch details in.

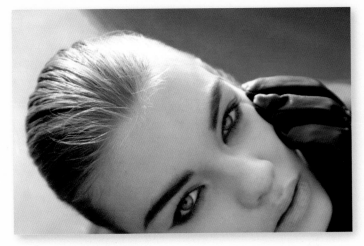

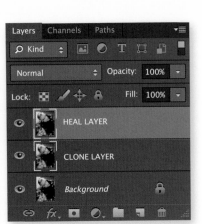

TIP
I personally prefer using the Spot Healing Brush for small imperfections such as pimples, and the Healing Brush for slightly larger areas and for those adjustments where I need to sample from a specific area.

4 With the Clone Stamp tool I next sample a "good" part of the image (taking into consideration elements such as texture and lightness) and clone over the larger problem parts, such as the surrounding wayward hair strands, hairline and large imperfections on the face. Don't worry about being too careful in the beginning, as you can always clean up detailed parts later on.

5 Having addressed the main problem areas, let's now look at more detailed areas. Make a duplicate of the Clone Layer and call the new layer "Heal Layer." By duplicating the Clone Layer, I'm working on a layer that includes the previous adjustments. Next, select either the Healing Brush or Spot Healing Brush depending on the size of the imperfections.

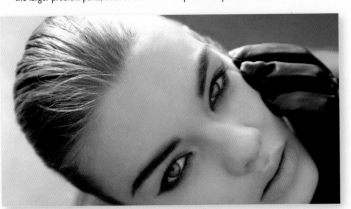

6 Here I'm going to use the Healing Brush tool. So let's zoom into the problem area, and set a brush size somewhere around 20-30 pixels. Sample an appropriate area—in this particular photograph it was the clear skin on her forehead—and let's paint over the areas we want to amend.

7 Obtaining good results when retouching skin requires a lot of time and practice. Concentrate on what is required in order to perfect an image, but don't go overboard. To create better imagery, improve what is there—don't try to create an entirely new image!

FINAL IMAGE
Here is the final image after tidying up the skin and stray hairs. I wanted to achieve a perfect version of the original image without making it too obvious it has been retouched. I have added a simple Curves adjustment to lighten the image ready for the next stage of retouching.

THE FINAL IMAGE

TEXTURES & BLENDING MODES

IF YOU'VE RESEARCHED the old photography masters you'll have noticed how their images often clearly exhibit film defects, which reinforces a sense of history. One way of recreating this quality in Photoshop is to use textures. You can use just about anything for its textural quality—a stock image showing tree bark, an old Polaroid film, the rugged texture of a wall, broken glass—anything, in fact, with an accent to it. The beauty of using textures is that you can control how they appear by experimenting with different blending modes. Blending modes determine how layers interact with one another. There are numerous Photoshop blending modes, and you should experiment with them all. Here we are going to use a texture and blending modes to create a unique and timeless image.

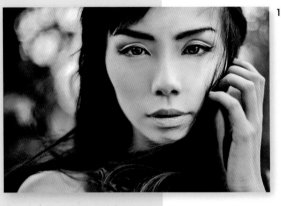

Model and Styling:
Bernadette Vong

1 Open an appropriate portrait in Photoshop. Next, open the texture shot, go to *Select > All* and copy it (*Edit > Copy*). Return to the portrait image and paste the texture (*Edit > Paste*) on top. Use the transform controls to fit the texture neatly over the portrait. You'll now have two layers, the Background layer and "Layer 1," the texture. Rename Layer 1, "Texture."

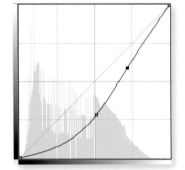

2 With the Texture layer active, change the blending mode in the Layers palette to Lighten or Screen—depending on which works best. Also experiment with *Image > Adjustments > Invert*.

BACKGROUND LAYER
In Photoshop, the Background layer, if still written in italics in the Layers panel, is fixed to the bottom of the layer stack. It is usually the basis of all your changes—the original image.

BLENDING MODES
When using layers to build up an image, blending modes alter the way that one layer affects the appearance of the one beneath it.

3 For this particular image the texture was too prominent, so using Curves I reduced the brightness, which also helped bring out detail.

TIP

It's always a good idea to make a catalog of your favorite textures and stock images in case you ever need them in the process of your retouching technique.

Here's a few great places to find them:

• Stock Exchange: www.sxc.hu
• DeviantART Stock: www.browse.deviantart.com/resources
• Texture King: www.textureking.com
• CG Textures: www.cgtextures.com

4 Next I went to *Image > Adjustments > Selective Color* to bring up the Selective Color dialog. Here, I created a vintage feel by adjusting the texture's black tone. The other tones are not affected.

5 Again, using Selective Color I adjusted the texture's neutral tone to reinforce the vintage and historic quality.

6 Finally, in Selective Color I adjusted the texture's white tone to fine-tune the look. Happy with the image I flattened the layers and saved it.

BLACK & WHITE

Models: **Ella @ Premier Models (left) and Maya @ IMG Models London (right)**

Styling: **Krishan Parmar**

Makeup: **Megumi Matsuno**

Hair: **Fukami Shinya**

CONVERTING A COLOR IMAGE to black and white is one of the most requested photo-editing processes. Lots of clients love a selection of black and white images scattered in among the color shots for the variety they bring, while photographers appreciate black and white as it adapts to almost any photographic style and works no matter what lighting setup is used. High- and low key imagery both benefit particularly well from black-and-white processing.

Although it's possible to convert a color image to a grayscale one in a single step (*Image > Mode > Grayscale*), to really tease out all the tones you need to work a bit harder. In Photoshop, there are many ways to create a black and white image, but my favorite involves using the Channel Mixer, as it gives me full control over the conversion.

Conversion with Channel Mixer

The reason why the Channel Mixer is so successful at black and white conversion is that it allows you to fine-tune the grayscale conversion of each channel—red, green, and blue—individually.

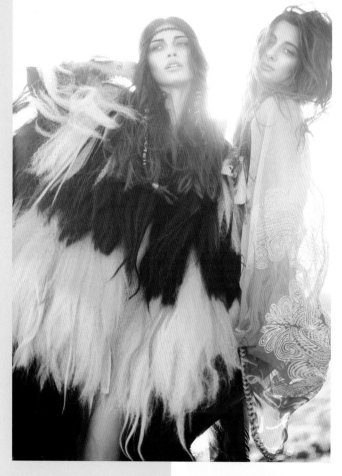

1 With your image open, create a Channel Mixer adjustment layer by going to *Layer > New Adjustment Layer > Channel Mixer*, or click the Create new fill or adjustment layer icon at the bottom of the Layers palette, or simplest of all, click the Channel Mixer icon in the Adjustments window. The Channel Mixer adjustment layer dialog window will appear above the Layers palette.

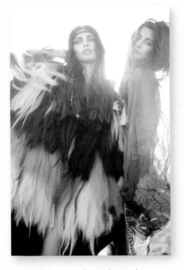

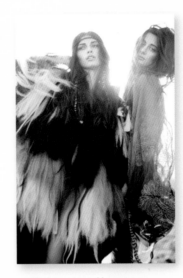

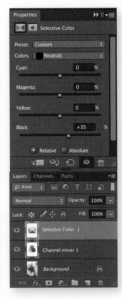

2 Click the Monochrome box in the dialog window to instantly convert your image to black and white. This provides a starting point.

4 The best way to add separate tones to specific parts of the image is to use a Selective Color adjustment layer. In the Selective Color dialog select Neutrals and move the Blacks slider to +30. This gives a gray shadow to my neutrals in the image and increases contrast. In order to boost contrast even further, select Blacks from the pull-down menu, and adjust the Blacks slider +10–+20 depending on your preference.

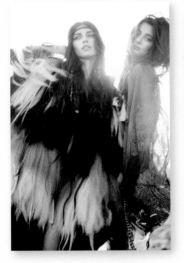

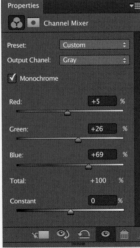

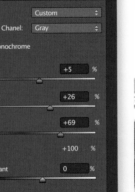

3 Next, experiment by adjusting each of the Red, Green, and Blue sliders. The idea is to move the sliders until you have the maximum range of gray tones present in the image. You'll notice that as you adjust the sliders, Photoshop warns you if you go over a total of 100%. 100% will provide the optimum quality. There are also a number of preset options you can try in the Channel Mixer pull-down menu.

Using Channel Mixer, this particular image only required subtle RGB adjustments, before the desired high-key effect was reached. However, I find that the neutral/dark tones are missing, and that there are too many light areas. In order to fix this, I am going to make another adjustment.

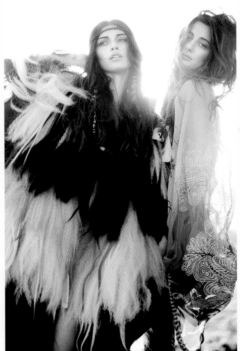

TIP
The best black and white processing results come from understanding what your image requires. Some images require subtle changes and some require heavier processing in order to achieve the desired results. Experiment with Channel Mixer and Selective Color together to gain a feel for what results you can achieve.

CROSS PROCESS

Model: Agata M

Makeup: Keiko Nakamura

AS DIGITAL PHOTOGRAPHY develops, ironically there is an increasing desire for vintage or cross-processed style images. These are images in which colors are shifted slightly, and often appear muted. Traditionally, cross-processing was achieved by using color transparency chemicals to process color negative film and vice versa. Creating a digital cross-process look can be done in a number of ways. In this section I am going to introduce you to a technique I am very familiar with and show you how to achieve a cross-process look in just a few easy steps!

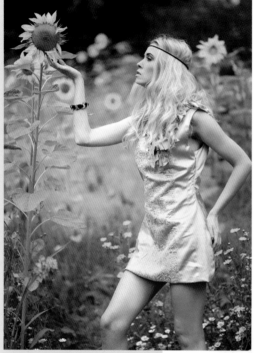

ORIGINAL IMAGE
Though I loved the original image as it was, I decided to process it to boost its vintage look.

1 Firstly, I am going to use a "Curves Adjustment" to boost contrast to give us a starting point to work with color tones. To do this, go to Layer (on the top of your Photoshop menu), then Adjustment Layer, then finally click on "Curves." This will add an adjustment layer in your Layers palette and the Curves adjustment tab should open accordingly. With the curve adjustment tab open, raise the curve on the right higher than the horizontal point to increase the brightness and contrast.

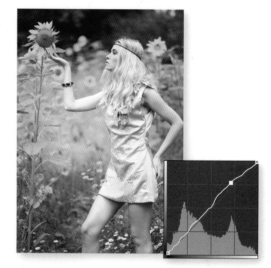

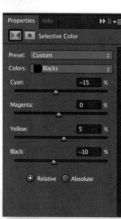

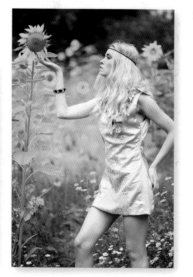

2 Next we need to remove the darker tones in the photograph and "tone" them to a specific color. The best way to do this is by using the "Selective Color" option by making a new adjustment layer (*Layer > New Adjustment Layer > Selective Color*). This will now be open on the right-hand side of your screen near your Layers palette. Whenever I tone photographs like this, I remove the "blacks" and tone them off-color, this helps the photograph to look more "aged." As you can see in the adjustment tab, I've used the "blacks" and reduced the cyans and blacks and increased the yellows. On this step, adjust your blacks and neutrals and add a color of your choice.

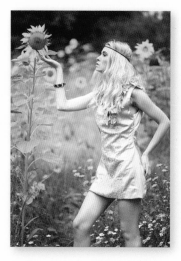
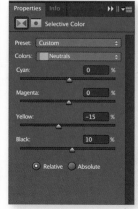
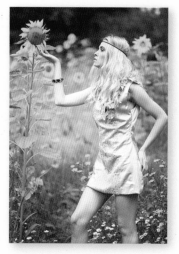
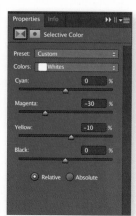

3 Once you've adjusted the darker tones in the photograph, repeat the same step as above but adjust the "neutrals" within the image. This adds a natural tone throughout the image and helps enhance

the cross-process look. The best way to know what works for the tones in your photograph is to experiment with the sliders until you're happy with the result.

4 Once you're happy with your dark and neutral tone adjustment, it's time to change the whites to an "off-white" appearance to further enhance the era of the photograph. Repeat the above steps so you have a fresh new

adjustment layer, but this time use the "whites" on the selective adjustment option tab. Here I have adjusted the whites by reducing the Magenta slider by –30 and increasing the Yellow slider by +10.

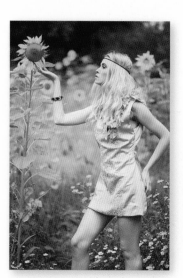
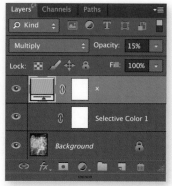
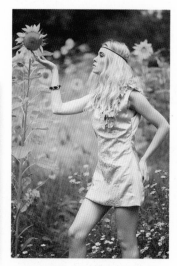

5 Add an overall tone to the image using "Color Fill." This enables you to enhance the warmth of your image and to boost the cross-process look. To do this, add an adjustment layer by going to *Layer > New Fill Layer > Solid Color*. If you're looking to enhance the warmth (like in this

specific photo) go for a dull yellow color. If you're looking for a more colder tone, then use a cold blue tone. Once you've chosen your color, you will need to select your layer mode so that it's on "Multiply" and reduce the opacity to your preference. Here I have adjusted mine to 15%.

6 When you're finally happy with your adjustments, flatten all of your layers (*Layer > Flatten Image*) and add Noise to your image. For this particular image, I have added 2.5% of noise and selected the options of Gaussian and

Monochromatic for the best results. Please note: this step can be skipped if you have a different preference on the noise in your image or it is already present.

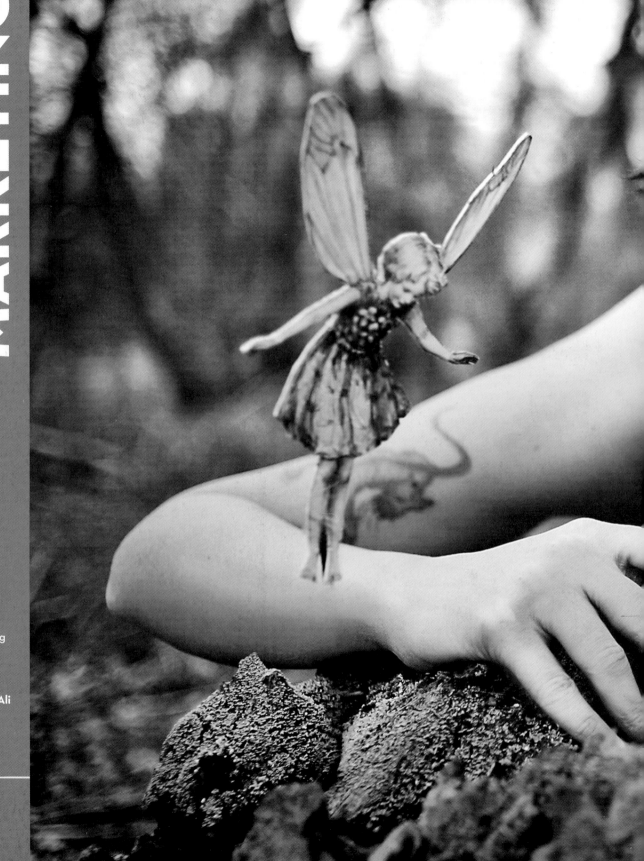

9

MARKETING

Some shoots will appeal to a niche market—try pitching your fashion work to a company that has a similar esthetic.

Model and Concept: **Kelli Ali**

Canon EOS 5D
ISO 320
f/2 1/800

MARKETING STRATEGIES

AT ALL LEVELS of professional photography, balancing the two sides of your business—the creative and financial—is challenging. Marketing is one of the biggest investments you can make, both in time and money, as a photographer and you need to get it right if you want your work to be noticed within the industry.

It's not uncommon for work to ebb and flow—some days you will find yourself incredibly busy, then there will be others when you're wondering where the next job is going to come from. All photographers go through this from time to time during their careers. Like many creative jobs, the rollercoaster will test your patience, however, being paid for something you love to do pays dividends.

The first step to successful marketing is to understand that it can be just as creative as your business, if not more so—just in different ways. The second step is to realize that there is no one-size-fits-all marketing strategy—some people benefit more from one type of marketing, while others from a different form of marketing. This section of the book is designed to encourage you to discover which strategies are appropriate for your business.

FINDING YOUR MARKET

Before starting a business you need to be clear about your intended market. In the long run you're likely to be more successful if you specialize in a certain style of fashion photography rather than being a jack-of-all-trades. Ultimately, your intended clientele are the people that are ideally going to be booking you, so in all cases you want to consider how well your approach works for them. Of course, our ideal clients would be happy with everything we offer, but in reality you'll have to define your style so it represents your own vision, but tailored to appeal to your intended clients.

The main objective with any photography business is to know your potential audience, and the best way to achieve this through research.

Here are the sort of questions you should be asking about them:

• Where are they based?
• What is their budget?
• What do they like to do?
• What are their interests?

There's always going to be somebody that offers a similar style or service to yours—the trick is to work as hard as you can at your craft, create your own niche, and try to stand out from the crowd. Once you're happy with the standard of your work, it is a good idea to think up a promotion or deal that will get your business noticed by, and bring in, your intended clientele.

Consider the following:

• Is there anybody else out there that offers similar services to you?
• Can you see a gap in the market that you can fill?

There are many ways in which today's digital photographers can market their businesses and services. To market your business successfully you should research your options, see what is available to you, and what level of financial or time investment is involved. It's easy to think there is a secret formula to earning recognition for your work, but in reality there is none—it's all about patience, persistence, and perseverance.

First you need to look at your product. What are you intending to sell? How successful is it already? Do you have a good body of work that is already earning recognition and a place within the industry? A strong portfolio is invaluable—marketing simply won't work if your images don't match up to the hype. So first things first: work hard on your craft, and work constantly—you should always be building your portfolio.

"Push" and "pull" marketing are two basic marketing strategies. Consider both before making a business plan to see how they can benefit your photography business. You should also think about how your intended clientele are going to respond to each and how they will work for you as an individual.

PUSH MARKETING

As a photographer you need to get used to the idea that you have to constantly "push" your way into the industry in order to get your message in front of the client. Push marketing involves contacting clients or enticing them to contact you by using a set idea or plan. Examples of push marketing include: sending our portfolios to art directors, agencies, and art buyers or even hosting exhibitions, sending direct mail or working with an agency rep to do all of the above. you as the marketer are in control of who sees this.

- **Objective:** You are intending to reach your target audience.
- **Advantages:** Push marketing is a direct way of reaching your target audience. It is also inexpensive (if you are self-marketing), as you are reaching your intended audience without having to advertise and entice the masses by using high expenditure like pull marketing does.
- **Disadvantages:** One disadvantage of this strategy is that it takes more time to develop a successful and personal brand that people can easily relate to. If you already have a successful brand/portfolio, then this strategy will work best for you. Another disadvantage of push marketing is that people can often react negatively if material, whether print or digital, is forced on them.

PULL MARKETING

Pull marketing is a strategy in which you inform a mass audience about you and your services and entice the consumer to freely buy into your brand. By using this strategy, you will most likely be using mass-media promotion to get your message to millions of consumers in the hope that a percentage of those people will consider you for a job or opportunity. Examples of pull marketing include, hiring PR consultants, coupons, social media (such as blogging, podcasting and online articles) and word of mouth. In today's industry, social media is a perfect example of how businesses now use pull marketing to advertise their services.

- **Objective:** You want to reach the masses with the intention that some may be interested in your service.
- **Advantage:** One huge advantage of this is that you are spreading the word about your work to the world—you never know who is going to book you!
- **Disadvantage:** Since you are reaching out to the masses, advertising will be quite expensive, anywhere from thousands to millions of dollars. You'll likely need to hire a PR company to create hype on-and-offline for your business. Since you're creating something to appeal to many people, the approach is more impersonal and nowadays clients prefer a more personal approach.

A successful business will utilize both push and pull marketing methods—and both are required in the photography industry. Among the most effective marketing tools today are social media sites, through which you can employ a mix of both push AND pull strategies. These are covered in more detail on pages 152–153.

BRANDING

BRANDING IS THE FACE of your business. It plays an extremely important role in getting clients to meet you or consider you for a job. There are two elements to successful branding:

Consistency: For branding to work it needs to be consistent throughout a business. In running a business—this is defined through how you or your employees work within your business—constantly giving great customer satisfaction and producing services on time. In terms of design, logos, website design, portfolios, image styles, letterheads, and so on should all be consistent. This will reinforce your brand in the client's mind. Consistent branding also demonstrates a sense of professionalism and indicates to clients that you understand the importance of brand—something they will readily identify with.

Relevancy: Branding needs to be relevant to the type of work you do. Think about how the theme of your branding will be relevant to your intended clientele and how this will help them make the decision to book you or not. For example: if you're a wedding photographer, you may want to think about the type or logo you use and how it speaks directly to your client.

Remember, a good impression is everything. If through good branding you leave a lasting impression on a client it's likely that they'll remember you when an appropriate job opportunity comes up. Good branding is especially helpful to young photographers. If you represent your own business and you appear young it's only natural a client will assume you lack experience. Having a strong brand will enforce the fact that you understand the industry and that you're the right person for the job.

A successful brand needs to be unique. With this in mind, think about how your branding will represent you as an individual and your business. Do not follow someone else's branding or ideas—branding is your own expression and voice.

Budgeting

Photography requires a fair amount of investment, so budgeting is necessary—and not just at the start. You'll need to budget throughout your photography career. From initial start-up costs, equipment, marketing, and to future business expansion, there are many things you must account for.

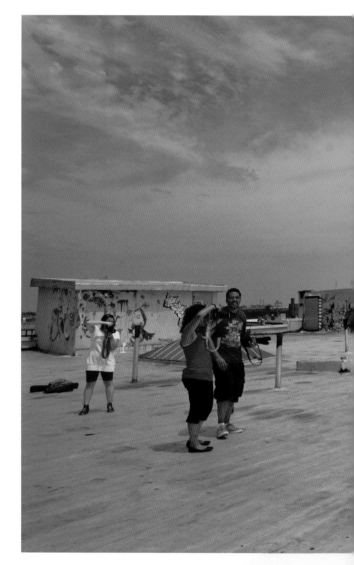

If you're starting out and planning your first budget, think about your goal for the coming year, then figure out how large an investment you will need. Where will the budget go? What are your plans for investment? Use your budgeting plan to figure out a way of improving your photography skills, or as a means of introducing new products or services, or as a way of marketing yourself effectively. Think about investing in your portfolio—the areas where you lack certain styles of work, or work in which you think you can improve on.

If you're at the start of your career, then it's likely that your investment will go into the obvious start-up elements: equipment, your portfolio, a website, photographic prints, business cards—these are initial start-up costs that every budding photographer must budget for.

As your business grows, you will need to upgrade your equipment and continue investing in your marketing strategies. You may eventually get to the point where you'd like to expand your business, and take on employees. If these are goals that you'd like to achieve, you must take these expenses into account when creating your budget.

No matter what your goals are, smart investing will yield results: by improving any part of your photography or business, you are going to gain more attention and recognition, thus getting you more work, and helping your career get to the next level.

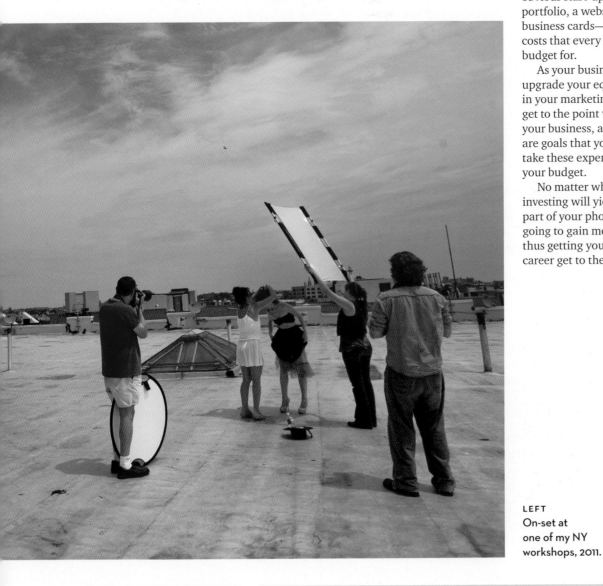

LEFT
On-set at one of my NY workshops, 2011.

10 TIPS FOR A SUCCESSFUL BUSINESS

1. Keep it simple.
2. Choose your direction.
3. Understand your equipment.
4. Stay inspired.
5. Keep shooting.
6. Create successful branding.
7. Network constantly to build your connections.
8. Understand your intended market.
9. Be open to constructive critique and learn from it.
10. Have confidence and a fantastic work ethic.

THE IMPORTANCE OF SOCIAL MEDIA

TODAY'S SOCIAL MEDIA mix of online communities and websites enables you to communicate with a worldwide audience, and all more or less for free. With the rise of digital media and interest in online communities, you'll find a lot of starting photographers use social media as a platform to showcase their work for critique or business. Clients nowadays are interested in what goes on behind the camera as much as they are in front of it. Today it seems everyone wants to be a photographer and the competition is fierce, so clients are keen to see what makes you tick—your inspirations, how you got started and how you executed that beautiful image in your portfolio.

You have to think of it like this; if a client is considering you for a job they are naturally going to be curious about how you create your work, and so they'll most likely research your online pages. This is similar to any business—clients are looking for past clients, recommendations, and even positive (or negative) feedback—so that they know you're right for the job.

WHY USE SOCIAL MEDIA?

- Attract new clients
- Establish a reputation
- Share your vision
- Express yourself
- Show new work
- Share your knowledge
- Connect with new contacts

ADVANTAGES/DISADVANTAGES OF SOCIAL MEDIA

Advantages
- Mainly free
- Gives you access to the world instantly
- Good for networking
- Saves time
- Gives clients an insight into you!

Disadvantages
- You may be revealing personal information
- Copyright—people stealing images/posting images without credit
- The sheer number of other people just like you

POPULAR ONLINE COMMUNITIES

There's a community of web-based galleries to suit every type of photographer; whether you are interested in being part of a community, to accept critique and share work, or whether you simply want to gain followers. Here are some of the most popular websites on the social media landscape:

DeviantART
An online community jam-packed with international artists working in all media. There is a strong sense of community and it's great for new artists to learn and be encouraged. Their large range of artists makes it a great place for visual inspiration!

flickr

Flickr
One of the most popular photography communities and home to various types of photographers who are looking to connect, share and critique. Some photographers (including myself) use Flickr to archive their older work that isn't featured on their main website. The privacy settings also allow you to hide certain photographs and groups!

Facebook
Let's face it, everybody is on Facebook. For us photographers it's extremely useful to advertise our services freely through our Facebook page. With a clean layout and an array of functions it's the perfect tool to share our experiences and easily track the interest surrounding our posts and picture uploads.

Twitter
While Twitter is not solely for photographers, following and listing photographers and photography related companies on your feed will ensure you receive constant new information and keep you in the loop! It's also a great way for other people to keep up with your conversation.

Linkedin
Purely for contact-building and knowing who's who; it's good for staying in touch with past clients for building a business platform. It is not for sharing photographs or receiving/giving critique.

500px
This website lets you create stunning online portfolios and share them with a talented photography community. The site is simple and straight to the point! Many photographers use 500px as a second online portfolio editing tasks.

Blogging (Wordpress, Tumblr)
Wordpress and Tumblr are blogging platforms that are very user-friendly and great for photographers who want to showcase their work. Tumblr's following and re-blogging format enables you to be able to get constant views and your work out to new people.

Vimeo/YouTube
Vimeo and YouTube are video/moving-image sharing websites that are popular worldwide. YouTube features everything from home videos to professionally made animations and Vimeo features industry-known talents and budding videographers alike. If you're a photographer and you're interested in finding visual inspiration or looking to experiment with moving images these are the places to go.

Google Plus!
A recent platform, Google Plus! is aimed at making sharing more like real life. It has a lot of privacy control and you can limit what is posted and seen. With this feature you can use it to increase your online followers or limit it to your contacts only.

PREPARING YOUR PORTFOLIO

A PHOTOGRAPHER'S most important selling tool is a portfolio and how it is presented. A photography portfolio can be the make or break point for a job decision, especially for photographers who have not yet established a reputation within the industry.

With new media, more and more photographers are drawn to the digital portfolio (online or on other equipment, such as the iPad). However, feedback online and in person has assured me that the best way to approach a portfolio is to have a professionally printed one that can easily be viewed by the client.

An industry standard portfolio is 11 × 14 inches with clear plastic acetate sheets under which images are placed, and is a personal preference of my own. If you regularly attend castings or client meetings then I recommend you buy a leather-bound portfolio. It will last longer and make a good first impression. It's also important that your portfolio is attractively laid out. Make sure images work side-by-side, and are consistent in style and format.

As for what images you should put in the portfolio, your image selection should be a mixture of your commissioned work (if any) and personal work—clients will want to see both. If you're meeting a person who already has you in mind for a job and you understand what the client is looking for then it is a good idea to organize your portfolio accordingly to tailor it more individually to their wants.

However, if you're a photographer with a unique personal style or you want to convey a specific theme in your photographs then you may want to consider organizing your book into a "story," especially if you're aiming toward the editorial market—this will show the editor/creative director of the magazine that you can carry a narrative. You don't necessarily have to create a story from start to finish, but rather, have something that flows and is cohesive all the way through.

Although your photography portfolio will help to show the client what you're like as a photographer, it won't necessarily book you a job. A client will ask you to present your portfolio and explain your thinking behind each shot. This way the client gets to understand how you think as a photographer and gets to know you personally.

TIP

If you know who you're going to meet, do your research on the company or individual and make reference to work they've been involved with recently. This will show them you've done your homework.

RIGHT

The images inside are obviously the most important part of a portfolio, but the design quality itself is important too, especially in face to face meetings.

YOUR WEBSITE PORTFOLIO

YOUR WEBSITE PORTFOLIO is just as important as your printed portfolio—if not more so. The aim of both formats is to showcase your photography and give the viewer an insight into your vision. One of the benefits of having an online website (as well as a printed portfolio) is that it's available to view by everyone—so with this in mind you want to keep the layout simple and easy to navigate.

It's very easy to get caught up in the design of a website and make it too elaborate. However, bear in mind that the viewers only want to see your photography—the design should compliment the content, not overwhelm it.

Gallery tips

It's important that you consider how to structure your website portfolio. Some photographers choose to display a number of shoots each showing a variety of photographs; some like to structure the gallery into set styles, for example, fashion, beauty and portraits, while others simply showcase one gallery of their best work. Again, as with the printed portfolio, how you arrange your material is down to you and what you wish to show to your intended clientele. However, if you do choose to have multiple galleries I would suggest limiting the content to 20–25 images per gallery only.

Further content

Further website content should include an "about me" or "biography" section—this provides a personal touch—and a contact page so that viewers can reach you directly. If you use other social media sites, or if you're a keen blogger, then you may wish to add links, so viewers have the choice of looking at alternative work.

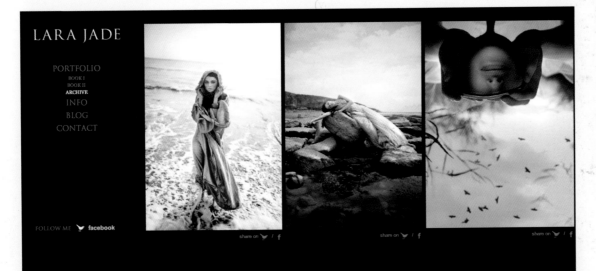

LEFT
Online portfolios should be cleanly designed and easy to navigate. Mine has a slider-based navigation system and additionally, each image can be shared on social media sites with one simple click.

PICTURE CREDITS

Model Agency Credits:
Elite Models NY: p65 (top).

FM Agency London: p87 (bottom left); p122; p134–135; p138.

IMG Models London: p57 (bottom); p142–143 (right).

Models 1: p4 (UK edition); p93.

New York Models: p107.

Premier Models London: p57 (bottom); p65 (bottom left); p84, p87 (left); p109; p142–143 (left).

Profile Models London: p2; p45; p47; p109.

Storm Models: p4 (US edition); p94; p99; p124; p130–131; p134–135.

Re:Quest Models NY: p73; p91.

Wilhelmina Models: p54; p62–63; p82–83; p87 (far left); p95; p96–97; p101; p103.

Photographer Credits:
Oscar May: p8–9; p11; p15; p26–27; p31; p40–41; p49; p51 (bottom); p60.

Kait Robinson: p17 (left); p51 (top); p71 (bottom).

Nicole de Waal: p18; p43; p50; p53; p71 (top).

Kim Akrigg: p66 (both); p67.

Thomas Cole Simmonds: p74–81.

Stock Agency Credits:
www.thinkstockphotos.co.uk: p10; p23.

www.shutterstock.com: p17 (right); p69 (center).

www.istockphoto.com: p20.

www.photocase.com: p20.

www.fotolia.com: p25 (both); p29; p33; p37; p68; p69 (left); p69 (center).

Equipment Image Credits:
With thanks to Canon, Nikon, and Sony.

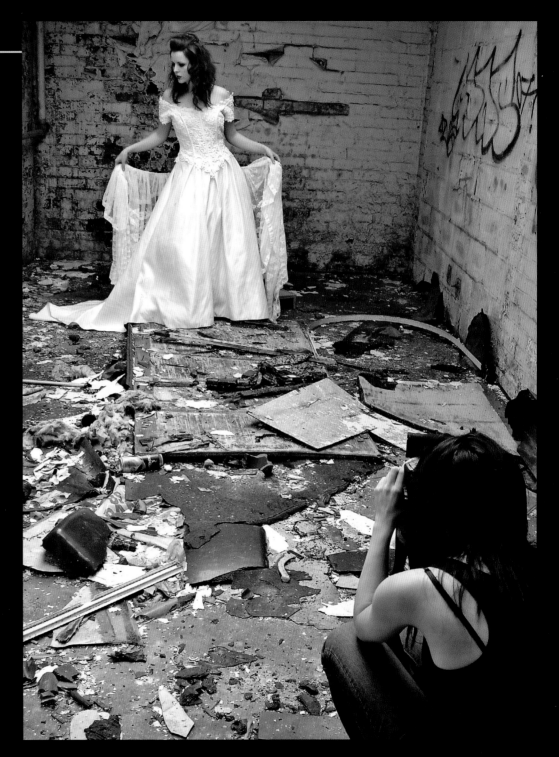

INDEX

ACKNOWLEDGMENTS

Author's Acknowledgments

In line with the creation of fashion photography itself, this book could not have been possible without the time and effort of those who appear on the pages. I have to thank the models who have stood before my lens and the styling teams that have braved the seasons and endured the endless shooting hours—it has been a pleasure working with you and sharing my journey thus far, and here's hoping to many more years!

I would also like to thank my close friends and family for their patience and for their second opinion on my notes while writing this book and to my industry friends for their wealth of knowledge and encouragement. A big thank you to my family, especially my mother, who has encouraged and believed in my career from the start—saving all of my media clippings and taking the role of human tripod/ chauffeur on many early shoots!

Most importantly, thank you to those who have supported my career from the start and continue to do so today online and within the industry itself—you have been a huge part of the foundation that has kept my business afloat and given me the confidence to expand my business internationally.

Lara Jade.

Information On Fashion Photography Workshops

I host intensive fashion photography courses all over the world! These 1–2 day courses feature everything you need to kick-start your career, and are great if you're looking for new inspiration. I share my advice and firsthand experience of the fashion photography industry, my business knowledge, as well as lighting techniques, model guidance, how to work with your creative team onset, and also retouching techniques. Look up my current schedule and find out more information at:
www.larajadeworkshops.com